FAKES

Hertfordshire
COUNTY COUNCIL
Community Information

2 5 APR 2000

- 2 MAY 2000

1 6 JUN 2000

3 0 JUN 2000

1 8 DEC 2000

- 6 DEC 2001

1 2 JAN 2002

L32a

- 7 MAR 2002

1 7 JUN 2003

2 7 AUG 2004

1 0 SEP 2004

Please renew/return this item by the last date shown.

So that your telephone call is charged at local rate, please call the numbers as set out below:

	From Area codes 01923 or 0208:	From the rest of Herts:
Renewals:	01923 471373	01438 737373
Enquiries:	01923 471333	01438 737333
Minicom:	01923 471599	01438 737599

L32b

ALICE BECKETT

FAKES

FORGERY AND THE ART WORLD

RICHARD COHEN BOOKS • LONDON

British Library Cataloguing in Publication Data:
A catalogue record for this book is available from the British Library

Copyright © 1995 by Alice Beckett

ISBN 1 86066 003 7

First published in Great Britain in 1995 by
Richard Cohen Books
7 Manchester Square,
London W1M 5RE

1 3 5 7 9 8 6 4 2

Typesetting by Rowland Phototypesetting Ltd,
Bury St Edmunds, Suffolk

Printed in Great Britain by Mackays of Chatham plc

FOR PAUL AND PERSEPHONE

Cui mille sunt artes, mille sunt fraudes.
He who knows a thousand arts knows
a thousand tricks.
Horace

Contents

List of Illustrations

Still Life with Pears by Bruno Hat whose work was mysteriously 'discovered' in the 1930s (Peter Nahum, Leicester Galleries)

The Furry Fish forged by the Royal Scottish Museum (The National Museums of Scotland)

Stolen 19th century Samson porcelain rabbit tureen, purporting to be 18th century (Sotheby's, Black Museum Collection)

Necklace and vases from a collection of fake gold antiquities auctioned in Zurich

Jesus Preaching in the Temple painted in jail by Han van Meegeren in the manner of Vermeer (Sotheby's)

'Rosetti's' *Proserpine* by Miguel Canals (Bonhams)

Tahitian 'Gauguin' by Susie Ray (Susie Ray Originals)

Icon of Hodeghetria, said to be originally portrayed by St Luke and imitated ever since (Trustees of British Museum)

Leonardo Da Vinci's *La Belle Ferronnière* in the Louvre, the subject of controversy for most of this century (AKG London)

A lapis necklace in the Sackler exhibition at the Royal Academy

The Helen of Troy necklace Carlo Guiliano designed, improving on the original (Wartski)

An 'Etruscan' sarcophagus sold to the British Museum last century (Trustees of British Museum)

Damien Hirst's pickled sheep, sold to a collector in 1944 for £25,000 (Topham Picture Service)

Bronze Egyptian cat, a favourite reproduction at the British Museum (Trustees of the British Museum)

Prologue

'Curiouser and curiouser!' cried Alice.

Everyone was smiling. My initiation into the dark side of the art world was a lunch with the expert in Russian and Greek icons at Christie's in London. It was Friday 11 January 1980. As I arrived it was snowing but there were pink roses on the table. The expert, Elvira Cooper, an elegant lady with long, bejewelled fingers assured me that icons were as good as Old Masters.

'Compare them with Duccio or Fra Angelico. They are so undervalued. People here don't understand them,' she enthused.

I felt privy to an important secret. She spoke of spirituality and of their mysterious power. Of anonymous artists who for a thousand years had followed tradition so fervently as to allow themselves only the smallest personal touches in depicting the Holy Scriptures. A bit more gold here, an extra angel there.

I began to catch Elvira's excitement. But why had such astonishing artists been overlooked?

She shrugged. 'Religious differences mostly,' she said. 'And the impossibility of getting good icons out of Russia.' Except, as I later learned, on the black market. The Interior Ministry department for economic crimes recorded more than 2,000 cases of icon smuggling in 1994 alone, worth 1.5 billion roubles and controlled by the drug barons of the Russian mafia. In the same time thirty icon dealers were killed with a single bullet through the head, a trademark of both the mafia and the KGB. This is now called the FSK and is in charge of eliminating the problem after 80 per cent of ALL icons have disappeared like the Cheshire Cat.

In 1980 Russia was still part of the Soviet Union. But Christie's, who

are the world's number two art auctioneers and constantly trying to snatch a lead on their rivals, Sotheby's, had, as it happened, managed to acquire for sale what was apparently the greatest icon collection in the West. The late owner was a lawyer and aviation pioneer called George R. Hann from Pittsburgh, Pennsylvania. Hann, it seemed, had been lucky in purchasing the icons directly from the Tretyakov Gallery and two other Moscow collections when the Soviet government sold off some works of art in the 1930s to increase their supply of foreign currency. So the provenance was perfect, urged Elvira. And what a chance to buy! In Germany, she admitted, there were icons smuggled in from the East; but how could you check up on them? It was a scandal. These, on the other hand, were unquestionably great.

Elvira's argument seemed seductive. She was certain in her belief.

When Hann's ninety-two icons came under the hammer in New York, the sale was a huge success. Prices were higher for icons than ever before, and everything sold. But then word was put about that many of the lots were fakes. Christie's immediately dropped their claims about the value of icons in general, and any market for them vanished. Elvira, I soon heard, was out of a job, though she continued her crusade.

Yet was the collection really 'wrong' (polite artspeak for downright crooked)? Or, as Elvira maintained, was it simply sabotaged? And if so, by whom? By the crocodile-shoed gangsters? By the KGB?

Undoubtedly fakers were liable to cash in on a rising market, and impoverished Soviets were likely to take advantage of a rich American. Yet the further I dug, the less I was sure about the truth of the matter. One problem was that Hann liked his treasures to look bright and shiny and new. He had no theme to his collecting other than the shape, colour and decorative value of the icons: they had to be in perfect condition. If they weren't, he had them repainted. He hadn't paid a lot for them anyway. Christie's catalogue indicated they had been cleaned and restored by the Russians. Close inspection led to reports that Hann was not satisfied and had many of the icons further prettied in America.

At least, that was the reply after the New York sale when a Russian émigré, Vladimir Teteriatnikov, denounced Hann's icons as forgeries.

Apparently Teteriatnikov was one of the seven Soviet state-qualified experts on icons and had worked at Moscow's Rublyov Museum, but he had defected to New York. He said Hann had refused to let him see the icons before, when they hung at the American's baronial home, Treetops, in Sewickley Heights. Hann, who had bought through an intermediary

and originally allowed experts access to his collection, had suddenly had a change of heart after visiting the USSR in 1972. Then, some say, he saw the real icons in Russia. His own collection had been established as the best in the USA thanks to an exhibition in 1944, but the expert who had hailed it as such, although Russian, was in fact a collector of butterflies and a watercolour artist untrained in icons or art history.

Teteriatnikov's case, I thought, sounded disturbingly convincing. But he ran into legal trouble with Christie's when he tried to publish his denunciation in a book, *Icons & Fakes*, even though he was backed by experts from the Getty Museum and Harvard and Columbia universities.

Christie's New York president, David Bathurst, was dismissive. Contacted while out shooting pheasant in the West Country in England, he replied: 'We can't have fellows floating around saying this sort of thing. Why, someone might believe him. We have every right to take up arms against him.'

Dealers supported Bathurst. 'Old Tet's a bit of a fruitcake,' said one. 'He just wants to create a sensation. It's all self-promotion.'

'He's like a character out of a Dostoevsky novel,' sniffed another. 'He thinks he's being ignored over here. People won't employ him. So he's using the classic Russian revenge technique of denunciation. You point the finger and it doesn't matter if it's true.'

Seemingly it didn't. Teteriatnikov had photocopies made of his book identifying the alleged fakes in the collection, and enough bidders from the Hann auction bought it and believed him to withhold payment of over $500,000. Among them was the Amsterdam dealer Michel van Rijn, the successful bidder on the most expensive lot, *The Ascension*. It was catalogued as sixteenth-century Moscow School, from the Tretyakov Gallery, and he had wanted it enough to bid over $150,000. Christie's, however, said van Rijn had just disappeared. Others who knew him well agreed this was not unlikely.

Two years later several of the unpaid-for icons were placed by Christie's with London's leading icon dealer Dick Temple, one of the other top buyers at the sale in spring 1980. He offered them on Christie's behalf at about two-thirds of the price they had fetched in New York. 'Once a good restorer has taken off the repaint, they look marvellous,' he claimed. 'There was one which I could easily see was fake, which is not unusual in any big collection. But I never doubted the rest.'

So, I thought, Elvira must have been right after all. Especially when one of her rivals at Sotheby's backed up her judgement.

'The icons would have been too difficult to forge and not worth enough money,' the Sotheby's expert assured me. 'You'd need old wood, the right gesso and correct draughtsmanship and you'd have to understand the theological background or you'd give yourself away immediately.'

Gradually a discreet veil was drawn over the whole episode; in fact all knowledge of the Hann icons strangely evaporated into thin air.

Then one day, out of curiosity, I wandered into Knightsbridge dealer Maria Andipa's Gallery, an Aladdin's Cave of icons and Russian eggs and other valuable religious knick-knacks.

'What did you think of the Hann sale?' I chatted.

'Oh, a lot of people were very cross,' she sighed. 'Of course, it was much too good to be true. Most of the icons were painted by a Russian restorer working at the Tretyakov — only a lot of dealers said the collection was okay to hide their red faces.'

So just who was one to believe?

I was beginning to suspect that I had tumbled like Alice into a Wonderland where nothing is ever quite as it seems.

· 1 ·

The real de Horys

*Alice had begun to think that very few things
were really impossible.*

'I want to make the market as big in the East as the West,' declared the
American expansively.

I was breakfasting with Alfred Taubman in L'Hermitage in Monte
Carlo. He said I could have anything I wanted: croissants, Krug, couscous
. . . He had recently acquired Sotheby's for £83 million after the firm
ran into losses in 1983 and were threatened with takeover by a couple of
carpet-underlay manufacturers. We were in Monaco for an auction. The
saleroom was conveniently only a few steps from the Casino and the
serious bidding was late at night to catch the big gamblers. Khashoggi's
yacht was in the harbour.

Taubman is pasty, heavy jowled and a builder of shopping precincts.
He had moved awkwardly among the exquisitely faded tapestries, the
Meissen and the Boulle tables at the viewing the evening before. But he
was eager and his excitement was infectious.

Like Peter Wilson before him, Taubman was inspired by the Riviera
mix of luxury and luck, of daring success. Wilson had created the Western
fine-art investment market in the post-war economic boom, virtually
singlehandedly. He was a spy for MI6, a homosexual, a friend of Anthony
Blunt (then Surveyor of the Queen's Pictures) – until they fell out over
a painting – and believed by some to be the mysterious double-agent,
the Fifth Man of the Cambridge spy ring. Here in Monaco, Peter Wilson
had sweet-talked the rich and famous into confiding their secrets and
consigning their heirlooms. He had persuaded Prince Rainier to let him
hold auctions in Monte Carlo and kicked off with the treasures of two

barons, one a Rothschild.[1] The greater the gamble the greater the coup. Eventually Wilson made his home close by the principality.

I asked Taubman if he thought he could match Wilson's golden touch. 'Give me ten years and you'll see,' Taubman beamed.

But for every legitimate mega market created there is another through the looking-glass, a shadowy counterpart. Such was the picturesque world of Elmyr de Hory, with his bitchy dealer sidekicks, Réal Lessard and Fernand Legros, initially boyfriends whom he liked to treat as servants. Thanks to the wealthy but slow-witted of the jet set, de Hory basked in the Mediterranean sunshine for seventeen years.

They still whisper about him in Monte Carlo because he had more effect on the art market than any Taubman might.

At L'Hermitage I met Coke bottle-designer Raymond Loewy in May 1981. Loewy's other achievements included furnishings and loos on the NASA space shuttle Columbia. But he was tired of discussing the problems of dealing with waste management without gravity. Instead he enquired eagerly if I knew of the Hungarian-born art forger, Elmyr de Hory?

'Did you ever hear how he conned Kees van Dongen?' Loewy asked me.

The Fauve artist, van Dongen, was renowned for his extravagance and his women, as well as his often cruel portraits of the wealthy and famous. He lived in Paris where Loewy was born until 1959 but had spent his last years in Monaco. Here in the early 1960s he had been visited by de Hory's associate, Réal Lessard, who had with him a portrait of an elegant woman with sculptured lips, a large hat and a necklace of blue pearls.

'It was like one he had painted nearly sixty years before. Of course, he was nearly ninety, poor fellow,' whispered Loewy, who was a skeletal eighty-eight with paper skin and watery eyes and several ladies in attendance. 'Van Dongen agreed he had done the portrait and signed a

[1] The auction contained treasures from the Château de Ferrières, east of Paris, because Baron Guy de Rothschild wanted to dispose of some of its contents before handing it over to the French state. His friend the Baron de Redé agreed to put part of his collection in the same sale, including items he had inherited from the Chilean millionaire Arturo Lopez Willshaw, to whom he had been financial adviser. De Rothschild had bought the Hôtel Lambert where de Redé lived in Paris and at the time de Redé was exchanging his apartment in the hotel for a smaller one. Ref: Sotheby's, *Portrait of an Auction House* by Frank Herrmann.

document to say so. Remembered the woman well. And how many times he had to put down his palette to make love to her'. Loewy's eyes twinkled. 'He said he had painted her exhaustively but had no idea where the portraits were.'

Naturally more began to turn up. Besides Paris De Hory was particularly *au fait* with the artists who spent time in Monaco and Provence: Matisse, Chagall, Renoir, Picasso . . . And, just like Wilson and Taubman, he believed in the winning streak.

Passed off as genuine, his early twentieth-century paintings and drawings netted a fortune, some acquaintances say as much as $160 million.

So who exactly was Elmyr de Hory? Loewy told me de Hory was born in Budapest into a rich aristocratic family. He had studied in Paris and got to know many artists by hanging around their favourite cafés. Then war broke out; he went back to Hungary and was imprisoned. The family possessions were all confiscated but he survived. After the Liberation he arrived back in Paris with nothing – except his artistic abilities and expensive tastes. Then, so the story went, one spring day in 1946 his career as a forger began quite by accident. De Hory had been trooping round Paris art galleries with his landscapes and nudes and selling none. However, he had pinned a sketch of a young girl's head on his studio wall, when Lady Malcolm Campbell, who lived in the Hotel George V, came by. 'That's a Picasso, isn't it?' she declared, adding that she knew a bit about the artist. Picasso didn't sign many of his drawings from his Greek period. This must be one of them. De Hory was a friend of his, wasn't he? Would Elmyr sell it? The drawing had taken him about ten minutes, and she gave him £40. Three months later, to de Hory's horror, she approached him anxiously at a cocktail party. She said she was worried. She had been a bit short of cash. She hoped he would forgive her but she had sold his picture on to a dealer for £150. De Hory was broke; but he realised he needn't be any more.

'What happened to him?' I asked.

Loewy was tired, fussed one of the hovering females. I should talk to one of Sotheby's picture experts who was here in Monte Carlo, Loewy murmured. But funnily enough, when I did, the expert said he'd heard of some such chap but then hesitated and added he really couldn't remember anything about de Hory.

The problem, as I soon discovered, was that it was hard to know where truth began and ended with Elmyr de Hory – except that he had died

on Ibiza in 1976 and was almost certainly responsible for over a thousand forgeries.

After he was exposed in 1968, he had told his story to Clifford Irving who was living on Ibiza, but the biography was withdrawn because of legal action by de Hory's other associate, Fernand Legros. Then, following de Hory's death, Orson Welles based a film on his life. However, neither Irving nor Welles could be trusted since Irving was responsible for faking Howard Hughes's biography and Welles for the US radio report of Martians landing, each using a respected medium to make believe his spoof was genuine. And de Hory himself was, after all, a faker. So what guarantee was there that anything he said was true?

One evening, after another late-night sale in Monte Carlo some six months later, I had arranged to meet my husband in the Far Room of the Casino. Not to play, but each time I returned to Monaco I was fascinated to see if the same faces were at the tables, especially one old lady who I had heard lived in a suite at L'Hermitage. She played without a flicker of emotion and only needed a tiara to have fitted into a family portrait with the last tsar. The Far Room has a quiet bar and as I waited there a dealer who had been at the same auction approached. I'd spoken to him several times before. His name was Etienne and he was down from Paris.

Etienne was preening himself. His hair was slicked silver grey, the same colour as his silk suit. He believed he had found a 'sleeper' in the sale. In fact he was sure he had. A sleeper is a valuable work which has gone unnoticed and he had bought it for very little. It was a painting by Lancret, he said. Exquisite, only just a bit dirty.

How had he spotted it? It was the bird in the cage that had given it away, he explained. 'Of course, I have some experience. Most people simply don't look properly.'

Had he, I wondered, ever come across de Hory?

Etienne leaned forward conspiratorially. Elmyr, he said, had lost heavily at these very tables. A croupier once told him. It was years ago. But the croupier remarked how de Hory always had to have the best of everything. The softest cashmere sweaters, the finest champagne, the prettiest boys. Easy if you had the money, and Elmyr did.

De Hory had spun a good story, continued Etienne. It was a common one among aristocrats at the time, about being destitute after the war and having to see what heirlooms he had left after his family collection was looted first by the Germans and then by the Russians; except he

seemed to have an inexhaustible supply. His Picassos, he said, were a gift from the artist years earlier. The same tale – with a little variation in detail – did for all the other artists Elmyr had known before the war in Paris. His memories of Montmartre in the twenties and thirties, the dealers and the collectors and which artist shared a studio or a bed with whom – and so might have been in a position to possess certain works – was invaluable. If the provenance sounded right, it didn't even have to be a good forgery. After all, what dealer could resist a quick profit?

Etienne shrugged. He had first become suspicious himself when drinking with other dealers, two of whom turned out to be de Hory's associates and were very drunk. One was young and freckled. That was Réal Lessard. The other, Fernand Legros, Etienne thought, was half Egyptian. He had a long nose and dark, receding hair and had pointed to his young companion saying: 'Do you know how he can afford such expensive perfume? He has a good friend who paints all his Vlamincks and van Dongens.'

The truth was bound to come out with a pair like that, declared Etienne. They were too emotional, jealous. Their rows became common knowledge. Clothes would be flung out of windows, the police would be called, accusations made and then they would kiss and make up. Etienne sighed. The young man was said to have endless gifts from Cartier as a result, quite apart from what he had stashed away by helping to sell Elmyr's fakes. And those could fetch anything up to $100,000 or more apiece.

Etienne edged closer, patted my arm intimately. De Hory was crazy to trust them. But in his opinion, whispered the dealer, Elmyr was bound to get caught anyway because he wanted to be a real artist. And he thought he could be. And he didn't like poverty. Ah, with fakers it was always the same . . . Then Etienne stopped. He sat up rather straight. My husband had arrived and the story ended.

I came across very little more about de Hory until one day in London when, to my surprise, I learnt of a collection of his work and was invited to see it. The collection was probably the biggest anywhere, even though some pictures had been sold, and it was owned by ex-bookie Ken Talbot. Ken had befriended de Hory in his later years and succeeded in republishing his biography. I immediately recognised the Lautrecs, Renoirs, Picassos and the rest as Ken ushered me up to his lounge. But I was astonished. They were decorative, gaudy even, yet obviously not the real thing. Why ever was de Hory so successful?

Ken knew nothing about art, he declared. However, he liked these paintings and he liked Elmyr.

'He was a talented man, especially when it came to creating money. Well, you only had to look at his crocodile-skin belt and immaculate cream trousers and handmade shoes. He was very slight, very Hollywood. He wore a monocle and could switch readily from one language into any of six others.'

Ken paused. He had first met de Hory in a café on Ibiza shortly after Elmyr had been unmasked as a faker. Ken had gone to live there too. Later he said he felt sorry for him.

He had bought four paintings to begin with, when Elmyr invited him to La Falaise. The house, Ken recalled, was as exquisite as Elmyr, white and airy with windows on to the sea – you could see Formentera on a clear day – a swimming pool and pictures by local artists on the walls. Elmyr kept his own paintings hidden away in his studio which you entered via a secret panel in his bedroom downstairs. It opened to reveal a flood of colour. Ken was privileged. He selected a beautiful girl painted against a bright red background, picked out three more 'impressionists' and handed over £1,200. 'Elmyr looked curiously disappointed,' said Ken, 'and I think as I hadn't bargained he maybe thought he could have asked for more. I was perfectly aware that he had painted them.'

A month later Elmyr got in touch with Ken Talbot again. 'He wanted to borrow five grand. I told him no way. I wasn't a bookmaker for nothing. But I said I'd take some pictures as collateral. He had the appearance of having lots of money, but it was obvious he could spend it faster than most. He had great generosity and loved holding dinner parties.'

Cannily Ken insisted on Elmyr putting the signature of the master he was imitating on each canvas instead of his own. When Elmyr hesitated because he said he didn't do that any more, Ken replied it was in case he didn't get his money back again. He preferred to see the paintings on his walls signed Renoir, Modigliani and so on. Not that he wanted to sell them, he explained. 'We had an understanding that I wouldn't do so while he was alive.' But Ken told de Hory he didn't want to see the name Elmyr grinning at him, reminding him about the cash. So Elmyr agreed to put his own signature only on the back. Consequently Ken bought more.

So was any of Elmyr's own story true, I asked? What about his so-called biography?

'I don't know about his aristocratic background. But it mattered to him what people thought. He had a blue rinse. He never smoked or drank much but if he did have a whisky he'd leave half of it to show he had money. There were plenty of freeloaders in the sun and he was well liked. He lived for today and forgot about tomorrow. He was very charismatic – like an actor whose role had taken him over. He could certainly stretch the truth. Though I think the tale he told at the end was pretty near.' Ken paused. 'He was a misfit. But he was basically a nice man.'

Elmyr de Hory's tale went something like this. A few years after the Second World War he had been lured to the United States by the belief of a better life. So he had taken a one-way ticket to South America where it was easier to get a temporary US visa. European artists were much favoured in New York at the time and he persuaded a major gallery to give him a show. Everyone who was anyone came to see it. But he still failed to sell any of his own work and so he continued faking. Besides the pictures, he also faked his name. His impressive string of aliases included Baron de Hory, which went down well with his richer acquaintances, and Elmyr Hoffman or Baron Herzog, by which he linked himself with old Hungarian families with known art collections – though he passed himself off as a cousin he invented who had been living in Paris. His party list included the likes of Lana Turner and Zsa Zsa Gabor – who later claimed he had sold her two forged Dufys.

To begin with de Hory only faked drawings. But the profits on an oil painting were much greater. He was tempted to try by a Modigliani. He saw it at Fannie Brice's house in Hollywood and the actress, whose life was to become the subject of the Broadway musical and film *Funny Girl*, said it cost $12,000. She died a year later and he heard her son sold it for over twice as much.

French impressionists and post-impressionists were becoming increasingly fashionable, helped by Sotheby's boss Peter Wilson's clever promotion, chancing considerable sums on unprecedented advertising. Above all there was the William Weinberg collection in 1957, marketed for all its pathos as the sole passion of the émigré financier after his wife and children died in concentration camps. The poignant tale gripped the press, enticed the Queen to visit the Bond Street salerooms the day before the auction, and publicised impressionists and Sotheby's worldwide.

De Hory, however, faced two major problems: acquiring authentic old French canvas and waiting, like any other painter, for the oil to dry. This

was particularly exasperating when he wanted to cash in quickly on the impressionist craze. On average he reckoned the paint needed two years. But at least he could solve the first problem by painting on American canvas and then, to disguise the back, cutting the picture from its stretcher and glueing it on to another stretched canvas of identical size. That was, after all, a professional restorer's method of rescuing a valuable work suffering from age.

Often de Hory seemed to have a charmed life. His first victim in New York, he claimed, was Klaus Perls, who was to become president of the American Art Dealers' Association. Elmyr duped him with a bogus study for a sculpture by Picasso by using the endpapers snipped out of a couple of oversized old French art books. He is also said to have conned Paul Rosenberg who had represented Picasso in New York for forty years. Wisely de Hory never stayed in one place very long; but unfortunately, during a spell in Los Angeles, he went into a gallery run by Klaus Perls's brother Frank and this time he had a portfolio of works by different artists. Frank examined them delightedly for a few moments. Then his smile vanished. He shuffled them and looked again. He had spotted a resemblance between de Hory's 'inherited' Picassos, Renoirs and Matisses and chased Elmyr out of the gallery and down the street. 'I'm not sure if it was the same dealer,' said Ken, 'but when we went into one gallery there and mentioned de Hory, the chap was still seething. And it must have been twenty years later.'

The FBI began to take an interest in Elmyr after he started a direct-mail campaign from Miami, writing letters to museums and galleries all over the country offering them drawings, gouaches, watercolours and small oil paintings by a variety of artists. Probably his biggest coup was selling one of his Matisses, *A Lady with Flowers and Pomegranates*, to the Fogg Art Museum at Harvard University, the top art school in America – though doubts surfaced and it was never exhibited. Ironically, his big mistake was to offer two supposed Renoir drawings he had not forged. In fact they were very good prints of the drawings and the originals were tucked away in the Hungarian National Museum in Budapest where he thought no one would look. The reproductions[1] were scarcely distinguishable except for the printer's stamp in the corner. Elmyr

[1] The prints were of Renoir drawings from the Paul von Majowsky collection, part of which is in the Hungarian National Museum in Budapest.

carefully cropped this, but the dealer who bought them became suspicious and began checking up. When he finally tracked the originals down, the dealer furiously alerted the FBI, who went after de Hory to charge him with using the post, telephone and telegraph in the perpetration of fraud.

They never caught him. Elmyr sought temporary refuge in Mexico. Only worse was to come. There he was accused of murder. He had gone to a party and given his telephone number to the young boyfriend of a rich old Englishman. One morning soon afterwards the Englishman was found strangled. Police investigating the boyfriend discovered de Hory's number by his bed. They put two and two together and de Hory had to buy himself out of trouble with the help of a top lawyer, though he managed to settle his legal fees with one of his Renoir drawings.

De Hory's penchant for unsuitable young men, however, led him into the hands of Fernand Legros, whom he picked up at a chic New York cocktail party, and Réal Lessard, a Canadian whom he spotted lying on a Miami beach. Réal, I guessed, must be a nickname based on the French word *réalité*. I wondered if it was a joke.

Fernand and Réal turned the tables on Elmyr by becoming lovers and selling his fakes, with him as the provider in the middle. So de Hory decided to return to Europe. As his visa had long since run out, he did some Degas pastels and a Renoir to buy a stolen passport, which was fine until Réal later tried to renew it for him at the Canadian consulate in Rotterdam. Then it transpired the Canadian to whom it belonged was wanted for possession of stolen goods and bigamy, and when the consul began to question Réal too closely he panicked and ran off. Elmyr's attempt to escape Fernand and Réal also backfired, since they followed him to Paris. As they already knew too much, it was easy for them to blackmail him into continuing their business partnership.

'That was when Elmyr moved to Ibiza. It was perfect for him at the start of the sixties,' explained Ken. 'It was very cheap. It was home to hippies and fugitives and everything was on a first-name basis. No one asked questions.'

Fernand and Réal kept de Hory supplied with paint, old canvases, art books, colour transparencies and restorer's varnish – used to make the paint dry more quickly and crack a little as if with age – and sent him orders and enough money to live on, though not enough for him to stop work. Meanwhile the couple set up base in a swish apartment in Paris as private dealers ready to travel the world with Elmyr's pictures. They covered the walls in Dufys, Derains, Vlamincks and Matisses and often

had several versions of the same picture ready to dispatch to Rio or Japan.

Their tactics, according to de Hory, were to get expert opinions, if possible from the artists' surviving relatives such as Jeanne Modigliani and Alice Derain, or, if not, to forge them. They also paid impoverished collectors to certify they had previously owned the pictures. Alternatively they would put a painting in an auction and, if no one bought it, they would only have to pay the handling fee to reclaim it, which was a small price for having it appear in a reputable catalogue as the real thing. They even hit on tampering with rare, out-of-print art books with detachable reproductions. These they removed, ordered paintings from Elmyr on the relevant subject and had his work photographed and printed on the same type of paper. They then glued these prints back into the book, so there could be no question of the paintings' authenticity. Any buyer could turn the page and see the proof for himself.

Finally, after a close shave with the Swiss authorities, they had false customs stamps made. Any valuable art work which is considered a national treasure has to have a permit to be taken out of the country in which it belongs. Fernand had taken some of de Hory's Vlamincks out of Switzerland on a permit, but had sold them elsewhere without realising Swiss customs would demand their return. Elmyr said that Fernand rang up pleading for some more fakes fast to replace the earlier fakes and keep him out of prison.

The demand for impressionist paintings was growing. They had become a status symbol since the 1957 Weinberg sale which Peter Wilson topped the following year with the auction of seven major impressionists for Erwin Goldschmidt, a New York insurance broker who had battled to retrieve much of his father's collection after it had been seized by the Nazis. Wilson gambled on the overwhelming success of the seven by promising to charge Goldschmidt a much lower sales fee than usual if they did not make as much as expected. Goldschmidt was thus induced to stick with Sotheby's and sell, and Wilson won. Police had to control admittance to the auction as film stars and international dealers fought to get in and spend more than anyone had ever dreamt on Manet and Renoir, Van Gogh or Cézanne.

Impressionist pictures, of course, were much easier for the *nouveau riche* buyer to understand than Old Masters, as were the brightly coloured Fauve works of, say, Dufy and Matisse. Fernand and Réal's biggest dupe seems to have been the Texan oil man, Algur Hurtle Meadows, who had endowed a southern university with an art museum and bought

forty-four of de Hory's fakes, including fifteen of his Dufys as well as eight Derains, seven Modiglianis, five Vlamincks and three Matisses. But the pair went a step too far as their lovers' quarrels escalated. Réal complained to the police after Fernand stole his briefcase and the latter ended up in jail in Dallas. Meadows was on hand to bail Fernand out, but the collector began to ask awkward questions.

Then Fernand made his biggest mistake. He had arranged to sell six pictures he had ordered from Elmyr at an auction in Pontoise near Paris. Unfortunately one of them, a Vlaminck landscape, wasn't ready; but it had been included in the catalogue. Instead of withdrawing it, Fernand found a substitute in one of the stores they used for Elmyr's work. He was unaware, however, that the painting had recently been aged by Réal with a nasty brown varnish that made it crack and look neglected. The trouble was the varnishing trick was too effective. An employee of the auction house decided to try to rub off the worst of the brown film and to his horror the pale blue sky came off too.

Fernand didn't wait to hear any more but fled to Ibiza. Conveniently de Hory's house was in Fernand's name because of the former's passport problems. Elmyr found himself homeless, while Fernand and Réal took up residence safe from French law. However, the couple reckoned without an angry Meadows and Interpol pursuing them from America, and in turn they vanished.

Elmyr sneaked back to his home in Ibiza. Before long he was exposed as Fernand and Réal's accomplice. But he claimed he hadn't personally sold any fake pictures in Spain. Nor had he let anyone see him painting them. So he had not committed any crime. He was the talk of the island. Confidence went to his head and he drove brazenly around in a bright red sports car. That was too much for the authorities. They began a routine investigation and in the late summer of 1968, for want of any other charge, arrested him as a vagrant and undesirable. He faced two months in prison.

Being in Ibiza jail, however, was more like house arrest. Elmyr had a steady stream of visitors. He slept in his own bed which he had brought in along with his books, music, clothes and toiletries. He hired an imprisoned hippie as his valet and cleaner and kept his drinks cold in the mayor's fridge next door, while he sunned himself in his deckchair wearing dark glasses, Bermuda shorts and a vivid sports shirt. His deckchair was famous. As other inmates idled the hours away in the shade, Elmyr would be improving his tan, apparently in a reverie. In

fact, he explained, behind this mask a spell of intense activity would be going on in his mind. He would first gaze at his surroundings lazily, seeing them as a Dufy, with pleasant colours and dancing lines, then these would become Matisse meanderings and brightly coloured Matisse shapes. Leaves would create patterns, shadows seem meaningful, edges sharpen and soften into Monet clouds and finally the scene would become a Bonnard medley of contrasting hues.

Back in the real world, of course, the problem was that de Hory's main money supply had dried up. So the meeting with Ken Talbot, soon after Elmyr's release, was opportune. 'Every time he was short of money he would come to me,' recalled Ken, 'and I took paintings in exchange. I began to feel a responsibility for him. Even after I moved back to London he would still come and see me. I just kept on buying the pictures because I felt there was something sincere about him and I liked them and they were a sort of investment.'

Elmyr claimed: 'If one of my paintings is displayed for sufficient time on a wall, it will eventually become an impressionist master.' Some put this down to his curious Hungarian logic. But Ken thought he had a point. Meadows's forty-four de Hory fakes are not known to have been sold as de Hory's own work since he was exposed. So in all probability, declared Ken, they have been recirculated into the impressionist market. 'The only way to halt this mix-up is to let Elmyr join his impressionist co-painters and I believe this will happen within fifty years.'

On one trip to London de Hory left three large red notebooks with Ken, saying he wanted Ken to find him a publisher. They contained his thoughts on various artists together with notes about his own methods and incidents that had happened to him. Ken started going through them and copied out a few parts; but then Elmyr asked for the books back.

Sometimes it seemed Elmyr was anxious to justify his faking. In one extract copied by Ken, de Hory wrote: 'I am continuing their work. Modigliani is dead. Matisse is dead. I sometimes feel their souls were transplanted to me. I have a mission to fulfil.' At other times he dismissed modern painters entirely. He believed it was his sacred duty to undermine the structure of the art market if Picasso could sell for more than Rembrandt. The brightness of Matisse and energy of van Gogh were, he maintained, brutal in comparison with, say, Vermeer. He had to remember to draw Matisse hands like bunches of bananas to fit in with the design of the picture. In comparison Altdorfer's and Cranach's hands

were beautiful. De Hory noted: 'All my life I wanted to prove myself better than other painters . . . but these moderns really are easy: I proved it repeatedly to myself sometimes, I think, to the point of doing it carelessly.'

He could do a Matisse drawing, he said, in five minutes – that is, in the style of Matisse, since he only ever actually copied the signature. So he reckoned Matisse could do it in even less. Picasso was a cinch; but so much was registered that it was dangerous to attempt him – though it was quite possible to get away with a small drawing from the blue or pink period, before everything was photographed. As for Modigliani, Elmyr stated, he was 'someone I did with great success . . . I don't think there's anyone in the art world who knows more about Modigliani than I do.'

Dufy was another favourite since he portrayed a world Elmyr knew intimately – Cannes, Deauville, Longchamps. Occasionally de Hory did a van Gogh or Lautrec, though he felt they were not really his scene, and he rarely touched Chagall because he was still alive and quite intolerant about fakes. Anyway, declared de Hory, Chagall's reputation was vastly overblown, his contours infantile and fumbling and his colours crude. Miró he never did at all on the grounds that even the real ones looked like fakes.

One of the most powerful influences on him, Elmyr said, was Leonardo da Vinci. When he first saw the *Mona Lisa* in the Louvre, however, he felt a mocking disdain. He was sure that the *Mona Lisa* was the biggest confidence trick in the history of art. The portrait was no more than a tourist trap with its famous 'enigmatic smile' and eyes that were supposed to follow you wherever you went. Moreover, claims had been made that after the original was stolen in 1911 the picture put back in the Louvre was a fake. But when de Hory returned to the *Mona Lisa* he found he was receptive after all. More than that, he became obsessed with painting his *Hommage à Leonardo* in the form of numerous *Mona Lisa*s. In his notes he explained that it was a way of improving his own talent, as with other Old Masters which he secretly copied.

Where are these Old Masters now? Ken Talbot had no idea. Nor was he sure why Fernand and Réal were able to operate so openly in France, though the rumour was that two French cabinet ministers had been bribed with pictures or boys in order to quash earlier suspicions. After the game was up, Ken believed Fernand lived in exile in Switzerland and Rio before being extradited to France and put in prison. However, he was released

almost immediately on psychiatric grounds. Ken thought Réal had probably returned home to Canada.

Meanwhile, de Hory gained sufficient celebrity status to be given several exhibitions of his own paintings in Madrid and London. Yet buyers showed more interest in his fakes. He even boasted that the Queen owned one of his forgeries.

Back on Ibiza, de Hory remained in fear of his own extradition to France where he had been wanted for questioning ever since he was exposed. When he thought this was about to happen late in 1976, he announced he would rather kill himself than let anyone carry him off to a damp French prison. He was found dead on 11 December that year, reportedly from an overdose of barbiturates.

'Of course, you know it wasn't suicide,' murmured Ken as I was leaving his house. 'They strung his pet dog up from a tree a week before and left him a note. It was a white Scottie. He was desperately fond of it. They said he would be next.'

'They?' I asked.

'Anyone there can tell you,' he replied.

Since Elmyr's death Ken admitted he had sold some of the pictures he had bought. I happened to mention this to a friend who had been living in Paris.

'Are you sure they're de Horys?' she asked. 'Did anyone see him paint them?' And then I heard an alternative version of the story.

It amounted to Réal having done most of Elmyr's supposed fakes himself, fooling museums and galleries from New York to Tokyo. He had learnt from de Hory and to prove he was capable he did a Modigliani on French television. He had also studied international law and he called the pictures his interpretations. He did not sign them with the master's name, although Fernand added the appropriate signature before selling them.

Réal apparently was particularly proud of the portrait of a woman that Kees van Dongen had believed was his own. According to Réal it was actually a Californian friend of his who had posed, attired in a hat her mother had worn for a masked ball.

Hebborn's Old Masters

'Would you tell me, please,' said Alice . . . 'Why you are painting those roses?'

'The funny thing is I didn't know he was a spy and he didn't know I was a faker.' Eric Hebborn chuckled. He had begun to tell me about his friend Anthony Blunt, Surveyor of the Queen's Pictures, who confessed before he died in 1983 to being a Soviet agent. It was fifteen years since we first met. I had wandered into Colnaghi's, one of the most rarefied art dealers in Bond Street. I was hovering over an Old Master drawing labelled Piranesi. A man, Eric as I later learned, was standing nearby. To my surprise he asked me what I thought of the sketch. He was a bulky sort of chap, suavely dressed but seemingly at odds with his surroundings. 'Very fine,' I murmured politely. His smile said he knew better.

In 1992 Eric was little changed, though I had remembered him as slightly taller. We were in Julian Hartnoll's upstairs gallery, tucked away at the end of Mason's Yard in St James's. Through the window came the sounds of a Japanese tour party clustered outside a solicitor's office below. That used to be a gallery, too, and was where John Lennon met Yoko Ono. Hanging on the walls around us was a show of Eric's own work as well as a number of his fakes.

One of Blunt's other friends had, it seemed, been suspicious. Or jealous of Hebborn's relationship with the art historian. 'Tried to stir things, but then he always did. It didn't get him anywhere. Blunt grilled me, but only the once . . .' Eric broke off. 'What do you think of this?' He gestured with the same quiet eagerness to what certainly looked like a Piranesi.

The Venetian artist Giovanni Battista Piranesi had captured the

imagination of eighteenth-century Europe with drawings that depicted his sublime vision of Rome. This was a romantic mixture of crumbling antiquities and baroque innovation which, as Horace Walpole had remarked, 'would startle geometry and exhaust the Indies to realise'. Travellers on the Grand Tour brought back Piranesi's etchings as mementoes.

Piranesi had begun to intrigue me after a row erupted in the back rooms of Sotheby's. Inconsistencies had been spotted in a group of six drawings attributed to him which were auctioned in 1987 for a total of £287,000. The four best, all apparently preparatory ink drawings for Piranesi's etched *Views of Rome*, were knocked down to the Duke of Beaufort, boss of the London branch of Marlborough Fine Art. The duke, it seems, was acting for Gianni Agnelli, the chairman of Fiat, a passionate admirer of Piranesi's work. The duke wasn't happy. Nor was his client. Nor were the US buyers of the other two drawings. None paid.

The drawings were said to have belonged to a dealer in Milan who was unable to sell them. Sotheby's declared they had to protect the vendor who wished to remain anonymous, but the auctioneers acknowledged the works had come to London from Switzerland. Most art sold from Italy that would not be given an export licence is first smuggled over the border into Switzerland where few questions are asked. Piranesi is in this category. So naturally the drawings lacked provenance and Sotheby's accepted what the vendor told them. But there was no previous record of the sketches.

Sotheby's expert, Professor John Wilton-Ely, had no qualms about the authenticity of the drawings. He had organised the artist's bicentenary exhibition at the Hayward Gallery in London in 1978 and was regarded as Britain's chief authority on Piranesi. He believed there were tell-tale signs that the sketches were definitely the artist's work. However, America's leading expert, Andrew Robison,[1] curator of drawings at the National Gallery of Washington, took one look and pronounced them 'wrong'. He was convinced they had been made after the etchings rather

[1] Andrew Robison, considered the top authority worldwide on Piranesi, was sent photographs of the drawings some months before the sale. But it was only when he saw the drawings themselves, a couple of weeks before the auction, that he realised they were 'not right'. He said later that he had spent 'a fair amount of time' explaining his opinion to Elizabeth Llewellyn at Sotheby's.

than the other way round, and suggested they had been done by an inferior contemporary copier.

The lesser artist was given away, Robison claimed, by hilarious errors that came to light in comparison with the etchings supposedly taken from them. He pointed to crucial mistakes which he felt it was inconceivable Piranesi would have made. Among them was the apparent movement of a statue of Marcus Aurelius, centrepiece of the piazza on the Capitoline Hill, which in one of the drawings turns up instead at the top of a flight of steps in front of a palace. Then there was the sketch of the Repetta Port depicting a terrific jigsaw puzzle of boats. In the etching these were all accurately defined, but in the drawing most of them would have sunk since whole sections of the boats were missing. 'In one line-up you have three bows but only one stern,' Robison warned the auctioneers just a couple of weeks before the auction.

Sotheby's hastily but quietly convened a meeting of scholars with a knowledge of Piranesi. However, Old Master drawings are notoriously difficult to authenticate and, as the pointers for Piranesi outweighed those against, the sale went ahead. Specialist dealers got wind of Robison's doubts and gave the auction a wide berth. Anyway, they shrugged, it was always thought that Piranesi created his images by drawing directly on to the plates without making any preparatory sketches. But the buyers, including the Duke of Beaufort, who normally dealt in more modern pictures, did not discover Robison's opinion until too late. They complained bitterly. Sotheby's, unusually except in the case of very important clients, said they would not be pressing for payment until the issue was resolved, and added that they would be having another look at the sketches themselves. This seemed to take an inordinate time. Months went by and the matter conveniently began to fade. Then I happened to mention it to a friend at Christie's.

'You can bet they're Hebborns,' he said. 'The fellow's been at it for years. He lives in Italy.'

I had never heard of him.

'Oh, no one talks about him,' my friend explained. 'Even though he got found out. The trouble is he's too good.'

Thus I began to learn about Eric, faker of hundreds of Old Master drawings, many of which had been sold through the auction rooms and via several highly respected dealers to museums and major collectors worldwide. There had been a small flurry of publicity about him a few

years earlier, but apparently the experts were mostly too worried to admit their mistakes. A big problem with Old Master drawings, of course, is that they are often unsigned, which means attribution may be just a matter of opinion.

So was Hebborn still working, I enquired of my friend? He didn't know. But it appeared that anything in red ink was now suspect after a number of drawings in this medium had been identified by Sotheby's as Hebborn's handiwork.

After that I gave any Old Master drawings I saw more than a cursory glance – particularly if they were labelled Piranesi, Rubens, van Dyck, Poussin or any of the others in which I gathered Hebborn specialised. I glanced from one to another on Hartnoll's gallery wall. Eric remarked that only an expert was worth fooling. Blunt, as director of the Courtauld Institute, was the expert's expert. His knowledge was regarded as virtually unquestionable, certainly on Poussin. The two were friends for twenty years.

'What attracted me to him above all was his mind,' recalled Hebborn, who had first met Blunt over a drink at the British School in Rome. 'He also kept filling my glass and talking about art and only ever tore my points to shreds in the most courteous and gentle tones.' I guessed that if anything Eric admired Blunt even more after his unmasking.

The previous night, at the opening of Eric's exhibition at the Hartnoll Gallery, another unmasking of sorts had taken place. Eric was one of a large family who had gone to live in Romford, Essex, shortly after he was born on 20 March 1934. He was approaching sixty and several of his family had come to the opening of his show. 'I hadn't seen any of them for fifty years. Not since I was sent to borstal,' he said. 'Well, what was the point?'

Borstal had been the punishment for burning down his school at the age of eight. Though it was not his fault, he explained. He had discovered that he could utilise the charcoal tip of a burnt match to sketch with and, when the charcoal had been used up, he could sharpen the tip on sandpaper – as he had no knife – and dip it in his inkwell to draw a line. Unfortunately his headmaster jumped to the conclusion that a match and sandpaper meant fire, and caned him. Eric felt this was unreasonable. In the end he decided his caning could only be vindicated if he caused a fire. So he did.

The reunion had left him curiously unmoved and one of his brothers comatose on the gallery sofa. 'It was impossible for me emotionally. It

was like meeting strangers,' he said. Eric had never tried to get in touch even when, as he recounted, he was so poor he had to sleep under a hedge in Epping Forest. That was during his early days as an art student, when he was always having to borrow funds which he had great difficulty in paying back.

His career as a faker consequently began when, unable yet again to return half-a-crown to a richer student, he was asked to do a couple of drawings instead in the Vorticist manner of Wyndham Lewis, a sort of English Cubism. The student provided some paper purportedly from one of Lewis's sketchbooks and Eric obliged – reluctantly, he said, 'Because I didn't much care for Wyndham Lewis.'

In the mid-1950s Eric went on to be a student at the Royal Academy, where he won prizes for drawing, though he was criticised for his old-fashioned approach as he preferred aping Old Masters to experimenting with abstract or pop art. However, the problem of paying for the next pint or week's rent, or replacing coins borrowed from the gas meter, dominated his life, along with a lover, Graham Smith, whom he met at an evening sculpture class. So, when the chance arose of some part-time work as an apprentice restorer[1] up the road from the Academy, Eric leapt at it. His particular talent, it turned out, was for filling in large areas of missing colour in a painting in the style of the original. 'The easiest artists to imitate are the ones that painted very finely – simply because they are so exact,' he explained. In the process he learnt a great deal about the materials and methods of the Old Masters; about how to deceive even a tutored eye; and about the deceit practised to varying degrees by dealers.

When it was simply a case of covering a gap in a picture, he said, the restorer would fill it with white lead paint and plaster of Paris, using a palette-knife. Before it was dry he would take a similar piece of unprimed canvas and press it on top of the filler so that the grain was imprinted, later improving the effect with a needle. Then it was Eric's job to paint over the area, using a needle again after the paint became tacky to continue genuine surface cracks across the filler. Into these he rubbed colour and so made them look just like the rest.

But restoration, Eric found, was often more a matter of improving a

[1] Eric Hebborn records in his autobiography *Drawn to Trouble* that he began as an apprentice restorer at George Aczel's top-floor studio in Haunch of Venison Yard, premises now occupied by the auctioneers Phillips.

picture to make it more saleable. So he became adept at turning an ugly woman into a pretty young girl, an offending skull into a tempting glass of wine, or a muddy field into a mass of wild flowers. He added tabbies and red setters, sheep or horses to dull landscapes and transformed unknown sitters into regal ancestors. He changed unpopular signatures into more fashionable ones and the value of the paintings rose by several hundred per cent.

At first Hebborn said he questioned the ethics. But he was assured by the restorer that, since most of his clients belonged to the highly reputed British Antique Dealers' Association, they would never risk doing anything crooked. So Eric carried on until one day, he recalled, an aristocratic-looking picture dealer turned up with a canvas for restoration. He declared he had found a painting by Willem van de Velde the Younger, the seventeenth-century Dutch artist who specialised in marine painting and whose work was extremely valuable. Eric said: 'I seemed to be the only one to notice that the canvas was completely blank.' Nevertheless the dealer went on to remark on the possibility of a signature appearing during cleaning and to deposit a pile of photographs of Willem van de Velde paintings on the table, pointing to one ship that he thought much resembled a vessel in the work he had discovered.

Consequently Eric set off to do some studying at the National Maritime Museum at Greenwich. Then he made a preparatory drawing in van de Velde's manner. He redrew this on the old canvas and prevented paint seeping into the age cracks by filling these with a jelly-like substance which resisted his paintbrush and would later dissolve in water. He took care not to use colours like zinc white and Prussian blue that were not available in van de Velde's day; those he did use were ground in a clearer oil than linseed and had a mixture of benzine and an artificial resin added. Then Eric copied a signature from a photograph. 'Quite simple, really,' he said, smiling.

Baked at just over 100°C for two or three hours, the paint hardened. Eric next endeavoured to remove the signature, adding the unlikely one of Jan Brueghel on top so that the latter would be removed as false and van de Velde's uncovered. The next trick was to coat the picture with dirty varnish and clean it off again, except in the crevices, stain and damage it further, and paint it with another shiny varnish.

Cannily, Eric's employer then gave the picture for restoration to someone else who had no idea it was not original. Finally, it was painted with a coating of size, a glue-like substance, so that the fresh paint would

not be given away by dissolving easily if tested with alcohol, and at last
Eric's first masterpiece was properly varnished. 'Though I gather my
employer remembers this episode entirely differently,' said Hebborn,
'since the canvas did not appear blank to him at all.'

Where is it now? Eric had no idea. But any further doubts he had
about restoration were soon assuaged by his own sense of justice. Rather
like the school fire.

Eric's landlord at that time had heard that pictures were a good
investment. Eric owed him 4 shillings and sixpence and offered him a
painting he had done to settle the debt. The landlord agreed, providing
a junk dealer friend said it was worth at least 5 shillings. When the
dealer offered £4, the landlord agreed to go half shares for £2, which he
proudly announced to Eric without any suggestion of dividing the profit.
Later, said Eric, he spotted his painting in the window of a Cork Street
gallery bearing Sickert's signature and priced at £40.

'Other people may call that business. But to me it was greed.' So
Hebborn had decided to get his own back.

Casually he dropped hints about the money to be made out of spotting
important pictures going for a song, until eventually the landlord enlisted
Eric's help in looking for art bargains. As a start one Saturday morning
he handed Eric £10 to go shopping. Hebborn chuckled: he and his lover
Graham had gone on a binge instead. On the Sunday morning Eric offered
the landlord a pencil sketch he had done specially as if by the early
twentieth-century portraitist Augustus John of his wife Dorelia. The
landlord was offered £90 for it by a West End dealer and was so pleased
he decided to keep it instead and start an art collection as an investment,
with Eric as his buyer.

'The funny thing is,' remarked Eric, 'I must have done more than
eighty Augustus Johns over the years and they've proved more popular
than many of John's authentic works. So much so that you can probably
get two or three genuine examples for the same price as one of mine.'

On the whole, however, Hebborn preferred doing Old Masters, but
for these he needed blank sheets of the correct old paper. He came across
a supply of this in a junk shop near the National Gallery where an Apulian
vase had caught his eye. Thanks to the money from his avaricious landlord,
he was able to go in and buy it. Eric's plot against his landlord, however,
finally backfired: the landlord did so well out of Hebborn's forgeries that
he was able to go and start a new life in Australia.

Eric pointed with some satisfaction to a number of watercolours of

Italian scenery. A woman in tweeds had wandered into the gallery and was regarding them reverentially. They were in the same vein as the Prince of Wales's holiday daubs but this time were entirely Eric's own work. He had won a drawing scholarship in 1959 to study at the British School in Rome and fell in love with Italy so much that he eventually made his home in a hill village called Anticoli, a little way outside the city. He divided his time very comfortably between there and Rome. Periodically he has a show and takes commissions, like the communal portrait of his fellow villagers he had been working on. A man, also in a tweed jacket, who had followed the woman in, tapped Eric apologetically on the shoulder, and whispered conspiratorially. Were those the fakes? He nodded towards another wall. Would Eric mind signing his book?

In 1991 Eric had published his autobiography, which he had written in desperation, I think, because he wanted recognition. His previous exposure as a faker in 1978 had been quickly hushed up as if it had never occurred. Some art dealers said the book just showed how big a chip he had on his shoulder about his own artistic talents being ignored. Others, including former lover Graham Smith who had moved to Dan Diego, accused him of boasting he had done drawings which he hadn't. The rest continued studiously to ignore him. The less said, the better – even though Eric indicated that he had by no means given up forgery and that he intended to fake at least as many drawings in the future as he had done already.

'Drawings are so much easier because they are quicker,' he explained. 'Forging an oil can take months.' But he thought he ought to do more painting. He handed me some photographs of an Old Master oil composition of animals and birds in a landscape which he had been 'restoring' – for himself, he said. The picture came from the sixteenth-century Venetian workshop of Francesco Bassano and half of it had been missing. It was only a transparency but the painting looked exquisite. All of it.

'Which half was the original?' I asked.

He beamed. 'It was particularly difficult because I realised it was actually painted by three different artists.' Eric had had to become each of them in turn.

Did he ever feel now that such pretence was wrong?

'Well, when I was fourteen and my foster mother saw me reading my first book on drawing, looking at a sketch of a female nude, she threw it on the fire saying I was old enough to know the difference between

right and wrong. But it's still not clear to me what relation art has, if any, to morals or wrongdoing.'

Dealers in Italy, he felt, cared little about his activities since they had been selling forgeries happily for centuries. For some years he ran his own gallery in Rome selling a mixture of real and fake works – like his Jan Brueghel drawing of Roman ruins. Colnaghi's attribution was on the back of the supposedly authentic sketch; but the more Eric looked at it the more he became convinced it was an engraver's copy. 'It had lost the spontaneous touch of the creative draughtsman,' he said. So in 1963 Eric set himself the task of making a copy of this copy which was absolutely exact except for a quality of freshness created by drawing faster than the plodding engraver: in his words, 'a more than perfect copy'.

First he found a suitable sheet of sixteenth-century paper by taking the flyleaf from a book he bought in Foyle's antiquarian book department for £20. As that, he recalled, seemed rather a lot, he replaced it with another leaf of period paper and resold the book for half the price. From his regular junk shop near Trafalgar Square he acquired for £18 an eighteenth-century paintbox containing both bistre and lapis lazuli, the pigments Brueghel would have used. He prepared the paper by sizing it – to prevent the ink turning blotchy – and hung it out on a washing-line to dry. Next he dampened it, attached it to a drawing-board with gummed paper at the edges to stretch it and let it dry again. Meanwhile he carefully removed the engraver's Brueghel from its frame and mount so that he could make the switch without leaving any tell-tale signs of tampering. Then, with the copy taped to his drawing-board to the left of the blank sheet of old paper, Eric began to study the sketch with a magnifying glass. He suspected that the engraver had not copied the lines in the sequence in which Brueghel had drawn them.

'It's like copying a specimen of writing without understanding the words or even the letters and imitating the letters in a random order. The result is that you have difficulty in linking them up with a convincing flow. If you really know how to draw you would know the proper sequence of Brueghel's lines – that is, which are construction lines, which the correcting lines and which the final strokes.'

Making the first marks of an Old Master, he said, was like overcoming stage fright. A tiny slip could spell disaster. But once he got going he might well have been sitting on a stone in front of the same ruined temples near Naples, purportedly dedicated to Venus and Diana, as Brueghel on a bright morning 300 years earlier. In fact, he did the drawing so well

that he said it ended up in the Metropolitan Museum in New York, donated by a client of Colnaghi's. He discovered this when he spotted it on loan in an exhibition in Italy. 'The Met seemed to be quite happy with their copy. But foolishly I tore the drawing up that I'd copied from and flushed it down the lavatory. So I hope it wasn't the real thing.' Doing so was also inconsistent with his belief about fakes being valuable – that it's the work itself, not the name of the person who did it, that matters.

After moving to Italy Eric used to return to London when Sotheby's or Christie's were holding their Old Master drawings sales and stay at Blunt's flat in the old Courtauld Institute in Portman Square. He was anxious to check how his own 'Old Masters' were doing and what else he might emulate. And he wanted to pick Blunt's brain.

'We were almost lovers,' he chuckled. But he said the nearest they got was falling onto Blunt's bed together too drunk to do more than sleep, thanks to the large supply of gin and tonic Blunt kept in his broom cupboard.

His friendship, however, lent credibility to Eric's picture dealing and gave him an invaluable insight into what goes on in the mind of experts: how, for instance, their judgement may relate to the owner of a work, like Blunt's sketch of feathery trees which he had picked up in a Cambridge junk shop and believed to be a Corot. Experts agreed with him when, because of the excess of 'Corots' around, they might have scorned anyone other than the Surveyor of the Queen's Pictures.

So as to thwart the experts himself, Eric endeavoured to be one step ahead of their reasoning. His checklist was as follows: that the style of a work was right; that it was not a copy of a known drawing; that it did not belong to a published group of forgeries; that it compared well with and related to other drawings by the same artist; that it appeared freely drawn; that it showed no sign of artificial ageing; that the ink was appropriate; and that the paper was of the correct kind for the period. The scientific tests Colnaghi's eventually did on a number of Eric's drawings failed to prove any were forgeries.

Hebborn was also clever enough to study the person whom he wanted to fool. From Blunt he learnt much about Hans Calmann, a highly respected but autocratic dealer in Old Masters. Calmann, Eric realised, liked to make discoveries, boasting about a Rubens no one else had noticed in a country sale or a Greek head he had spotted on a Victorian bust. So Eric decided to be discovered himself. On hearing Calmann was

in Rome, Hebborn lured him with a photograph of a supposed work by Mantegna, that he had sold to Colnaghi's. Eric let it seem that he had left the snap by chance in a folder of insignificant drawings which he asked a friend to show to Calmann. Immediately Calmann hotfooted it round to Eric to see if he had anything else extraordinary. Naturally he had.

But was it possible to con a real expert, I asked Eric? What about the theory that forgers always betray themselves by lack of freedom in the drawing? Or by personal mannerisms? Or by the period in which they live?

'Bunkum,' he declared. 'They are theories which may work sometimes, but certainly not always. The so-called experts are the biggest fakes. They are responsible for the false descriptions of unattributed drawings. They are the real criminals. They are full of waffle. They will talk about what the artist's mother did, or his sister. They will call him a genius. They will do anything but look simply and honestly at a drawing.'

Even when Hebborn's van Dyck of *Christ Crowned with Thorns*, which the British Museum bought form Colnaghi's, was hanging on the dealer's wall next to one of his van Huysums in June 1970, no one seemed to notice any resemblance in style.

'Of course, the trouble is most experts don't draw. Some can't even tell the difference between pencil and black chalk,' he added. Eric had spotted another of his Augustus John portraits of Dorelia in a Cork Street gallery with even the medium mislabelled.

Hebborn's ploy had always been to seek someone else's opinion of his work, never to make any claims himself. Blunt, who was one of the few experts he didn't despise, represented the biggest challenge. 'Irresistible,' exclaimed Eric. It was a time when Blunt had fallen out with Calmann after buying a Poussin cheaply from him because the dealer hadn't recognised it. Then Blunt crowed about his coup and, as the leading expert on Poussin, added insult to injury by deriding another drawing which Calmann believed was by the artist. Eric decided to play on this antagonism. He had happened to discover a similarity between a soldier's helmet in Poussin's *Crucifixion* and one in an engraving by a member of the Ghisi family, who were considerably influenced by Raphael. This, he concluded, Poussin had used for reference. Poussin would have made a preparatory sketch of it but there was no record of such a drawing. Eric, therefore, set about providing one with the help of some old paper and old-fashioned ink. He wanted his work to be close enough in style to

Poussin to be taken seriously, but not quite perfect. Thus Blunt would have doubts which Eric would relate to Calmann, and Calmann would snap up the drawing.

'I've a large number of ink recipes,' he explained. Some were based on willow soot, others on cuttlefish ink. But he chose one using oak galls, the excretions conveniently left by insects on trees near his house in Anticoli. He ground the galls to powder, he said, then added rainwater, gum arabic, and a rusty nail to provide iron sulphide, and left the solution to evaporate to a suitable consistency. Next he had to imitate Poussin's style convincingly but create doubts with cross-hatching – which Poussin would rarely have done with a pen – and other discrepancies such as a misspelt French inscription on the back of the work. Finally, he tampered with the ink to make it look as though it had been in contact with the page for over 300 years. But this time he was coy: 'moisture, heat and a corrosive' was all he would admit to using.

Blunt, initially attracted by a photograph Eric showed him of the supposed Poussin, duly rebuffed it on closer inspection.

'Never underestimate the stupidity of others,' Calmann advised Eric when he bought the drawing as a Poussin some time later.

Since Blunt was also the great authority on the seventeenth-century artists Stefano della Bella and Giovanni Benedetto Castiglione, both of whom Eric faked, Blunt's approval was often sought by Eric's clients. However, Hebborn said he did not normally seek this himself, even if Blunt came across any drawings while visiting. 'Anthony would ask why ever didn't I show them to him. But I didn't want to compromise him.'

How did he manage to imitate so many different styles so successfully?

Hebborn pointed to an 'Annibale Carracci' sketch on the wall. 'You have to study with a pencil, not by reading what the experts say.' He would follow a drawing with a pencil in his hand to get the feel of the artist, but never copy one line for line. 'I make variations on a theme, like Beethoven pinching a melody and playing with it.' And he had learnt another trick from an earlier mistake. The natural reaction to drawing on an old piece of paper is to fit the sketch to the paper and skirt any holes. But the convincing way, he announced gleefully, is to continue a drawing off the edge of the paper as if it has been torn. 'Though you must always complete the drawing,' he advised. The 'Carracci' was apparently partially destroyed, sketched on the back of a torn letter. 'You have to be more and more subtle,' he said.

Wasn't it going a step too far to add false collectors' marks to his 'Old Masters'? Wasn't that deception?

'They look nice,' replied Eric. 'I gave up doing them because people thought it dishonest. They can't look at the marks just as aesthetically interesting.' He paused: 'But the value of a piece of art should be regardless of its age or whether it is real or fake. It should stand on its own merits.' Over the years whenever he visited Florence he had bought a pile of souvenir coins, supposedly Greek or Roman. 'But I don't care who made them or when. They are small pieces of sculpture, works of art. I bought them because they are beautifully designed and executed. In the same way I regard it as ample proof of my draughtsmanship that my drawings in the style of Mantegna, van Dyck, Piranesi and many other Old Masters have ended up unsigned and on their merits alone in such great institutions as the British Museum, the Metropolitan Museum in New York, and the National Galleries of Denmark, Canada and Washington.'

Titian's last work, the *Pietà*, he pointed out, made him cry because it was so wonderful; yet that painting had been finished by his pupil and assistant Palma Giovane. 'It made me realise one could work so completely in another painter's manner that one's work would be indistinguishable from the artist's own.'

Who, he added, would dare call Rembrandt's copy of a drawing by Mantegna a fake? The drawing is in the British Museum and Rembrandt is one of Hebborn's favourites. Alternatively, would it be dismissed as worthless if it were incorrectly labelled Mantegna? Or what about Michelangelo? Hebborn seemed to grow several inches. As a young man, he recounted, Michelangelo had faked many drawings, smoking and tinting paper to age it, and even carved a sleeping Cupid in the manner of the antique. At first he tried to sell it for 30 ducats and couldn't. So he buried it to give it the patina of age, then dug it up and sold it as an antiquity for more than three times as much. Unfortunately the cardinal who bought it became suspicious. He demanded his money back and Cupid was returned. But do you know what has happened to it since, Eric asked?

He continued eagerly as I shook my head. 'Well, it was eventually presented to the Marchioness of Mantua and was last heard of in her family palace, but then it disappeared. It's thought to be lost. But it isn't. I recognised it because I've studied his sculpture so much. It's now catalogued as ancient Roman marble and it's a secret between me and Michelangelo.'

So how many drawings had Hebborn faked? He didn't know. He kept no records. Possibly over a thousand, and comparatively few had been

discovered. Maybe little more than a couple of dozen, he reckoned. At least thirty-seven Castigliones, he believed, are still undetected in museums and important private collections round the world. Castiglione was a great influence on French eighteenth-century artists such as Fragonard, and Eric came across his work through Blunt, who had catalogued the Castigliones at Windsor. The problem in imitating Castiglione was that he drew with a brush and oil-paint on paper and Eric had to thin the oil with turpentine. But the turpentine smelt highly suspicious. So Eric washed the drawings in detergent and pegged them out to dry, like the paper he sized, with the rest of his laundry. Blunt was especially keen on one, Hebborn recalled, when he came to visit Eric in Italy.

Eric considered his faking had improved with practice and thought some of his earlier attempts should really have been uncovered much sooner. Among these was the *Page Boy* supposedly by the Ferrarese artist Francesco del Cossa, a fifteenth-century follower of Mantegna, the drawing which led to Eric's exposure in 1978. It was bought in 1963 by the Pierpont Morgan Library in America after passing the scrutiny of three sets of experts, namely at Sotheby's, Colnaghi's and the library itself. Only fifteen years later was the library discreetly alerted by the curator of the National Gallery of Washington that they might have made a big mistake. The curator had become suspicious after he had bought a Cossa from Colnaghi's along with a sketch by a lesser-known artist from a different school and then noticed a resemblance in the hand that had drawn them. When a doubting eye was cast at the Pierpont Morgan it suddenly became obvious that the pen was too flowing in the *Page Boy* and the ink had been aged with the careful friction of a razor blade instead of the passing of years.

The doubting eye, just like the credulous eye, remarked Eric disdainfully, only went to prove how lacking experts were in objectivity. Thus once the US galleries had informed Colnaghi's and the dealers had used the doubting eye on works from the same source, which they recalled from their clients, they decided the drawings all bore an uncanny resemblance. Colnaghi's announced publicly that because of doubts they would refund their clients' money.[1] 'They made me a scapegoat rather

[1] On 10 March 1978 *The Times* quoted a statement from Colnaghi's saying: 'Scientific tests failed to prove that any of the drawings are forgeries, but in some cases where the owners have requested it and the consensus of opinion has been against their authenticity, Colnaghi's have refunded the purchase price in accordance with long standing custom.'

than admitting their own errors,' remarked Eric. Everyone else kept strangely quiet. 'They didn't want to rock the boat,' he added.

Even now the National Gallery of Denmark insist that the Piranesi they purchased from Calmann for $14,000 (over three times what he paid Eric) in 1969 is genuine. After all, it was authenticated by Blunt. Hebborn has claimed it is his. 'But people believe what they want to believe,' he said.

'And dealers exploit this. Only three weeks ago I had a dealer ring asking me to do some Tiepolos. They mostly telephone. Though of course what they say is, I wonder if you could help? I have a client for a Tiepolo. Do you think you could find one for me? Then there was a German who rang enquiring if I could locate some expressionists, and a Spanish dealer who said he needed a Murillo . . .' Discretion in such deals is generally maintained by making an exchange at one of Rome's smarter hotels, leaving a package containing a drawing with the dealer's alias on it at the reception desk where an envelope with the money in it will be waiting.

What does he charge? Eric wouldn't say. But he has seen his better drawings sold on for anything up to £140,000 after they have passed through two or three hands. He laughed. 'The only trouble is if I wanted to sell a genuine Old Master myself it would immediately be suspect because of the same prejudgement. If I was selling it, then it must be a fake. The same would apply if I were to comment on all the fake bronzes in the dealer's up the road. Have you seen them? They're dreadful. But if I say they are fake, who'll believe me?'

He added that he could do much better. He had had a show in London just after being unmasked for forging the Cossa. His sculpture was described as in the style of Rodin. It was romantic, in the tradition of Michelangelo and the Renaissance artists. He had created near-life-size bronze figures in the form of multiple images, based on the study of pentimenti in Old Masters. Pentimenti are the signs of an artist's changes of mind while trying out different ideas or poses; earlier lines were not always removed from the final work and the lack of them can sometimes give away a fake as easily as the wrong facial types. Eric had thus sculpted a child on a rocking horse, for instance, in a series of positions, forward and back, as if the eye had acted like a camera and made several exposures.

He hadn't by chance been creating any new Rodins as well, I enquired? Eric smiled. He said he liked sculpting – bronzes especially.

'The trouble is you can't afford to get them cast without a commission.

Otherwise they're quite easy to do. Easier than drawings. I knew one chap who took a lump of clay to the Tate very early one morning and put it over the faces of the *Burghers of Calais* by Rodin, which is outside. Then he cast the impression in bronze and sold it as a study for the sculpture. No artistic ability was needed on his part but it would be difficult to prove the study wasn't by Rodin, wouldn't it?'

In fact, now he had been unmasked as a forger, Eric Hebborn seemed to enjoy the whole business rather more. It was so much more of a challenge.

To put the experts off the scent, he said, he made a number of drawings that caricatured his earlier unsatisfactory productions. He called them his red herrings and made them unusually red, letting the ink bleed excessively and putting too much energy into them. He was sure the experts felt safe in having identified the Hebborn 'factory' when some fake red-ink drawings were spotted by Sotheby's. The irony was that the Rembrandt and the Venetian views in question were not his own.

So what about Sotheby's Piranesi drawings? Was Eric responsible for those too? Should they have been obvious?

'Possibly I had a bad day. All artists do,' he murmured, adding that he had done about twenty-five important Piranesis and probably as many lesser ones. 'But you know Piranesi was also a faker?'

Eric's beard trembled delightedly. Apparently Piranesi had a friend excavating Hadrian's Villa who supplied him with bags of ancient fragments. Piranesi used these genuine bits together with a lot of infill and imagination and created some magnificent sculptures. Like Eric he operated as a dealer for a time in Rome where he was patronised by wealthy travellers on the Grand Tour. Anything antique, which was to say Greek or Roman, was the height of fashion and he sold one outstanding vase to the English collector Sir John Boyd. Later it was bought by the antiquities department of the British Museum. 'I believe,' added Hebborn, 'that Piranesi said he had to do a little restoration.'

• 3 •

In the eyes of the law

'I don't think they play at all fairly,' Alice began . . .
'and they don't seem to have any rules in particular.'

Detective Chief Inspector Phil Brown was a busy man. It was February 1991. It might be weeks before I could see him, I was warned. There was a waiting list. There were regulations.

Brown was head of the three-man Art and Antiques Squad at New Scotland Yard: an unenviable task. The squad had been re-formed eighteen months earlier after its previous incarnation was disbanded, because of cutbacks, not through any reduction in crime. Art theft was now a worldwide industry second only to drug trafficking, with which it had become linked, and was worth billions of pounds a year. The three members of the squad had no art background but had been given a crash course in art and antiques over several weeks by Sotheby's and Christie's.

One morning I was finally summoned to DCI Brown's office. He had had to get up before dawn. Sleepy criminals were easier to catch, he said. But he looked disappointed. Less than 10 per cent of his cases were cleared up successfully. He offered me a cup of coffee and apologised for the beakers. 'The best cups always get nicked by the Drugs Squad upstairs.'

His room was small and narrow and sparsely decorated except for a portrait. 'My Picasso.' He brightened. 'At least two experts thought it was genuine.'

The inspector had been given a tip-off that a Colombian was planning to exchange a Picasso for £1 million in cash at a meeting in a London hotel. 'So we were waiting.' He beamed. Informants, mostly dealers, were his lifeline. The painting was supposed to be one stolen from the Peugeot family in France. 'But what neither the Colombian nor the

would-be buyer knew was that the family had already got the original back.'

Most times the inspector was less lucky – art-world discretion constantly defeated him – and in any case the actual faker got away. The squad concentrated on major picture theft, though Brown himself had a soft spot for longcase clocks and porcelain, the chances of regaining which, if stolen, were minimal. 'Out of the country within hours,' he said ruefully. Forgery investigations were the worst nightmare of all but he thought they were on to something. 'It's big,' he said, but couldn't tell me more. 'Security, you understand.'

The 'something' was a fake factory churning out paintings, autographed souvenirs and other memorabilia, cashing in on the allure of big names, mostly of this century. The alarm had been raised after an expert at Phillips inspected the backing of some framed pictures, one purportedly by D. H. Lawrence, who had unwisely turned to painting late in life, only to run up against obscenity laws for a second time. The risqué scene of two lovers, typically badly painted but valuable if genuine, was documented on the back as having been rescued from a disastrous fire at Aldous Huxley's house in the 1950s. But when the expert removed a bit of masking tape, it was obvious the surface beneath was new. The rest had been stained with teabags to produce an aged appearance – one of the oldest tricks around. Edwardian ladies often dipped white lace in tea to give it the fashionable antique look.

Once doubt was raised, more items came into question. Faker's overkill suddenly became obvious on a rouble banknote with the coveted signatures supposedly of Colette, the writer, and Debussy, the composer, neatly framed and apparently authenticated on the mount by Dame Laura Knight, the artist.

Other auction houses began to examine items relating to celebrity names more closely. Christie's discovered six 'wrong' Noel Coward paintings. Sotheby's found that important drawings for Robert Louis Stevenson commemorative coins were inventions. The *coup de grâce*, however, was the adaptation of letters stolen from Sotheby's into certificates of authentication. One from Lord Mountbatten had been used to fake the provenance of two cigar labels meant to be from the Casablanca peace conference of 1945 and signed by Churchill and others. The forgers had simply blanked out the writing on the letters, inserted their own messages and then made photocopies.

Detective Chief Inspector Brown, I had heard, was planning a swoop.

But that would probably be only the beginning of his difficulties – at least regarding prosecution. The obstacles were myriad. Few fakers ever went to jail. David Stein, who sold his own fakes by posing as a playboy art dealer in the sixties in America, was convicted of larceny in 1967, but he is one of the few.

The very definition of a fake is the first stumbling block. Strictly speaking a fake refers to a genuine item that has been tampered with, while a forgery implies fabrication from the start. But there are many grey areas, which may have led to the two words becoming generally interchangeable.

Restoration and faking, as Eric Hebborn discovered, can be very closely linked. A current favourite with the rise in popularity of naïve paintings is to add a fat cow or a couple of oblong sheep to an ordinary Victorian country landscape, thus enhancing its value by hundreds if not thousands of pounds. Happily for the faker, most old naïve pictures are by unknown artists, so he doesn't have to fake a signature or worry about a particular painter's style. New York dealers Hirschl and Adler, specialists in American folk art, saw so many forgeries appearing that in 1988 they held a show exhibiting fakes alongside the real thing.

Another recent ploy of restorers has been to colour in unfinished portrait sketches by Egon Schiele. The Austrian expressionist, notorious for being jailed for his erotic drawings by a judge who collected pornographic pictures, is now receiving much wider acclaim. His nudes were uncompromising, often anguished and ugly almost to the point of caricature. But when he did portrait commissions Schiele would start several different versions and then allow his sitter to choose before he completed the job. The number is limited since he died in 1918 of influenza aged only twenty-eight. Lately, however, Christie's were ordered to repay £557,500 plus interest and costs to Marie Zelinger de Balkany over an excessively restored religious subject by Schiele.[1]

Direct copies, of course, have been made by art students of their

[1] Madame de Balkany, a Swiss art dealer, had bought *Youth Kneeling Before God the Father* at Christie's in Geneva in 1987. She told the High Court in London she had been 'head over heels in love' with the painting until she read a book that expressed doubt over its authenticity. Then she felt 'physically sick'. The picture had been heavily restored. But the catalogue described it as both painted and signed by Schiele. The case ended in January 1995 when the judge concluded that the restorer sought to deceive since he did not want it known how much he had restored.

masters' work for thousands of years and these are also being produced
for perfectly legitimate reasons worldwide. If sold as the real thing,
though, they then become forgeries. Yet without a sale a forgery is harder
to establish. It may be unethical but it may not be criminal. This was a
matter of extreme irritation to the stepchildren of a nurse who married
their rich father just before he died. She quietly sold off his entire art
collection, replacing it with copies, and was last heard of on the QE2
having a ball. The heirs might have done better had the pictures been
stolen, as in the case of a Picasso and Magritte that belonged to an art
dealer's ex-wife, Emily McFadden Staempfli, in the United States. Her
sight was failing and so the thief cannily switched the two portraits for
copies. This was only noticed after she died when Sotheby's were called in
to appraise the estate. Both the Magritte and the Picasso were eventually
retrieved. The Picasso was innocently handed in for sale by a new owner
to the same auction expert who had been dealing with the estate, and
the resulting publicity unearthed the Magritte.

Copies in the manner of an artist, often described as pastiches, can
equally be forgeries – like those of Elmyr de Hory – and may be harder
to identify as 'wrong' since few artists have ever documented or even
signed all their work. Composite pictures are one method: the copier or
forger lifts bits from different pictures by the same artist, thus creating
the illusion of the new painting being related to other work and helping
to place it apparently authentically within a certain period of that artist's
oeuvre. Alternatively, similar versions of an existing picture are popular
among forgers, since artists often have several goes at a subject and don't
always admit it.

More adventurous is the forger who 'discovers' a non-existent master
in a particular field – like the 'forgotten impressionist' Pascal, created in
a New York studio, probably one of the sweatshops employing artists
having trouble with their work permits. Or the Spanish artist Antonio
Huberti, said to have died in obscurity in 1980, 245 of whose Cubist-
style works netted more than £200,000 in a Paris auction eight years
later. In fact they were the work of an elderly artist called Bernard
Globermann, whose life was romanticised by his friend Brigitte Menais,
a former nurse, to help him and aspiring young artists who came to stay
in her house in Villejuif south of Paris.

Maybe her idea stemmed from the joke perpetrated in the 1930s when
the work of Bruno Hat was shown to great acclaim in London. Hat's
abstract paintings now change hands for around £15,000. It was the

heyday of the Bright Young Things who made a point of enjoying themselves in as lavish and conspicuous a way as possible, thumbing their noses at establishment respectability, holding parties on eccentric themes and devising elaborate hoaxes which would attract maximum publicity. Brian Howard, the effete socialite dilettante upon whom Evelyn Waugh modelled the languid Anthony Blanche of *Brideshead Revisited*, had just had his twenty-fourth birthday party and was looking for a way to launch himself as an artist. So, with the help of his friend Bryan Guinness, then husband of Diana Mitford, he planned an exhibition of work by a mysterious Bruno Hat, to be held at Guinness's Westminster home. It opened on 23 July 1929.

Hat was supposed to be an abstract painter of German extraction whose work had been spotted by Guinness when he went into a village general store near Clymping and entered the wrong room by mistake. The paintings had ostensibly been done by the son of the old lady who ran the store, though astonishingly he had never been to Paris and rarely even to London. His father was German and his work entirely intuitive. The story of this amazing discovery was 'leaked' to the press.

At the packed private opening of the show, Hat appeared in a wheelchair, morose and taciturn, with a thin cheroot in one hand and a glass of iced tea in the other, and spoke in a heavy German accent, grumbling about the attention he was getting. In fact, it was really Bryan Guinness's brother-in-law, Tom Mitford. There was an awkward moment when an Oxford don started to chat in fluent German, but Tom declared: 'Ach, I am naturalised English. I do not care to remember that I am German.'

Evelyn Waugh added a convincing touch by writing the introduction to the catalogue, parodying pompous art critics by hailing Hat as 'the first signal of the coming world movement towards the creation of Pure Form' and signed himself A. R. de T.

Bruno Hat was exposed as Brian Howard, though it may be that his friend the artist John Banting, in whose arms Howard died from a morphine overdose in 1958, was partly responsible. Banting was to become one of Britain's most significant surrealist painters and the rope-framed canvases on which all Hat pictures were produced relate to a motif in several of Banting's works just prior to the hoax. The writer Lytton Strachey purchased one of the paintings at the opening. Another is now owned by the London dealer Peter Nahum, who is noted for annoying other dealers with his over-truthful statements; one is that 50 per cent

or more of the goods on the market are in some way 'wrong'. He kept the Hat *Still Life with Pears* because he was so upset at having sold on two others. 'It's a very good painting,' he said.

The most daring forger, however, is the one who produces something unique, something that is hard to verify by direct comparison. The most likely areas are antiquities or tribal art, the former because certainty about anything decreases as the length of time involved increases, and the latter since it is comparatively little understood. But the limits of belief are boundless, as with the tale of the furry trout said to exist in Canada after a Scotsman wrote home about an 'abundance of furried animals and fish' 300 years ago and, when asked, obligingly dispatched an example. In recent years they have been produced using rabbit fur by Ross Jobe of Sault Ste Marie, Ontario, with a text saying the fish grew their coat because of the 'great depth and extreme penetrating coldness in which they live'. In the early seventies someone, believing an example to be genuine, brought it to the Royal Scottish Museum. The expert, recognising a hoax, rejected it. But the story had got out and public demand to see the furry fish was so great that the museum had to 'recreate' it – a fake of a fake.

Museums, of course, also produce many high-quality reproductions which turn up regularly at Sotheby's and Christie's front counters, brought in by hopeful relatives to whom they have been left. A postmodern neo-classical revival has the British Museum scarcely able to cope with orders for new casts of bits of the Parthenon frieze and other antiquities to decorate modern interiors, just as the demand was a hundred years ago when Britain was in the grip of an archaeological craze.

Rather murkier is the question of casts and prints created after a known artist has died. The exact moment of death may make no difference to the aesthetic value of a Picasso or Rembrandt etching or a Henry Moore bronze, but in financial terms it could be devastating. Produced while the artist was alive, the work could be worth hundreds of thousands of pounds. The same work created at a later date, albeit using the same mould or plate, would be far less valuable.

Some sculpture is actually more familiar in inferior replicas than from the original casts. Certain sculptors are happy that their work should proliferate. But others are not. For example Rodin wanted his art to reach a lot of people and left much work in plaster when he died, with no directions about what should happen to it. Therefore many more casts have been taken and as a result their quality is questionable. Moore, on

the other hand, destroyed his plaster casts; and Modigliani's great friend Brancusi cast only one or two bronzes at a time and finished them himself. So when a bust of General Davila was completed in his absence Brancusi declared it wasn't his. Yet he did not forbid posthumous reproduction, probably because it didn't occur to him. Consequently his heirs have turned out a variety of work since, including a specially commissioned cast of *Bird in Space* in 1973, sixteen years after his death, for the Nationalgalerie in Berlin.

The Italian sculptor Medardo Rosso, a contemporary of Rodin, was particularly concerned that his textures should capture fleeting impressions, as Monet did with rapidly changing light on canvas. Rosso had a foundry in his studio in Paris and held extremely hot parties there during the castings. He also believed in chance happenings. So he retained any irregularities in or accidents to a cast which he then allowed to oxidise. The power of the piece, in other words, strongly related to the process of making it. This, however, is lost in his polished posthumous reproductions; and possibly only one of five in the Museum of Modern Art in New York, called *Concierge*, was produced during his lifetime.

Surmoulage, which entails taking a cast from an existing sculpture, is even more debatable. It results in a slight loss of definition and size, and large numbers of Rodins have been copied in this way, along with work by Camille Claudel, his mistress before her brother had her committed to a lunatic asylum because of her 'sinful' liaison. Size, of course, can be of extreme importance to the impact of a work. So, for instance, two vast Elie Nadelman sculptures in a promenade of the New York State Theater in the Lincoln Center are in a sense fake. The only versions Nadelman touched were five-foot-high papier mâché models. These were cast into bronze after his death by Nelson Rockefeller and were then turned by Italian carvers into nineteen-foot-high marble for the architect Philip Johnson.

The medium can similarly be crucial to a work. Therefore bronzes of Gauguin's wood-carvings are questionable, as they are of Henri Gaudier-Brzeska's stone-carvings and Julio Gonzalez's welded iron. Bronze violates the integrity of the work, for example with Brzeska, because the size of the marble slab was originally a limitation and the block-like shape clearly led to a Cubistic composition; the strength of the piece is lost in bronze. The exception to prove the rule is Degas whose bronzes are accepted although they are all posthumous, and his *Little-Dancer, Fourteen Years Old* created a record for any piece of sculpture at auction when it was

sold by Christie's in New York in 1988 for $10,175,000. In fact for forty years Degas modelled in wax and clay and had only three of his models cast in plaster. They were extensively repaired after his death by his friend Bartholomé and cast by the Hébrard foundry.

Misattributions can also cause serious financial loss. Many are straightforward mistakes or wishful thinking, as in the case of numerous 'Rembrandts'; but not all. Thus the extent of an artist's *oeuvre* increases according to popularity. Artists today still sometimes sign their students' work as their own, adding to the confusion – though one student in New York plans to get his own back if his master's work is ever subjected to X-ray, by writing cryptic messages beneath the painting on the canvas. Other artists like Dali have simply sold blank sheets of paper with their signature and left the rest to chance. Less scrupulous dealers will just point to the name. If the work is returned as forgery, no problem. As proof of their honesty, they will refund their client's money – then sell the work to someone else.

The auction houses take a more oblique approach. They say that any statement as to 'authorship, attribution, origin, date, age, provenance and condition' is solely an 'opinion'. The balance of scholarly opinion, they argue, may change. Much of their business is based on secrecy, which they call client confidentiality, and Scotland Yard's Art and Antiques Squad cannot force them to reveal anything without a court order unless they see fit. Though the word is that they do snitch.

Cataloguing terms, moreover, easily confuse the uninitiated. Who, after all, would guess that 'bears a signature' is a way of suggesting that the artist's name has been added by another hand? Only the full name of an artist such as Pablo Picasso means that the auctioneers consider a work to be by that artist. 'Attributed to' really means probably by Picasso; 'studio of', by another artist with or without Picasso's help. Even less obvious is the differentiation between 'circle of', 'style of', 'manner of' and 'after' Picasso. These reflect decreasing value, meaning respectively by someone closely associated with Picasso, a contemporary painter, working in his style, a later artist working in his style, and a copy of a known work by Picasso.

On top of this, the auctioneers' terms of business are virtually watertight when it comes to getting out of any claims against them. Though settlements are made out of court from time to time to avoid scandal, as was the case of the Fabergé egg which Eskander Aryeh, an Iranian collector living in New York, bought from Christie's in Geneva

in 1977 and tried to sell through the same auctioneers in New York eight years later. The egg was said to be imperial when he bought it, one of only about fifty-seven in existence. He paid $250,000, believing it to be the Equestrian egg the tsarina Alexandra had presented to her husband Nicholas II to celebrate the Romanov tercentenary. Aryeh sent it back for sale after discovering imperial eggs were fetching around $2 million, only to be told it was not imperial at all but had been elaborately sophisticated. Or faked. Christie's disclaimed responsibility, referring the owner to a one-year statute of limitations that applied in Switzerland. So the owner filed a suit alleging fraud, misrepresentation, breach of contract and breach of warranty in the New York Supreme Court. The dispute dragged on for three years, during which time Aryeh died. But, according to a family representative, Aryeh's estate finally won a settlement with a proviso that the recipients would not disclose the amount. Including costs, however, it was believed to be about $5 million.

Five years is the usual time during which an item can be returned to an auction house, but the buyer has to prove it is 'wrong'. The auctioneers, besides disclaiming responsibility for their description or for the authenticity of an item, declare subsequent proof against it unacceptable if they were reflecting the general opinion of the time or if proof was only established by unreasonably expensive scientific means.

But the most important get-out clause is that the forgery must be 'deliberate'. This can rarely be proved satisfactorily since intention is hard to pinpoint in old forgeries; and any forger today will generally deny it. If anything, the forger will blame the person to whom the forgery was given for assuming it was something it was not – even if the forger has aged the work and added a false signature. 'Not my fault,' said Los Angeles artist Tony Tetro, when accused of forging the fine art of Marc Chagall, Joan Miró, Salvador Dali and the modern watercolourist Hiro Yamagata. Tetro had long been suspected of drug dealing, such was his high-profile lifestyle. He drove a Rolls Royce Silver Sprite when he wasn't in one of his Ferraris or his Lamborghini Countach. He papered his walls with lizard skin and suede. He partied across Europe and America and threw thousands of dollars away in the Casino whenever he visited Monte Carlo. Yet the expansive and charming Tetro had no visible career.

After he was arrested and proclaimed one of America's major art forgers at a preliminary hearing in spring 1990, he expressed some satisfaction: 'Finally these idiots knew I was an artist.' But he said: 'Forgery indicates intent to defraud. I never sold anything as real.' He preferred to use the

term 'reproductions' – as shown on his business cards – which to him meant an exact copy, as close to the original as you can get. 'Every one of my friends knew what I did,' he pointed out. Indeed they bought from him and mixed Tetro Chagalls and Yamagatas with originals. But they were also sold, apparently as the genuine article, to galleries in Beverly Hills, New York, Illinois and Florida. Tetro said in court that he thought they were on sale as re-created art. His. And his attorney blamed many of Tetro's troubles on the criminal justice system's lack of familiarity with re-created art: that it was not like counterfeiting; if you sign someone else's name you're not committing a crime. However, the lawyer for Yamagata, the one artist involved still alive, pointed out that Tetro's images violated copyright. That is why forgers tend to go for artists who are dead and have been for some time. Copyright in Britain lasts for fifty years after an artist's death; in other countries such as France it is longer, and EC plans to make the general rule seventy years are underway.

In France art forgery is taken much more seriously. It is a grave affront. Culturally detrimental. Just to possess a fake is a breach of criminal law, whereas in Britain a crime is only committed if someone is deceived into buying a fake.

French police, whose art fraud squad is considerable, may seize a forgery, have experts examine it and, if the verdict is that it is 'wrong', have it destroyed. The opinion of widows and children of deceased artists is paramount, since next of kin become official authenticators under French law. Thus Jean Charles Millet, grandson of the nineteenth-century French painter Jean François Millet, was able to do a flourishing trade in forgeries with the help of his friend, the painter Paul Cazot. However, experts in France can, of course, be held legally liable for their judgements. Jean Charles and his friend were sentenced to jail.

Another to be caught out was the late Paul Petrides, a leading Paris art dealer who represented Utrillo, Vlaminck and Fujita among others and had a gallery on the rue du Faubourg Saint-Honoré near the Elysée Palace, where he was visited regularly by major international collectors.

Petrides came from a poor family in Cyprus and would recall how he had set out on his path to success by saving a pound to buy a third-class passage on a ship to Port Said, where he began work as a tailor. In 1920 he made his way to France and was soon hired as a cutter for a Paris tailor who had converted one of his fitting rooms into an art gallery for up-and-coming artists he admired. Consequently Petrides met them all and when he opened his own shop in Montparnasse, the artistic hub of

Paris, he put up a sign saying: 'Special prices for artists'. More than that, he entered into barter arrangements: five suits for a Fujita painting, an overcoat for a Utrillo gouache.

In 1929 he married Odette Bosc, an art dealer. His acquaintance with painters multiplied and, after discovering he could sell a Fujita for the equivalent of thirty suits, he changed career. Somehow he even managed to stay open during the German Occupation.

Utrillo had given Petrides exclusive rights to sell his work, and the dealer became the world expert, controlling the market and even organising the public burning of fakes. After the war he dealt in the Ecole de Paris and did particularly well out of the soaring value of Modiglianis. One estimate put his fortune at £20 million. However, he was charged with receiving stolen paintings. Utrillo's *La Caserne de Compiègne* was discovered at Petrides's gallery following an armed raid on the home of the millionaire businessman who owned it. In 1979 Petrides was sentenced to three years' imprisonment. Age saved him from jail, but not from further accusations that he had bought plundered masterpieces from the Nazis and then sweetened the Americans at the Liberation by loaning them works for their apartments. He also lost his 'expert' title.

Then came the sticky business over Utrillo fakes. Petrides was accused of authenticating pictures as by Utrillo when they weren't.

The problem arose in the first place because Utrillo was a junkie. He would go around Montmartre signing all sorts of pictures in order to pay for his next fix or a drink. He had learnt to paint as a form of therapy at the instigation of his mother, the artist Suzanne Valadon, after spending years in and out of sanatoria. Mostly he did town views and had a surprising ability to feel the atmosphere of a certain street or building – especially as he was generally just copying picture postcards. Because of his remarkable success, he repeated scenes himself and was widely faked in his lifetime. His work can now change hands for over $100,000, thanks, it is said, to too many Americans in Europe with too much money and too great a faith that if the documentation is in French it must be true.

After Utrillo died in 1955, a radio journalist, Jean Fabris, met the artist's widow, Lucie, while he was making a programme on Montmartre, as her husband knew it. Fabris began to work for her as her personal secretary. He said: 'I had lost my mother at thirteen and she became like a mother to me.' So when Lucie died in 1965, and Fabris was left joint

heir of the Utrillo estate, he also felt it his duty to rid the market of fakes – only at first his right to do so was not generally accepted. His chief adversary was Petrides, who was still universally consulted despite his loss of title, and their war lasted almost until the dealer's death in 1993.

Four years earlier Fabris had carried his crusade to London where Christie's and Sotheby's were both due to sell Utrillos in their impressionist auctions. They had relied on Petrides for thirty years and these pictures all carried his certificates. Fabris, however, criticised incoherent roof patterns and limbs of trees he said Utrillo would never have perpetrated and pointed out the inconsistency of quoting Petrides's catalogue on one work depicting a street corner scene when the version with Sotheby's had miraculously acquired a lamppost in the middle of the painting. He also enlisted the help of Mark Stephens, an international lawyer otherwise known for representing the estates of Picasso, Matisse, Chagall, Magritte and, in the past, Dali.

Stephens and his team are known for their grasp of art law, the intricacies of which may sometimes prove an even greater hurdle for Scotland Yard's Art Squad than catching an alleged faker. Mark Stephens's office is large and airy, with London transformed beyond his window into a fairyland of crenellated towers, gleaming domes and elongated spires. He eagerly pointed out several distant landmarks when I called to visit him in 1993. He had a teddy-bear-like charm. A lot of lawyers who are interested in art simply become dealers. But Stephens had grown up with artists because his father was one. 'The house was hung with art and we went to the Tate and the National and the National and the Tate every weekend.' His knowledge of the art world was intimate. He didn't paint himself, he said, but it was clear that artists were being ripped off and needed protection.

Glaswegian artist Stephen Conroy, best known for his dung-coloured Scottish gentleman captured in an Edwardian time-warp, was a typical case. He had a difference of opinion with his agents who he thought would look after his career while he just got on with painting, and it took Stephens's intervention to allow him to sell any of his own work again – or to move on to greater things at the Marlborough Gallery.

Stephens was also responsible for seizing gigantic copies of paintings by Lichtenstein, Picasso and others from Selfridge's Oxford Street window and putting them on a bonfire. 'Great for a window display but they were in breach of copyright,' he explained to me.

'And Fabris?' I enquired.

'Fabris was not as loony as people liked to suggest,' replied Stephens. 'They said it because he was prepared to speak out.'

So was Fabris right?

'You have to believe in a case. At least for the time being,' he declared. Stephens had decided to use Fabris's reputation to advantage. When negotiations failed to stop the supposedly forged Utrillos being auctioned, he had Fabris upset the rarefied air of the salerooms by leaping up at the appropriate moment and yelling 'Fake!' At Christie's, Fabris was led out by security guards. But come Sotheby's sale shortly afterwards, television crews and press were waiting, and Fabris reached an audience far and wide. Nevertheless at lot 159 he was ejected as an undesirable into the driving April rain, while all seven so-called Utrillos soared above estimate and one, *Rue Saint-Rustique*, went to a Japanese bidder for £297,000, little short of a record.

Back in Paris, Fabris was more successful. Six paintings and one sketch were seized from the Drouot auction house and a judge ordered their confiscation after Fabris complained they were all forgeries. They had certificates of authenticity, but Fabris maintained the technique was poor and the signatures unconvincing, although the latter varied considerably according to Utrillo's state of mind and the fact that his mother had sometimes signed them for him.

The outcome of the Utrillo case Stephens described as a Parisian compromise — though effectively Fabris won. Petrides didn't want any further risk of prison and they ended up dually authenticating Utrillo's work.

That case was relatively straightforward, however, compared to what Stephens is preparing to deal with in the future: the question of when restoration — already fraught with such problems as whether or not to remove later-painted celestial underwear in Michelangelo's Sistine Chapel frescoes — constitutes forgery.

The issue has arisen because of artists' desires to experiment. In the last fifty years far more materials have been available and the parameters of what is acceptable as art have become much wider. Some materials deteriorate rapidly, as the Tate has found with the acrylic used by Hockney in one of his best works, *Mr and Mrs Clark and Percy*, which is greying with the absorption of dust. But, confusingly for a restorer, some artists actually intend their work to change and decay. Josef Beuys was gleeful to discover the oily and rancid state which his *Fat Battery* (made of felt, margarine, wood and cardboard and resembling a big sardine tin) had

reached by 1984, twenty years after he created it. Likewise, at what point should one conserve a work by Damien Hirst that included a rotting cow's head being consumed by bluebottles? Should the conservator consult the owner or the artist? Or a taxidermist? If preservation interferes with a process intended by the artist, is the result then a fake?

When the American sculptor David Smith created *Seventeen Hs*, he carefully layered the sculpture with six coats of cadmium red and aluminium powder. But the owner felt it needed some improvement and stripped it back to the original metal. So was it then truly a work by Smith? And what if an ancient sculpture is rebronzed or repatinated or, in the case of marble, merely cleaned? Or if a restorer uses a different technique, like Daniel Goldreyer, who went to huge trouble over Barnett Newman's *Who's Afraid of Red Yellow and Blue III?*, only to be accused of ruining the picture by using a paint roller when the original comprised millions of tiny dots?

Some artists maintain any meddling is wrong. Oscar Wilde's great friend Whistler, the American artist who lived in London and impoverished himself suing England's leading art critic John Ruskin for libel, pronounced: 'Tampering with the work of an artist no matter how obscure is held to be in what might be called the international laws of the whole art world . . . a villainous offence.' And he was just talking about the repainting by the Royal Society of British Artists of a signboard for its meeting-room.

In arguing the case against meddling, Stephens and his colleague Robin Fry believe they can invoke the copyright law. Now in most countries this incorporates two specific moral rights which restorers would be well advised to note. One is that a person has the right not to have an artistic work falsely attributed to him when the work was not created by that artist; or attributed to him as an unaltered work when the work is dealt with in the course of business and has been altered since it left the hands of the artist. The other is that an artist can bring an action to prevent derogatory treatment of his work 'if it amounts to distortion or mutilation of the work or is otherwise prejudicial to the honour or reputation of the author'. Moreover, the latter may even include exhibiting or photographing the work.

Legislation only came in to this effect in the UK in 1989. But France has always had much greater regard for artists, and views any work of the mind as bearing the imprint of its author's personality, as illustrated by the case of expressionist painter Georges Rouault.

The artist had signed an agreement with Ambroise Vollard in Paris, who was the main dealer for Gauguin and Cézanne. Rouault was to hand over his entire output in exchange for a yearly retainer; but work was only to be classified as finished once it was signed. Rouault got into the habit of dropping into Vollard's gallery every so often and working a bit on various pictures – mostly of the Passion and bleak countryside, interspersed with an occasional bouquet – and finally, when he was happy with them, he signed and effectively delivered them. It was a neat arrangement – until Vollard died in 1939 leaving over 800 canvases in the gallery, all unsigned. Vollard's heirs tried to claim the valuable cache. But the law came down on the side of the artist: that only he had the right to determine when his work was complete. In other words, if they were marketed as such they could be called fake.

American law, especially Californian, goes further. The latter says: 'No person, except an artist who owns and possesses a work of fine art which the artist has created, shall intentionally commit or authorise the intentional commission of, any physical defacement, mutilation, alteration or destruction of a work of fine art.' Thus an artist could denounce a restorer's attempts sensibly to preserve a fast-deteriorating work as gross interference. The bottom line could be that the artist disowns the work entirely. So how can it then be classed as authentic?

Of course, some artists, like Giorgio de Chirico, have thrown a spanner in the works themselves by denying they have painted pictures long believed beyond doubt, simply because they have gone off them, whether due to age or change of style. Even van Gogh valued only a relatively small number of his 800 or more pictures and, as he wrote to his brother Theo, intended very few to be considered as his *oeuvre*. These, he believed, formed a 'coherent whole' in which he best expressed his artistic personality.

Stephens beamed with anticipation of the battles ahead.

As I left his office I spotted one of J. S. G. Boggs's controversial artworks on the wall. Boggs was one of Stephens's first triumphs. The case centred upon whether or not Boggs was a fake artist, not whether or not the works were genuine Boggs. Scotland Yard was not amused. Nor was the Bank of England which was chiefly responsible for giving Boggs publicity.

When I spoke to Boggs he was nervous, secretive, protesting his innocence with the police on his tail. Was it all an act? Or did he truly believe in his art – which is to say currency notes resembling real ones

that had so upset the Bank of England he had been accused of counterfeiting. Though, as Stephens remarked: 'Even a moron could tell the difference.'

Boggs, deliberately or otherwise, had egged the authorities on, and gained notoriety, by 'spending' his currency drawings as if they really were the currency depicted, rather than selling them, in a kind of performance that he claims is central to his work. He said it all started in 1984 in a Chicago café when he was doodling on a napkin, à la Picasso. The waitress asked if she could see and thought the drawing looked like a dollar note. So when she returned with a bill for coffee for 90 cents, Boggs suggested she take the drawing instead and give him change.

'Real money is art,' he maintains. 'But people see it without thinking. I want people to think, to wake up to art.' He added that he also wanted to bypass the middlemen who usually set the price of art.

From the café beginning the performance has now become much more complex, aimed at collectors with a childlike love of treasure hunting. Boggs, besides getting change, insists on a receipt from the vendor whose goods he is 'buying' with a drawing. He next sells the change and receipt to a collector. The latter then endeavours to track down the relevant Boggs banknote, for which he is prepared to pay well above face value. The 'artwork' is only complete when all the elements of the deal are framed on the collector's wall.

In England Stephens won the day for Boggs on the grounds that his pound notes were not reproductions but renditions or interpretations of real currency because he did not create them by any mechanical means. Since then Boggs has been charged in Australia, but the charges were dropped as soon as Stephens got off the plane. Boggs continued drawing at the Sebert Town House, one of Sydney's poshest hotels, and the Australian government agreed to pay him damages of $20,000. The FBI, on the other hand, who seized $1 million of his art money, have so far proved less understanding.

However, Boggs has 'spent' $250,000 of his own notes on airline tickets, hotel rooms – including the Grand Hotel, Washington – clothes and a motor bike, and his work is so collectable in Switzerland he can't buy anything with real money there. Now a university professor in the USA, he has turned to photocopying to increase his output by creating limited editions of his art notes. Well, editions of real money are in millions, he points out.

So does the 'art not fake' argument hold as good as for his initial free-hand drawings with coloured ink and pencils, sometimes entirely done from memory? Since the mechanical reproduction is of his original notes, then the photocopies, Stephens pointed out, must be art, too. Anyway, now so much money has been invested in Boggs's work, who would admit to being conned? Certainly not the Washington hotel where even Boggs's dressing-gown is hung on the wall with the transaction as part of his artwork.

• 4 •

A true mystery

'When I used to read fairy-tales, I fancied that kind of thing never happened, and now here I am in the middle of one!'

'Is anyone following me?' the Irishman asked breathlessly, as he slipped into the bar where I had agreed to meet him one spring day in 1983. He was a collector, in Zurich for an auction. He had written to me out of the blue, promising to tell me a highly important story if only I would see him.

'You must be . . .' He held out his right hand, glancing quickly over his shoulder, and dropped his briefcase beside a chair. With his left hand he reached into his top inside pocket and pulled out a photograph. 'You haven't seen this character, have you?'

'No,' I assured him. The bar was fairly empty.

'He calls himself Pantovitch.[1] I'm Michael, by the way. But you guessed that. He's Russian. He was in the Foreign Legion. He's dangerous. You're sure you haven't seen him?'

'Never,' I said.

The snapshot was indistinct but showed a respectably suited, dark-haired gentleman engrossed in conversation with another in what I took to be a hotel lobby.

'Lucky I just caught him over the top of the sofa. It was tricky, I can tell you. Though it'd have been even more so if he'd spotted the camera.' The Irishman shuddered. 'What are you having? You should always

[1] Pantovitch and Blüm are pseudonyms used for legal reasons.

choose the best wine, you know. Then you can drink as much as you want and you won't get a hangover.'

I said I would remember. I was beginning to wonder if meeting the Irishman was a mistake. He seemed so implausible.

'Why is this person Pantovitch after you?'

'It's a long story. I've copied everything for you,' he said, as he looked round the bar again and dived furtively into his briefcase. He extracted a huge wad of papers and my heart sank. I had been handed case histories of arguments before and spent hours trying to unravel the facts, all for nothing. I must have appeared doubtful.

'Well, I was the first to expose him, you see. It's not that he's a bad sort. Just a liar. Of course, what can you expect given his Russian origins . . . And part French . . . I hate the French. Look what they did in the war. But then I hate everybody equally. I'm Irish, you understand. I treat everyone the same.'

'Yes,' I replied weakly.

'Mind you, the Arabs are the worst. In a way, I suppose you could blame them for this. I mean, Syria or the Lebanon must be where the stuff came from. It's really quite obvious. Professor Cahn told Blüm himself . . .'

'Blüm?' I was puzzled.

'Oh, I'm sorry, he's the auctioneer. I haven't shown you the catalogue.' Michael fumbled in the briefcase again and produced a book with an ornate gold vase on the cover. 'I can't understand why I haven't got a letter from his lawyers yet. Everyone else has, and they must be able to find me. Blüm sent me the catalogue when I hadn't even asked for it and now expects me to pay him. Well, I think that's a bit rich. Considering what's in it.'

The Irishman pushed a catalogue of gold antiquities across the table towards me. It said: 'Collection d'Orfevrerie Antique, Galerie Blüm, Zurich.' The auction had been the previous November.

'Just look at that.' He leaned closer, nervously, stabbing his finger at a picture of a gold necklace as I flicked over the pages. 'Any fool can see it's a fake. Mind you, they're not all so easy to spot. Some are really quite clever.'

'You mean . . . ?'

'They're all fake,' he declared, his voice rising in agitation. 'The whole collection,' he added in a whisper.

I asked, was he sure? Definitely, he said. 'It was being sold for Pantovitch.' Michael darted another glance uneasily towards the door.

Back in London I decided to investigate further, but it was far from straightforward. Nothing seemed as obvious as Michael maintained. His accusation was so outrageous, it would be easy to dismiss it. Yet could he be right? And if so, how on earth had such a collection come to be auctioned, as he said?

I frequently spoke to the experts at the London auction houses as their press offices inveigled me into reporting some new discovery. So I asked Richard Camber at Sotheby's.

The Galerie Blüm, he said, was a leading Swiss auctioneer. Of course, anyone could make a mistake – especially with antiquities. Early Christian and Byzantine jewellery of some quality, he told me, had been manufactured in the Near East at the beginning of this century. Production had peaked between the wars. Much had gone into important French collections, for France was then a colonial power in Syria and the Lebanon. But Blüm was highly reputable. One could easily be misled, he repeated.

Sotheby's had not long before had their fingers burnt over the supposed treasure of an Avar warlord. An astonishing hoard of buckles and other belt accoutrements apparently found in Albania, it was trumpeted as the greatest collection of barbarian antiquities to be sold this century. They had catalogued it as around AD 700 judging from the style of the pieces and an initial radio-carbon dating report on a tiny sample of flax webbing removed from a belt strap. The collection had been exhibited widely in Europe and in New York before the auction and speculation had been encouraged that it could be part of the fabled Albanian Vrap hoard, a noble treasury-cum-workshop that had trickled on to the market before the First World War. Some of this was said to have been bought by a diplomat and had disappeared. But, when the auction was held, one lot after another failed to sell. Sotheby's, in a quick turnabout, blamed too high reserve prices (below which items cannot be sold), some mystery about their provenance and the unique nature of the treasure. The affair had been a big embarrassment for Richard Camber himself as the expert in charge of the sale.

Camber, however, directed me to a St James's antiquities dealer, who cheerfully remarked that at least 50 per cent of the pieces on the market were forgeries. He had himself written to Blüm to warn him about the collection. Perhaps the Irishman's claim was less surprising than I had first thought.

So I rang the Galerie Blüm. Monsieur Blüm was away, but an assistant

pointed out that antiquities were a relatively new field for her boss and that dealers had talked 'very bad' about the collection. One in particular, she snapped, had been making a lot of trouble. But, no, she couldn't say more.

The troublemaker, I had no doubt, was Michael, who had been telephoning me at regular intervals to learn how I was getting on. He wanted me to meet Peter Clayton, an Egyptologist formerly employed by the British Museum, who was chairman of the Antiquities Dealers' Association in Britain. I must see him immediately, before he went off on his next dig, the Irishman persisted. I hesitated – was he too eager? – and gave in.

I arrived at a wine bar near the British Museum clutching the Blüm catalogue. Michael was there, fidgeting, gesticulating at a waitress. Peter Clayton was precise and uncompromising.

'It's a beautifully printed catalogue,' he said. He shook his head as he took it from me and opened it. 'You can spot the mistakes on the items straight away. You don't even need to examine them in the flesh, as it were. It's rather like looking at a Rolls Royce with Morris Minor headlamps. Take these two miniature gold vases, for example.' Clayton indicated one which was estimated at around £5,000. It was the one reproduced on the front cover and catalogued as originating in Syria in the ninth century. The other, valued slightly more, was described as third century at the latest and had apparently been found at Sidon in the Lebanon. 'They were obviously made by the same hand,' he declared. 'And look at this . . . and this . . .'

Clayton frowned and I frowned harder as I tried to follow his criticisms. Then he chuckled. The page had fallen open at a magnificent gold chain hung with five portrait medallions in jasper, corneliam and lapis lazuli. It was catalogued as Vespasian's necklace.

'Ridiculous,' Michael butted in. 'I heard the estimate was supposed to be £150,000.' The catalogue omitted this, but said the portraits represented Vespasian and his sons Titus and Domitian who became emperors after him. The two female heads were described as Titus's daughter Julia and Domitian's wife, Domitia. The necklace, it continued, was probably made in AD 70 to commemorate the fall of Jerusalem. 'Impossible,' muttered Michael. 'They're all grown up in the portraits, but at that time at least one of them wouldn't have been.'

I smiled. I began to feel convinced. I asked Clayton how it was that anyone could get away with such forgeries. 'Gullability,' he said and told

me to look in Phillips' last auction catalogue at a couple of figures of Egyptian gods. 'They went for twenty pounds. But they were made by children at Luxor out of Nile mud. They usually sell the figures to tourists for the equivalent of eighty pence each, but they know me, so I get them for twenty pence to bring back as presents.' The necklace, Michael prompted, was just on a grander scale.

I mentioned I had once visited the gold souk in Beirut, and how I was astonished by its riches. Michael nodded. He said he had been out there setting up language programmes for the Arab States — though he had planned it so that he spent three months of the year looking for loot dug up by peasants in Turkey. Hoteliers, chemists, all sorts of people apparently saved things for him in every village. 'It was an excellent system,' he declared.

So had he always been interested in antiquities, I asked?

It was a gold spade-guinea that started it, he explained. He had swapped ten comics for it at the age of ten. It was extraordinary what you could learn from a coin about a country's history. But Saudi, he said, was disappointing. There was no civilisation in that area, though he had tried digging after the rains. Saudi got most of its coinage from its neighbours. Its own coins, lamented the Irishman, weren't even worth faking.

'I once found a gold aureus in Iran, but that was about it. We often used to go from Kuwait to get the Shiraz wines. Now they were very, very good . . .'

I attempted to steer the conversation back to the mysterious Pantovitch.

Had Michael met him in the Middle East?

'Oh, I don't think he was ever out there. Surprisingly. Mind you, when I was in Dhahram . . .'

Clayton laughed. He said he had to go. He was leaving on a long trip to Egypt the next day.

I waited for Michael. As we left the wine bar I began to wonder again about my improbable Irishman and his far-fetched tales — all as unlikely as a whole collection of fakes. Yet there was no real reason not to believe him.

How, I asked him abruptly, had he got involved in the Blüm auction? Had he intended to buy something in the sale?

No, he replied, quickly. His own interest these days was chiefly in coins, particularly Byzantine. You knew where you were with coins since they were very precise, although you did get some good fakes.

'There's a chap in Italy, a baron, who's behind a lot of the supposed Greek coins coming out of Sicily. But I'd keep clear. He looks like a Renaissance prince and he's the sort of person who would book into a hotel in his enemy's name. I'd be wary walking down the street with him.'

I persisted. If Michael weren't bidding, if he weren't interested in buying anything in the auction, how had he become so involved?

'Well, Pantovitch was a Paris coin dealer,' he said, as if this explained everything. According to Michael, Pantovitch was a charming fellow but crooked – the sort of person who would tell you anything that crossed his mind and be so convincing that you would be taken in. The Irishman guessed my doubts. He said: 'I can see how people believed him. He was always very smartly dressed, not like myself in my hacking jacket . . . And, of course, there are degrees of crookedness . . . But the most extraordinary thing about him was how ugly he looked when he smiled.'

Michael had last met Pantovitch in the George V Hotel in Paris. 'He was wearing a leather coat and carrying a small bag, very French, like a handbag. He was very polite, though he has a reputation for violence – for killing. It stems from when he was in the Foreign Legion in Algeria. He's been in prison too . . . He'd got several addresses at that time, and a company based in Liechtenstein. He's a real ladies' man. He'd been involved with a suspect antiquities auction before in France. It was probably a trial run for this one.'

So what exactly happened at the Blüm auction, I asked as we walked past the museum gates?

Michael, it seemed, had tried to talk to Blüm both before the sale and after. 'But he didn't want to know,' said Michael. Unfortunately, as Blüm informed Michael, Pantovitch had produced what appeared to be impeccable references showing that he had done five million Swiss francs' worth of business in the previous year with an eminent coin firm. He gave every appearance of being a moneyed dealer and collector. 'And you can waffle more in the antiquities world than coins,' added the Irishman. 'Blüm was duped. Even if he suspected that some of the objects were false, he could never have imagined ninety-seven per cent or so were modern fabrications.'

On the day of the auction the saleroom was packed. Suspicion had spread.

The confusion over what had actually sold was enormous. Out of

ninety-three lots, Blüm, a very experienced auctioneer, let it be obvious
that three alone remained unsold, so the auction seemed a great success.
But most lots appeared to have been knocked down to bids 'left on the
book' by buyers who had given Blüm permission to go to a certain level
on their behalf because they could not attend the sale. In doing so Blüm
had nodded at the wall or chandelier or no one in particular. The rest of
the lots supposedly went to bidders in the room.

'But only two people were bidding,' said Michael. 'They bought two
lots between them. They were young and obviously employed by Blüm.'
The prices which were published after the auction, he added, muddled
the issue further, since they indicated that about half the lots didn't sell
including seventeen knocked down to the invisible bidders in the room.
'In fact, I don't think anything sold. I hope not. It's bad enough that
they have gone through a known Swiss auction house and been reproduced
in a glossy catalogue that looks as if it's been written by experts. That
is enough to make the stuff seem genuine.'

Local newspapers had picked up the furore surrounding the auction.[1]
Dr Herbert A. Cahn, a professor at Basle University and president of the
Art and Antique Fair in Basle, had been cited before the sale as having
doubts about the collection, along with other members of the Association
of Swiss Antique and Art Dealers. Blüm had counter-attacked with the
views of experts given in the introduction to his catalogue. Chief among
these were Professor Richard Hahn and Professor Guy Demortier and his
team at the University of Namur, who, Blüm said, had thoroughly tested
the pieces. Blüm had even removed about a hundred items because they
had been repaired too much to be considered strictly genuine.

Who owned the collection was a matter of varying opinion. Blüm
claimed it belonged to a company in Belgium which he could not name.
Some said it was the property of an important French aristocratic family.
Michael was quoted as identifying Pantovitch as the owner. Pantovitch
was reported as having been imprisoned several times in the past for high-
class swindling and forgery of cheques.

After the auction, the collection disappeared as mysteriously as it had
appeared.

Blüm was in a difficult position. He needed to save face. So he began

[1] The controversy over the auction was reported in the Swiss newspapers, *Zuri Woche
Donnerstag*, *Tages-Anzeiger* and *Berner Zeitung* around the time of the sale in November 1982.

legal action against whoever might be deemed responsible for wrecking
the sale. Experts similarly vanished, along with their opinions. They had
no time for trials or upsetting the market with scandal. In the end
Professor Cahn and a Basle coin firm were left to carry the can. Blüm
put the episode down to jealousy, claiming Professor Cahn, as a rival
auctioneer and archaeologist, was miffed at not getting the collection to
sell himself. In a newspaper article following the auction Blüm said the
collection had been torpedoed by a series of false statements and omissions,
that Pantovitch had not been 'several times in prison' or charged with
high-class swindling and cheque forgery, that references to the provenance
and ownership of the collection including the naming of the 'late' Comte
de Puytison – in fact, in good health and living in Paris – had been
incorrect, and that two of the most important experts involved in
authenticating the collection had not been mentioned, namely the
Sorbonne antique jewellery technologist Dr Nicolini and the archaeologist
Professor Hackens.

The mistakes were troubling. Proof of the collection's fabrication
seemed to be falling apart again. Which experts should I believe?

Was Pantovitch really dangerous or might that just be a figment of
Michael's imagination?

'Oh, didn't I tell you? He was given a clean slate after turning police
informer,' said Michael, when I enquired. 'I forget what for. But it was
common knowledge. I was told by a police commissioner who was a
great collector himself. Unfortunatley the commissioner was arrested for
stealing documents from a French museum.'

I sighed. It all seemed so unreal. But then maybe it was such doubts
that allowed fakers to get away with so much.

Where did the collection come from, I urged? According to what Blüm
had written, a couple of the necklaces had been in the auction of the
Puytison collection at the Hôtel Drouot in Paris in 1972 and purchased
later by his client. Was that right? Were those fakes from earlier this
century? Were the rest old fakes? Or were they new?

'Let me introduce you to an Armenian friend of mine,' was Michael's
reply.

A few days later I arrived in the foyer of the Marriott Hotel in Grosvenor
Square which was hosting COINEX, one of the world's major coin fairs.
Michael was waiting to usher me in to meet the Armenian and an Italian.
'Don't worry. They'll talk to any friend of mine,' he encouraged. 'Only
be careful how you put your questions . . .'

As we shook hands they regarded me suspiciously. The Armenian lived in Syria and was a big collector. After about twenty minutes I plucked up courage to broach the subject of fakes. I asked him how he managed to avoid them in such a tricky field. He paused, then said it was quite easy really, since he knew where many of them came from. In fact 80 per cent of the small artefacts and jewellery – things I would pay £200 to £1,500 for – were forgeries. European dealers, Germans especially, ordered a lot of them.

I tried not to appear too eager. But he motioned to me to lean closer. I wondered what Michael had said to him.

There was one particular master forger at work, the Armenian continued. He also was an Armenian, and he worked under cover of the war in Beirut. He was a specialist in Byzantine and early Christian jewellery. Before the fighting he had been a leading goldsmith; but now he was earning far more than he ever did in the old souk. Naturally he was heavily protected by the local militia, who took their cut of the profits in return.

'And so he gets away with it?' I murmured.

'He says there is a market for copies and it is not his fault if they are taken to be originals,' explained the Armenian. 'Life is too cheap for anyone ever to follow up a complaint.' Anyway, he continued, there was a long tradition of forgery in the Lebanon and Syria. Now there was a new flash of activity. It had last peaked after the First World War. The only difference was that forgeries today were of a much higher quality, both in craftsmanship and in historical accuracy.

When I mentioned the Blüm collection, he showed no surprise that it might all be fake. Neither did the Italian, who had been listening.

'Come and have a look around.' Michael nudged me. He thought he had spotted two Arab runners, as they were known, Freddie and Dimitri. They didn't often turn up in London, he said. Paris was more likely. They usually brought sacks of stuff – antiquities, coins, some good, some fake. 'The trouble is, many people think they're important because they wear gold Rolexes and spend their time in night clubs or gambling and often lose £7,000 in an evening. But they're conmen. Anyone with serious money would never be so blatant.'

At last I was sufficiently convinced to write a story about the auction of fakes. Michael was excited. So was my news editor. But when I had finished he was worried. 'There is the problem of the legal case still going on,' he muttered. My story was handed to a lawyer. Then it was dropped.

Switzerland was a great place for bringing legal action to prevent publicity. It took so long that everyone had forgotten about a case by the time it was sorted out.

Or almost everyone. 'Irishmen have long memories,' said Michael when he telephoned me three years later. 'Especially when it calls for a celebration. Professor Cahn has won. I don't understand all the niceties yet. It's in German, you see. But come and have a drink.'

Had he any idea what had become of the collection, I enquired later that evening?

'Well, nobody seems to know,' he murmured. 'Except, funnily enough, there is something that might be worth checking . . .'

Christie's in London, it appeared, had been sent a photograph of one of the pieces from the sale, presumably with the idea that it might be included in an ensuing King Street auction. Michael had heard this from a friend. The snapshot had come in via the auctioneers' Paris office from whence it had been dispatched by a recent or possibly a current employee – he wasn't sure which. But when he enquired in Christie's antiquities department the Irishman met a blank wall.

This, he believed, was the first time anything from the Blüm auction had surfaced in Europe and he was anxious to know which piece it was. 'Then people can be warned,' he declared. He had, he added, informed Christie's of the Blüm auction scandal at the time. 'Perhaps now you can write about it,' he said.

Christie's, however, maintained client confidentiality was more important and refused to reveal the identity of the owner of the piece or even which one it was. 'Though they offered to forward a letter to their client so he could reply if he wished. That is to say Pantovitch or his agent or some poor fool who might have bought the item in good faith. As if any of them would want any publicity once the forgery was detected!' Michael laughed bitterly.

I couldn't believe Christie's attitude, I said. But when I approached the auctioneers the answer was the same. The Christie's boy in Paris, I was informed, had been enquiring for a friend. He had been told gently, as it was a friend, that his friend had been sold a 'pup'. The London expert had sensed it didn't look quite right. No, I couldn't talk to the boy. He was ill today. No, the expert couldn't help me either. The consequence of client confidentiality, it appeared, was that they would rather a fake go undetected than its owner be exposed.

Loath to give up again, I began making more enquiries elsewhere.

I rang the dealers I had spoken to before, and I again asked Richard Camber at Sotheby's. I discovered a rumour was circulating that part of the collection had been sold off in Texas, where lack of knowledge about antiquities and reverence for them were equally great. They had apparently been offered around a number of small museums, but nobody seemed very sure which, nor thought it of sufficient consequence. Museums were full of fakes, I was warned.

'Sir John Pope-Hennessy himself bought our most famous mistake,' remarked one of the British Museum curators as I persisted. A former director of the museum, Sir John had purchased a stone head of a tetrarch, hailed as Constantius I. But it turned out to be one of four identical heads made in Rome around 1970, sculpted out of an original Roman column, and this accounted for its unusually flattened features. The curator, however, had seen nothing of the Blüm auction pieces.

It seemed impossible to pin anything down. Then several years later I saw the autobiography of the international art dealer, Michel van Rijn. His photograph on the cover reminded me of Michael's snapshot of Pantovitch, though it was obviously not him, and I read van Rijn's confession about the Avar hoard that had so embarrassed Sotheby's some years earlier. He had commissioned it himself from an Athens antique dealer and goldsmith called Patrikiades, formerly an Egyptian shoemaker, who was renowned for forging ancient coins. He created the belt fittings out of old gold coins and fragments of Byzantine silver to confound any expert testing for appropriate impurities, incorporating the tiniest pieces of Coptic funeral shrouds that van Rijn had picked up in Egypt. The goldsmith worked from sketches van Rijn had made as a result of visiting libraries and museums in London and sending for photographs of collections in Albania and the Soviet Union. Yet just before the sale van Rijn himself spread the word that there was something wrong. Why? Because Sotheby's had caused him to lose face over a major Japanese deal. The Avar hoard was revenge. Very costly, but very sweet. In order to promote his own business he had set himself up as middleman to negotiate a partnership between Sotheby's and the Japanese art firm Gekkoso. But just as he thought he had succeeded, Sotheby's signed up with Seibu to hold auctions in the department store instead.

I met Michael, the Irishman, again, shortly afterwards.

'Oh, that wicked business,' he said, when I remarked on the similarity between Michel van Rijn and Pantovitch. No, he hadn't seen any more items from the Blüm collection, nor seen or heard anything of Pantovitch.

He shook his head. Someone somewhere some day would once again be duped.

But one question to do with the Blüm auction still bothered me. Why had Michael gone to such trouble to expose Pantovitch?

It is the only time I've ever known the Irishman pause. Finally he replied.

Pantovitch had gone off with Genevieve, Michael's ex-fiancée. They had already separated, but Michael had been anxious, and so he had hired a private detective. It transpired Pantovitch had been married twice before. 'The detective actually remembered him in the military because Pantovitch had beaten him up. But Genevieve had Pantovitch's child and I think she married him in the end'. The Irishman had tears in his eyes. Since then, while still very young, she had died.

The vendetta at least was not fake.

· 5 ·

The Keating phenomenon

'No, no!' said the Queen. 'Sentence first — verdict afterwards.'

I don't know why I said it. Unless it was the champagne. Or the clipped and bored voice of the lady ahead of me as I examined some particularly attractive cedars by Edward Lear. But I couldn't help it when David Posnett, the director of the Leger Galleries, glided imperiously towards me.

'Are you going to bid for any Keatings?' I asked.

His colour rose scarlet above his silk collar, but politeness won. 'No, I think not,' was all he said, and he has avoided me ever since.

Posnett probably suffered more than anyone at the hands of Tom Keating — though as Keating would have said, Posnett brought it on himself. For it seemed to me that as a forger Keating was simply leg-pulling. Mercilessly. Which is why he became known as the greatest British faker this century.

His output over twenty-five years from the beginning of the 1950s was prodigious. He probably forged over 2,000 works by a whole galaxy of artists. He kept no record, however, except in his own head of what he painted, or to whom he gave or sold the pictures, or with whom he left them. But he always maintained he never sold anyone a fake claiming it to be genuine.

When I met him several years after his exposure as a forger in 1976, he seemed an odd figure, short and stocky with a red face and white beard, his story-telling running away with him in roller-coaster Cockney. About being a lather boy for a barber just like the teenage Turner. And hiding in the jungle to escape invading Japs. Then being advised at art

school to copy pastels by Degas – and doing so on and off for the rest of his life.

I had found him in his local pub in Dedham, just down the road from East Bergholt, the Suffolk village where Constable was born. It is a comfortable and luxuriant area of large houses, Elizabethan plastered cottages, riverside idylls and overpowering greenery. But old cottages, he warned, could be chilly. He had been painting by the River Stour, one of his favourite spots, and he was drinking orange juice.

I brought up the subject of fakes and apologised. Everyone must ask him the same questions. He chuckled. In fact he was still beside himself with mirth that anyone, especially anyone who thought themselves important, should mistake his pastiches for the real thing. They were fun. He enjoyed doing them, he said. But there was a hint of sadness in his voice. In the end he had been overtaken by his own practical joke.

Like Eric Hebborn, Keating was one of a large family. He was born in 1917 in Forest Hill, south London, where his father was a house painter and his mother a cleaner. 'People call my background working class. It's a euphemism for sharing the same lavatory with two dozen others,' he remarked. Aged fourteen he left home.

After the war, during which he was invalided out of the Navy and also married, he was awarded a grant to study art at Goldsmith's College. He omitted to let on that he did not have any academic qualifications and he failed his diploma. His original composition was poor. But his technique was good.

His first 'Sexton Blake', as he called it, was a head and shoulders portrait for a gallery owner who had previously paid him to do some restoration.[1] The dealer handed him an engraving and asked if Tom could paint an oil version. 'I didn't realise his intention at the time,' said Keating, explaining that one of his friends later spotted it offered as a genuine nineteenth-century painting. The story was pat through telling it often.

When he had it out with his employer about being paid two pounds a week to forge works that sold for hundreds, he said the dealer produced

[1] In *Fake's Progress*, Keating's autobiography, he refers to the dealer as old Frippy. He says he discovered the dealer had a stable of old ladies dotted around the country churning out copies mostly of Dutch flower pictures, which he then baked like a cake in an oven to crack the paint.

an old Bible. He had Keating swear not to repeat what he was about to learn until he, the dealer, was dead. Inside were a couple of Leonardo drawings, a Raphael and two Michelangelo nudes. Each bore a royal crest and the monogram of Sir Peter Lely, painter to Charles II. They should have been in the Royal Collection at Windsor Castle. Lely, the dealer told him, had fallen so much in love with the drawings that he felt he must have them, so he copied them and substituted his copies for the originals. Keating's employer had stolen them from their last owner – which seemed quite fair since they were stolen already – but they proved too 'hot' to sell.

'Well, you tell me if it's true,' said Keating, as I listened open-mouthed.

These days he was quite open about his forgeries. But then, he said, he always had been. It was other people that weren't. He had learnt how, he said, while restoring pictures for the London trade, Scottish lords and ladies and repainting the frescoes at Marlborough House, where he looked down one day to see the Queen Mother staring up at him and was so surprised he nearly dropped his paint all over her. He was particularly fond of doing seventeenth-century Dutch landscapes, Paulus Potter most of all. However, these detailed rustic scenes full of farm animals were so acclaimed in their day that the number attributed to Potter was already well beyond the bounds of possibility, Tom pointed out, even before he got going. For Potter died in Amsterdam aged only twenty-eight.

Keating was keen on seascapes too, especially those by the van de Velde family. Then there were the Rembrandt drawings, masses of them, 'beggars, canals, crucifixions, the guvnor's missus, the lot', which he did with quills, using the brown juice of simmered apples and a spoonful of ground coffee to give the appearance of age. The impressionists were even easier – such as the Gauguins on sugar sacks. Tom had heard there was one in a 'boozer' in Tahiti. He just mixed poster paint with emulsion, 'or anything else that would make a cheap, thick paint', he said. He had done the earlier French painters as well, including Charles-François Daubigny, chiefly because he had heard that Renoir also used to fake this nineteenth-century landscape artist who was a friend of Corot.

The list seemed endless before he even got on to all the English artists he loved: Turner and Constable and Gainsborough and Girtin, who, he said, would have been 'better than his mate Turner if he'd lived'. Cornelius Krieghoff, Canada's most important nineteenth-century painter, Keating

Self-confessed faker Eric Hebborn: 'The so-called experts are the real fakers.'

Sotheby's chairman Peter Wilson, inventor of art sales hype after declining to remain on the staff of MI6 in 1946.

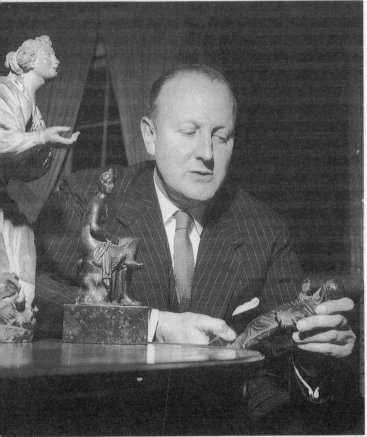

Spy Anthony Blunt, The Queen's picture expert and faker's friend. His mind attracted Hebborn.

Going, going, gone. The Hon David Bathurst who in 1981, as Christie's New York President, faked the sale of a van Gogh and a Gauguin.

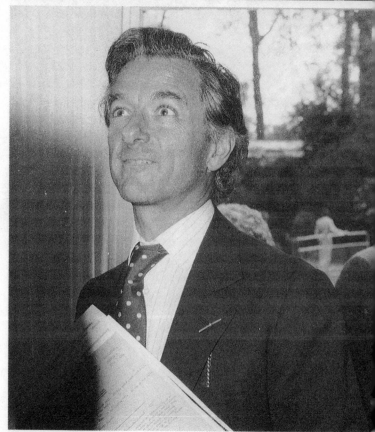

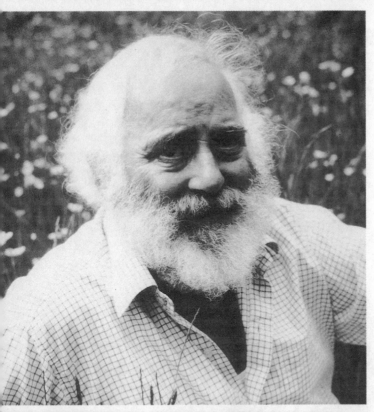

Exposed faker Tom Keating, joker and television star: 'Dealers exploited artists. I wanted to cause a few red faces.'

Lawyer Mark Stephens, defender of art and artists against dealers, auctioneers and the Bank of England.

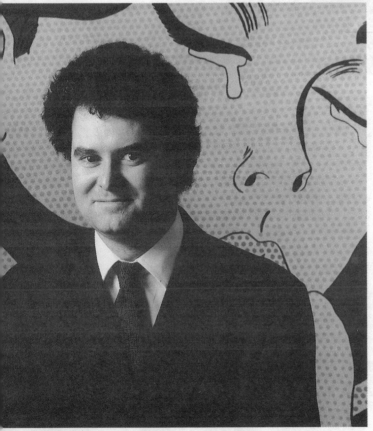

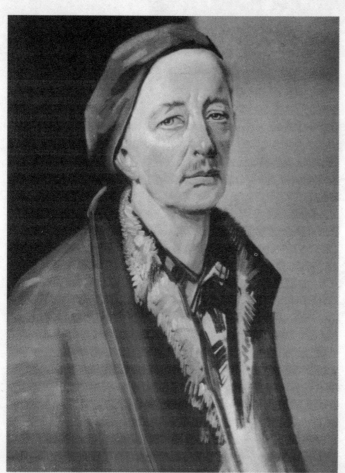

Left: Reluctant faker Han van Meegeren, Dutch national hero for fooling Reichsmarschall Hermann Goering over a supposed Vermeer.

Below: Top copyist Susie Ray: 'When I see pictures I've copied it's like meeting old friends.'

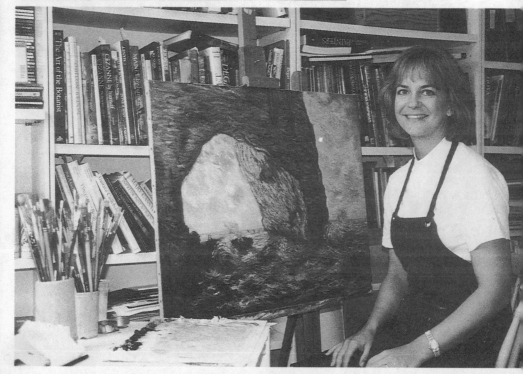

had imitated by the hundred. And of course there were the Russian icons . . .

I drew a sharp breath. But it appeared they were only nineteenth-century icons, mostly repainting jobs, and a few from scratch, all for 'a Polish bloke in Kew'.

Anyway, added Tom, he always left clues. Before beginning a painting he would write his own name, or the word 'fake' or something ruder, on the canvas in white lead paint which would show up under X-ray, and he would use a heavy varnish to make the work look old, but one which you couldn't clean away without removing the paint as well. If he was going to use another artist's old canvas he would rarely scrape the picture off but instead give the work a protective coat, 'out of respect', before painting on top. For drawings he often used paper of the wrong date. The paper he had done his Durers on, for instance, was several centuries out.

The point was, he never really intended his work to be mixed up with the masters. He just wanted to cause a few red faces. Dealers exploited artists and looked down their noses at the likes of him, or pretended not to and were patronising, which was worse, and this was his way of making a protest. If they were 'proper blokes', they would see the funny side of it. Few did.

Curiously, Keating took little interest in what happened to his pictures once he'd done them. Some he sold himself, others he used to pay his creditors, many he simply gave away. He really couldn't tell me any more because he didn't know, he said.

Among the few whose whereabouts many people now knew were some of his Samuel Palmer drawings. He had taken a shine to Palmer when he was confined to bed with a bad back. It was in the early sixties and a friend had given him a book to cheer him up – Geoffrey Grigson's *Valley of Vision* in which he read the story of Samuel Palmer, whose adolescent fancy led to his intricate and stylised drawings and paintings of the countryside at Shoreham, until he became disillusioned with his rural paradise.

Keating's first Palmer to turn up on the market, which combined elements of two drawings in the Grigson book, was his study of a barn with shearers in the foreground which was purchased by the Cecil Higgins Museum in Bedford in 1965. It had been knocked down for £30 at Bonhams where the buyer thought he had made a discovery. He sold it on for £200 and a profit-share agreement to Colnaghi's, who had the

attribution confirmed by the British Museum before letting it go to the Cecil Higgins for £2,500.

In his autobiography, which he wrote as soon as his fakes were exposed, Tom openly describes how he did his Palmers. He says: 'I got my drawing-board and a pile of pristine paper together and began to draw very rapidly in the style of the guv'nor, banging in a couple of sheep here, a shepherd there, the moon, trees and Shoreham church. Sometimes I put in the hallowed figure of Christ, sometimes a barn, and sometimes a three-arched rustic bridge. I used watercolour, sepia ink, wax and varnish and all the other materials that Palmer would've used himself except, of course, that mine were of the synthetic modern variety.'

Keating continues: 'I gave some of them to the kids who'd been so kind to me while I was laid up with my back. I think they flogged a few in local junk shops, but I like to think they kept one or two and still have them on their walls now that they're grown up. I rarely bothered to frame them. I just handed out slips of paper with Palmer drawings on them. I gave them to all kinds of people, like the gas man who came to read the meter, casual acquaintances and complete strangers and I even sent them to my family and friends as Christmas cards – I expect they chucked them in the dustbin on Twelfth Night.'

One of Keating's Palmers, *Sepham Barn*, was purchased by the Leger Galleries at a Woodbridge auction in 1970 for £9,400. Such prices, Tom said, horrified him. The picture had been put in the auction by his former pupil, Jane Kelly,[1] with whom he was living in Norfolk before they moved for a while to Tenerife. Three others were bought by the same gallery directly from Kelly, who, on being asked about their provenance, explained they had come from Ceylon where her grandfather was a tea-planter. She thought his father must have taken them with him when he went out there in 1868.

The Leger Galleries initially were incredulous when the suggestion was made that they had been handling forgeries. Then they began what appeared to be a cover-up. The gallery struck a confidential deal with the client who had bought *Shoreham: Moonlight*, taking the work back in

[1] Jane Kelly is also mentioned in *Fake's Progress*, living and working as a picture restorer with Tom Keating in Suffolk. She was not involved in the court case, however, which was brought against Keating and his friend Lionel Evans, a dealer to whom Keating had given a number of paintings.

return for an undisclosed number of *objets d'art* and an assurance from their client that he would 'make no statement about whether the painting was authentic, that he would bring no legal proceedings against the galleries, that he would not discuss with any expert the authenticity of the work, and that he would not speak to the press about the matter'.

The Leger Galleries were backed up by the British Antique Dealers' Association for acting with the 'utmost propriety' and BADA announced an inquiry into the Keating affair. This was to be headed by Sir Anthony Lousada, a former chairman of the Tate trustees, and the panel of investigators would include responsible art historians, conservationists, technicians and painters – helped by forensic-paper expert Julius Grant, who had confirmed *Shoreham: Moonlight* as modern. The inquiry, however, focused on only thirteen disputed Palmers – seven of which were finally deemed to be of the wrong date – while Tom regaled a growing following with claims about what else he had done.

The Society of London Art Dealers, exasperated with the narrowness of the inquiry, decided to go to Scotland Yard. In 1977 the police began to assemble a case against Keating. He was charged with criminal deception, but only to the value of a few thousand pounds, since both dealers and auctioneers were reluctant to talk. Far more was at stake than dirty washing. The art market is built upon confidence: when things are going well, business snowballs, but a hiccup can easily start a downward spiral. Keating's 'crude daubs', as he called them, were liable to prove a very nasty hiccup. How could dealers convince buyers of the value of a unique, original production of a famous mind – so much so that a few scribbles by a famous master are worth far more than a fine painting by an unknown artist – if more and more turned out to be Keatings?

The case against Keating eventually reached court in 1979. The charges were based on four Palmer paintings on panel, typically depicting sheep and haystacks and Shoreham church, which Tom had given to an antique-dealer friend. These had been offered to the Leger Galleries and the Faustus Gallery as genuine Palmers and were hence nicknamed the Faustus Four. The prosecution claimed that the care taken to achieve the look of nineteenth-century grime and wear on both picture and frame constituted evidence of deliberate intention to deceive. But the defence's case rested on the fact that one was indistinctly signed 'not S. Palmer', while another actually bore the signature 'Tom Keating' along the edge of the panel.

When Keating fell ill during his trial and the case was dropped on account of his heart and bronchial trouble everyone involved was extremely

relieved – everyone, that is, except the public. Keating had become a Robin Hood figure, sticking two fingers up at the establishment. Consequently, instead of doing time in jail, he did a television series imitating the techniques and styles of great painters 'off the top of his head' on camera, sometimes re-creating a famous work like *The Haywain* in reverse or including himself among the figures in the picture. Cannily he managed to give relatively little away, yet won an award for the series.

Ironically he was still quite poor. He was renting his cottage at Dedham but wanted to buy one and thought of having an auction of his fakes to pay for it. So he rang Christie's in South Kensington where he startled the picture expert David Collins with his proposition. 'But it seemed a genuine request, so I went to have a look,' said Collins, who was chiefly responsible for the spectacle which followed, with ten television crews crammed into the saleroom. He chose 120 of Keating's best, stamped the back of the works with indelible ink and auctioned them for £72,000. The 'fakes' made more money than any of Keating's own compositions, and more than enough for Tom's dream cottage. However, he died a few months later in February 1984, before he had the chance to buy it. He had already paid for his burial plot in exchange for painting a picture of Christ the Good Shepherd in Dedham Church.

Keating's daughter and son asked Collins to hold another sale. The paintings were not as good but his infamy was still gaining momentum and the result was £274,000, about seven times the estimate. The bidders, unusually for a picture auction, were virtually all private including two major buyers who already owned work by most top impressionists and wanted a Keating to complete their collection.

Collins had, in fact, spotted a whole new market in pastiches, whether acknowledged fakes or legitimate copies. The time was ripe as the sale of van Gogh's *Sunflowers* led the impressionist boom. Every collector wanted a bite of a Cézanne apple or Monet cherry, but few could afford it. At the same time interior decorators were having a spree, in need of endless pictures to cover blank walls. In fact, buyers continued to buy more in the recession when they had even less chance of acquiring the real thing.

Nowadays David Collins is in business importing copies chiefly from the Far East. 'The pastiche trade is based on crud,' he admitted, 'but you can get high-quality work there far cheaper than in England because of the different overheads.' Some 75 per cent of what he sells, much of it to the trade, consists of flower paintings. These look old on the front but when you turn them over you can see it's modern canvas or panel on the

back, he added. Eighteenth-century Dutch are favourites. They are not exact copies but painted in the style of, say, Jan van Os, himself an imitator of Jan van Huysum, in a sympathetic and old-fashioned way. 'It's what people want,' he said. 'Something nice and affordable to put on the wall.'

Bonhams gambled on this too after handling a number of works from the studio of the Spanish copyist Miguel Canals, now in his sixties, who used to be a wallpaper and textile designer until there was a slump in trade. One irate buyer of a 'Eugène Boudin' by Canals had refused to believe it was not the real thing; after all, it was signed by the artist and looked sufficiently old. Worried by this incident but loath to stop selling Canals's work, Bonhams decided to target the market head on. They began holding an annual auction devoted to the work of Canals and his team of copyists in Barcelona. Now, to be on the safe side, they stamp his picture stretchers indelibly with his signature and provide a certificate of authenticity that each painting is a genuine Canals.

The auctions have repeatedly been sell-outs, to the delight of the Spaniard sometimes seen lurking at the back. Of course, it is always possible to cut a canvas from a stretcher and most buyers like the tingle of excitement at the idea of having a fake even if, in artspeak terms, it is an 'original copy'. Keating had raised the profile of the art forger at a time when prices were soaring – so much so that Bonhams reported a flurry of fake Keatings turning up; and even Sotheby's, whom he had taken for a ride, saw the positive side to forgery too. They began to promote their Black Museum. This is a collection of all manner of fakes and forgeries, some of which line the office of its curator, David Battie, when it isn't on tour. It's a bit like keeping a skull on one's desk. I was curious.

When I called to see Battie, he began: 'You can't be too careful buying antiques.'

I murmured something about Keating and he laughed. Sotheby's didn't have a Keating, he said. Not any more.

Regrettably forgery was so prevalent that he advised: 'The golden rule is to assume an object or a painting is wrong and ask it to prove to you that it's right.' Battie said he had followed this rule since he started his career at Sotheby's as a porter twenty-five years earlier and was shown a reproduction of a Meissen figure. It had a patch where the glaze had been ground off, along with the real maker's mark, and had been quite legitimate until the owner decided to increase its value a hundredfold.

Battie's mentor, who had begun the collection at Sotheby's before the Second World War, was Arthur James Bartram Kiddell, the doyen of the firm's Ceramics and Works of Art Department. 'He would look at twenty tea chests and weed out the duds and ask if he could keep them for reference,' explained Battie. Usually he could, since recent imitations then didn't have the decorative value they have today.

'There are several questions you should pose over any piece,' he added, handing me what appeared to be a Staffordshire pottery stately home. 'Firstly: why make a forgery of this? If the reason is that it is, or was, worth a considerable amount of money, the next question is: would the amount of time and effort put into the forgery represent a healthy profit for the maker?'

The argument appeared sound. Staffordshire has risen in value considerably in recent years. The miniature replica which I was holding, of Stanfield Hall in Norfolk, famous for its owner's murder, would probably have been worth £300 if it were genuine nineteenth century. It was a fair return on a rough earthenware piece that was among the easiest types of pottery to forge.

The reasoning likewise applied to the pots made by a couple of prisoners in Featherstone jail, Wolverhampton, who asked to do a ceramics course while they were inside. Their elegant but simple vases had found their way into several London salerooms as the work of Bernard Leach, then worth about £1,000 each.

But what about Keating? He was not in it for the money, I pointed out, even if someone had recently paid over £25,000 for one of his Old Masters.

Battie picked up a reproduction Art Deco figure of a lady and said: 'Maybe not Keating himself. But few collectors can resist patting themselves on the back when they think they've made a find. Take this, bought at a fair for forty pounds. If it were real it would cost three thousand pounds. Some unscrupulous country auctioneers and dealers play on collectors' enthusiasm – or greed – and deliberately leave out full catalogue descriptions of reproductions, or claim they don't know if a figure is bronze when they are fully aware it is carefully disguised plastic made in Paris, probably last year.'

I peered into the cabinets full of pottery and glass. There were bits of plastic scrimshaw and netsuke made with dental filler too, some quite convincingly. Then I spotted a dusty bottle, apparently containing exceedingly old vintage port. Battie saw my quizzical look and shuddered.

It was, he said, one of a pair left for sale in 1986. Sotheby's wine boss suspected the glass had been deliberately aged by being left in a river. However, he could hardly open the bottle to check it. 'Then one of the bottles lying in the tasting room exploded, spewing pink foam all over the carpet. It was Lambrusco. Don't ask me why. We had burglars in not long ago. They ransacked the place. I wish they'd taken this bottle.'

Instead Battie's favourite porcelain bunny was among their hand. Presumably they imagined it was a real eighteenth-century Chelsea rabbit tureen worth maybe £25,000. In fact it was more like £700, he lamented. The rabbit was actually part of the vast output of Emile Samson's factory in Paris last century. Samson's reproductions, like Keating's fakes or Canals's copies, have become collectable themselves. Many were deceptively accurate, even down to the factory mark; and although supposedly identifiable by an additional 's', this could be removed with hydrofluoric acid by any unscrupulous dealer.

A 'T'ang Dynasty' horse and rider, which had also lately been on exhibition, would not, I thought, have been so easy to dispose of, although that too was an old forgery, produced in China around the turn of the century. Railways were being constructed across the country with European assistance and tombs uncovered full of such pottery. As this captured the imagination of collectors in the West, forgers set out to supply the demand using original moulds, local clays and fragments of genuine pots to confuse any date testing. Now the figure had the benefit of nearly a century of wear, but the facial features were too emphatic.

I knew this because I had a similar figure – only a much better forgery. I was aware it wasn't the real thing because I knew who had made it. I had watched. The potter was another artist who in every other respect was a most law-abiding citizen. But he had been inspired by Keating's stance against the snootier side of the art world. He, too, had studied the Old Masters in detail. The Spanish School was his favourite, especially El Greco. Recently he had refused to part with a fine 'Velasquez'. He said he was much too attached to it.

He knew a considerable amount about pottery: not just who made what and when, but how it was made; at what temperature it was fired and for how long; what paste had been used and what glaze. He loved pottery. He saw it as something of beauty. He collected it, though he refused ever to spend more than a few pounds on it. He restored it, deriding amateur attempts with glue as criminal. And he made it. He

created his own studio pottery and he copied earlier pieces – initially, he said, in order to learn more about them.

Sometimes when I visited I would hear the buzzer go on the cooker and he would hasten into the kitchen. He would return with a carefully modelled hand or flower, the original of which had long since been broken off a Derby figure or Meissen candlestick. Or on occasion he might be carrying a Worcester plate exquisitely painted with garlands of flowers. 'Well, it wasn't very interesting as it was,' he would say.

One day I arrived with the catalogue of a recent sale of Chinese ceramics at Sotheby's which I thought would interest him. In China, ceramics have never been regarded as a minor art, either by those who made them or by those who collected them, as he often reminded me. The result was an elegance of design and harmony of materials and method rarely attained by Western potters. It was the mid-eighties and the prices were high, in some cases over £100,000. As he flicked through the catalogue, admiring one piece, frowning in astonishment at the bidding I had written in on another, a T'ang figure caught his eye.

'Now, I do like that one,' he said.

'A bit expensive,' I replied. 'You'd have to sell the house. Anyway, it could be on its way to Hong Kong by now.' That was where most of the richest, scholarly and determined collectors were based.

'That one, yes,' he mused. 'But there might always be another.'

The next day, he said, if I wasn't busy, I might like to see what he meant. When I peered round the door into his upstairs studio, which doubled as a spare bedroom with wardrobe, blanket chest and satin curtains, he had a huge piece of reddish clay on the table. He was cutting it with wire and turning and pummelling it, rather like kneading dough.

'You have to get the air out,' he explained, then grinned. 'I thought I'd get some Rockingham clay. It'll subdue the colours a bit if they're on a dark base.'

He gave the lump of clay a last pat, picked it up and sat it on an oblong pottery base, a kiln shelf, he said. It had been fired at a very high temperature, so you could fire other things on it and they wouldn't stick. Sotheby's catalogue was on the table, open at the entry for the T'ang horse. It was, he remarked, a good photograph.

On the table, he had several wooden modelling tools, like spatulas, with varying ends. 'They'd have used something of the sort twelve hundred years or more ago, only made of bamboo,' he pointed out. Then

he began from the top downwards, cutting away the clay and modelling in stages. Before long I began to detect the shape of the horse's head and mane. Next he made a large hollow in the horse's back and filled it with screwed up paper. 'You'll see why later,' he murmured. He sealed the hole up again and added another lump of clay on top which he proceeded to model into saddle and rider. 'Come back in two or three hours,' he said.

When I returned he had cut the clay away to give the rough shape of a back leg and was shaving away at it bit by bit. I gasped. 'Bit slow, this part,' he muttered, as each leg in turn began to take shape. At last he levelled the clay remaining on the shelf to create a plinth, carefully working round the hooves attached to it.

An inch and a half diameter column still remained under the horse's stomach. 'You can't risk putting any weight on the legs while the clay is still wet, or they might buckle,' he warned. 'That's why you often get figures made in several pieces and then joined together. But if it's all in one, it's stronger.'

Finally he disappeared to the bathroom and came back with a damp sponge with which he wiped the figure down, and we left it drying.

The next day he announced the horse had become 'green'. He meant that the clay was neither soft nor properly dry. This was the crucial moment. He picked up a very sharp scalpel and gingerly took a sliver off the top of the column so the horse was resting on its own legs, but only just. I held my breath. He paused, nodded in satisfaction and neatly removed the rest, touching up the underbelly and base with a tool and sponge. In place of the column he fixed a pot stilt normally used for holding up shelves in the kiln. It wouldn't stick to the clay of the horse, he said, because, like the shelf, it was made of very high-fired pot. Then he said the figure must dry for a couple of days. Before I left he made two tiny holes in the horse's body. 'To prevent it exploding,' he explained. He had modelled it around the ball of paper so it would not be too heavy, but the paper would burn away when the horse was fired.

Two days later I found him scrutinising the photograph and modelling the horse all over again. The colour came next, liquid clay mixed with an oxide which he brushed over the figure. The oxides were in powder form – tin, copper and cobalt creating the bluish hue of the horse, copper for the rider's green robes, their yellow trim from lead and the brown hair and shoes from iron. The face and hands he scrupulously avoided. They 'often left the features as if half-finished,' he remarked. Cobalt blue

was a colour favoured by the wealthy nobility for their burial wares. It was expensive, imported to China from Persia by merchants travelling the ancient silk routes through hostile country to secure the rare mineral.

Then he told me I'd have to wait another week for the horse to become bone dry, before we could take it to the kiln.

'Do you want to carry it or drive?' he enquired, when I returned.

I gave the horse a nervous glance and drove. The kiln he used was at a pottery owned by a friend in a village a few miles away. The roads were winding and potholed from mining subsidence. I gripped the wheel tighter over every bump.

'Just pop it down over there,' said the friend casually, when we arrived. 'It can go in with the commemorative stuff. Did you see Prince Charles on the box last night? What a load of old cobblers. I reckon I could paint better than that. And that's saying something. About 105°C for the biscuit firing, OK?'

'Will it be all right?' I couldn't help asking as we left. It stood a better chance than in the process used by the Chinese to fire their clay figures, I was informed drily. They would put the figures and other pieces in the middle of a hollowed-out bank and surround them with wood. The end was sealed when the wood was in place and a small gap was left for a draught. The problem was that holes had to be made along the sides of the bank so that more wood could be pushed in to keep the fire burning, but this caused 20 per cent of the new pots to be broken. The rest, however, were beautiful.

The following weekend the horse was back in the artist's studio. I puzzled over the lack of colour. 'Well, it isn't glazed yet,' he said, as he pressed a runny paste through a fine sieve – a felspar mix, like that used by the Chinese. Slowly he poured it over horse and rider, again avoiding the face and hands and also the underside of the plinth. The figure was to go back into the kiln in a few days to be fired again, this time up to 135°C and then left where it was to cool.

'Come to the pottery next weekend,' he suggested.

When we walked in, the potter was getting up from the wheel where he had been giving a local women's group a demonstration. The horse was standing on a nearby table and one of them paused over it.

'It's very, very old,' remarked the potter, 'isn't it?' He glanced at me.

'I thought it was. It's lovely,' she replied.

The colours had appeared as if by magic, the streaks of Rockingham clay showing through perfectly. One proposal had been to rub lamp-

black, which the Victorians used for their stoves, on to the figure and
then bury it in a compost heap at the bottom of the garden until the
following year. The chemicals in the compost would attack the surface
of the horse and do nasty little things to it, I was assured, to age it.
Then, the artist said, he would send it to one of the salerooms as a test.
Like Keating. A real T'ang horse could fetch tens of thousands of pounds.
'Might take them down a peg or two. They can put on all the airs and
graces they like. But it doesn't mean they know what they're talking
about.'

However, when I admired the horse, he handed it to me instead.

'What about your plan?' I asked.

'It doesn't matter. You like the horse. And I could always do another.
Or maybe a camel? Perhaps you could find me one in a catalogue some
time?'

The auction illusion

Thus grew the tale of Wonderland . . .
Its quaint events were hammered out.

David Bathurst, who is the son of the late Viscount Bledisloe and was Christie's top man, had, I felt, some explaining to do.

One May evening in 1981 Christie's had auctioned an anonymous collection of eight impressionist paintings at their Park Avenue saleroom in New York. There were two van Goghs, a Morisot, a Cézanne, a Renoir, a Monet, some Gauguin mangoes and Degas's well-known portrait of Eugène Manet, younger brother of the painter Edouard, sitting on the dunes by the sea. It had been a present from the artist to Eugène and Berthe Morisot when they got married in 1874 and was meant to remind them of their engagement at Boulogne. Each painting had been valued at $1 million or more. The collection was followed by other impressionist and later works including eight pictures by René Magritte which had decorated a restaurant. The Belgian government, I had been told, insisted the Magrittes be sold as one lot.

Bathurst was then Christie's New York president. He was friendly with Henry Ford, and the previous year, after his divorce, Ford had sold ten impressionists at Christie's and they had fetched over $25 million. This evening all the right people appeared to be there. The saleroom was overflowing with immaculate coiffures and sparkling stones. A heady incense of Dior and Givenchy mixed with the tension as millionaires from all around the world jostled for seats. Those who weren't intent on buying were anxious, eager to see their own last season's investments grow as prices for similar pictures rose.

Then there was a sudden stillness as David Bathurst took the rostrum and raised his hand. I watched from near the back as bidding began. Or seemed to.

I had never found it easy to spot the uplift of an eyebrow or tweak of a tie, dab of a hankie or tap of a pencil that meant someone was willing to part with hundreds of thousands of pounds. So it was no surprise that I could not tell if it was a rich Texan or fidgeting Greek or anyone else in the room who was bidding. It was made harder, of course, by the number of clients who bid invisibly on the end of a telephone via a member of Christie's staff and might be listening anywhere from Japan to a neighbouring room. Then there were those who left bids *in absentia* entirely and those who didn't exist at all except on a convenient wall or chandelier. These were the ghosts upon whom auctioneers called when only one buyer was bidding and the price level was still below the reserve. There were rumours that sometimes all the bidders were imaginary. But as the reserve price, usually a little under the bottom estimate in the catalogue, was a secret between the vendor and auctioneer, and the auctioneer was not obliged to announce if an item had sold, there was no means of knowing for sure. Irritated dealers frequently accused the auctioneers of 'puffing' the bids in this way so that they would pay more for a subsequent item under the mistaken assumption that a previous one had been bought.

As Bathurst's gavel came down on the first seven pictures the bidders as usual eluded me. The pace was disturbingly slow. I watched, puzzled. But on the eighth, the Degas portrait, the room began to strain. Moments later the record for the artist had been topped. Then it was doubled – $2.2 million. The gavel struck home to a sense of relief. I tried vainly once more to spot the buyer, but Bathurst was already on to the group of Magrittes.

When the auction ended I was baffled. Was it a success? I was pretty sure the Magrittes were unsold. But what about the collection and everything else?

'We sold three,' declared Bathurst, referring to the collection. 'I'd call that a success in the current climate.' The two others besides the Degas were van Gogh's gloriously coloured Mediterranean village street scene, *Mas à Saintes-Maries*, painted in 1888 soon after the artist had moved to the south of France, and Gauguin's *Still Life with Mangoes*, dating from his early years in Tahiti. The buyers of all three, I was informed, insisted on anonymity. The rest of the sale, the Magrittes excepted, had done moderately well.

It was not until four years later that I discovered Bathurst had faked the result. By chance his lie was exposed in a court case in New

York.[1] Only one lot in the collection, the Degas portrait, had actually sold.

When I asked him about this, Bathurst, who in December 1984 had risen to become Christie's London chairman, claimed he had been trying to protect the market from possible collapse. He added: 'It was a very unusual situation. I would not like you to think this happened a lot.'

According to Bathurst, an increase in interest rates had made buyers think twice about paying vast prices. Then he had panicked at what he imagined the newspapers would say.

The owner of the collection and Christie's had since fallen out. The former turned out to be the Lausanne-based art investment group Cristallina SA, whose chief agent was Dimitri Jodidio. He had initially taken a group of pictures out of the bank where they were stored for Cristallina and asked Bathurst to select enough to raise $10 million. He did so and agreed a cut-rate vendor's commission. When the sale went wrong, Jodidio at first appeared to accept the situation and Bathurst's lie. For the lie meant any future private sale of the van Gogh and Gauguin would be much easier than if it were known they had failed to attract a buyer at auction. However, Jodidio eventually took legal action against Christie's for negligence and other damages based on misrepresentation about the way the sale was mounted and the state of the market. This reached the New York Supreme Court, only to be thrown out, resumed on appeal and finally settled out of court. But in the process Bathurst admitted in an affidavit what his lawyer called his 'erroneous' statement about the van Gogh and the Gauguin.

This appalled the New York Department of Consumer Affairs who proceeded to take a keener interest in auction houses. The law in New York was already tighter than in London; owners were not allowed, for instance, to bid for their own works. De Hory's associates had got away with this in the past, giving the forger's work greater credibility by inclusion as the real thing in an important catalogue. But when a London dealer, Kuei Liang, and his wife took a painting called *Plum Blossoms* to Christie's in Park Avenue a year or two after Bathurst's exposure, they were less lucky.

[1] Tony Allen Mills, then a *Daily Telegraph* journalist working in New York, happened to examine an affidavit on a related matter in which Bathurst admitted what he had done. Tony rang me in astonishment and broke the story.

The twenty-five-foot scroll painting had been bought by Liang for a few hundred pounds. He attributed it to Li Fangying, one of the leading Chinese artists of the eighteenth century, and Christie's accepted this when he put it up for sale. Before the auction Liang had approached the Linden Museum in Stuttgart, for whom it appeared he then proceeded to act. When the Christie's sale took place he registered as Chiao Ling Chang of Taiwan and his wife as C. Chang of North Finchley, London. The bidding at that sale was with numbered paddles, which look as ungainly as they sound but make it simpler for an auctioneer to identify buyers. Liang was number six and his wife was number seven, though they sat apart. Between them they bid the picture up to $180,000, which with buyer's commission brought the final price to $198,000, just under the maximum Liang said the museum had indicated it could afford. Unfortunately, the final bid was by the dealer's wife, and Liang was supposed to be acting for the Linden Museum. So they claimed after the auction that their children had been playing with the paddles beforehand and as a result the paddles had got mixed up. Christie's obligingly altered their records. But then the museum said it had not appointed Liang to buy the scroll and the Consumer Affairs Department began to investigate.

Liang said he and his wife had decided to bid against each other to push up the price of the painting to 'establish its reputation' and rebut critics who had called it a fake. 'It was for the painting's honour,' he explained. In fact, it was Christie's who faced being charged with breaking New York City regulations.

An investigation into the London auction market was also triggered by the Bathurst affair. The Director General of Fair Trading, Sir Gordon Borrie, made a visit to New York which he called 'a first step towards new legislation'. But this was hastily forgotten on the grounds that Westminster City Council, under whose jurisdiction the top auction houses come, had already revamped auction regulations. In fact all the council had done was move on fly-by-night auctioneers to neighbouring boroughs.

Ever after the Bathurst business, however, as salerooms reeled off their record prices and success stories, I had a niggling doubt. I began to wonder at the auctioneers' sleight of hand. How often, behind their highly respected façades, were they able to fix the results?

Uneasily I remembered the night in New York when Sotheby's sold the Erna Wolf Dreyfuss collection and Baron Thyssen bid $3.5 million for her Gauguin, *Mata Mua*. It was one of the most important pictures

Gauguin painted when he first went to Tahiti and showed his passion for bright colours, exotic plants, native women and island mythology, though apparently the idol he depicted of the Goddess of the Moon may only have existed in his imagination. One might wonder whether Thyssen would have paid so much for the Gauguin if he weren't on Sotheby's advisory board, anxious to keep up the share price and also liable for a discount. But then, a man of his international reputation and wealth would only have splashed out on such a picture because he loved it.

Likewise, one might ponder whether Alfred Taubman's glamorous wife Judy, a former Miss Israel and, ironically, an ex-Christie's employee, really wanted the over-the-top French furniture collection her husband's firm were reputedly hard put to sell? But the answer had to be yes. For she and her shopping-mall billionaire were stepping seriously up the social ladder.

Then there was the question of discoveries, when a major artwork was overlooked and turned up in a minor sale. 'Bit of bad luck for someone,' a dealer once confided, after two others had fought it out in thousands over an Old Master portrait estimated at a hundred in a West Midlands auction. 'Yes,' I agreed, assuming he meant whoever was outbid, both having anticipated a bargain. Next time I saw him, however, he remarked that people who sent things to auction would do better to know what they were selling. With a little more prompting, I understood. The auctioneer, it seemed, hadn't really made a mistake at all. He was the unlucky one. He knew exactly what the portrait was but had, so my acquaintance believed, deliberately inserted it in an ill-attended minor auction so an associate could buy it for next to nothing. The portrait could then be exported and sold for its true value, probably to an American, and the auctioneer and his associate would split the proceeds.

Did this happen often, I asked? Enough, grunted the dealer.

I began to consider the genuineness of auctioneers' advice. Was it really possible to act for both the vendor and the buyer at the same time? The trustees of the British Rail Pension Fund, for instance, had decided in the early seventies quietly to invest over £40 million in works of art. They had come to a working agreement with Sotheby's whose advice they sought over what to purchase. Secrecy was said to be vital to avoid the manipulation of prices if the fund was known to be an interested buyer. Yet Sotheby's also had a responsibility to their vendors to obtain the highest possible prices. How difficult it must be to advise one client what to acquire, knowing what another client badly wants to sell.

I was starting to understand some of the arguments that still rumbled on about the buyer's premium. The fee which auctioneers charged in addition to the vendor's premium had been introduced some years before I set foot in the salerooms. It meant that the auctioneers took a larger percentage than ever, recently up to a quarter of the full value, on anything they sold, since vendors may be charged up to 10 per cent, and buyers between 10 and 15 per cent. The biggest issue at the time was an accusation that the top auction houses had colluded in introducing the extra fee. But a more pertinent cause for complaint seemed to be their explanation that the fee was for providing the buyer with expert advice – especially given all the disclaimers in their catalogues' small print and the fact that museums, whose expertise was probably called upon by the auction experts in the first place, had to pay the fee too.

So it was difficult to see what buyers were actually getting for the additional payment – although sometimes they could only blame their own stupidity. The most renowned case among experts concerned an English landscape depicting country folk on their way to market. It had been sent for auction at Christie's some time before the buyer's premium was introduced, but I doubted that had prevented similar jokes occurring. When the expert looked at it for cataloguing, he said: 'Oh God, it's a bastard.' First name? enquired his assistant. 'Lawrence,' the expert replied. The bidder who bought it must have had second thoughts, as it was returned to be auctioned again only a few months later. Still under the same name, Lawrence Bastard, it was sold to the London dealers Frost and Reed for 65 guineas.

When Sotheby's ran an advertisement headed 'Capitalise on our Expertise', many dealers turned apoplectic. But most bit their tongues when I asked them why because, it appears, the golden rule of high-class art and antique dealing is not to do anything to give anyone the idea that theirs is not a safe and exclusive world. It would also have demonstrated how much dealers profit by the auctioneers' genuine mistakes. However, these did sometimes filter out, like the little Turner watercolour of Petworth that one dealer, who had a weekend cottage in the vicinity, spotted at Christie's, South Kensington, and snapped up for £50. Or the blunder over a Bernini bust which went for £85 in a house sale held by the same auctioneers and was knocked down two years later at Sotheby's for £120,000.

The auctioneers, of course, are only too ready to trumpet their own discoveries through their extensive publicity machine, of which I soon

found I was a part. There were the masterpieces unearthed in the attic, the Ming saucer left out full of milk for the cat, the old wooden carving that a client's missionary ancestor had brought back from Africa and which had languished for years at the back of the garage. The permutations were endless. In the beginning I believed they were always based on a strong element of truth. But as the boom in antiques escalated, helped by television as well as the auctioneers, I started to suspect some items were being imaginatively 'discovered', the better to publicise them. Stories were easy enough to invent and not difficult to pass off when the owner wished to remain anonymous. Moreover, the frequency of these amazing discoveries was immediately forgotten whenever the latest find was deemed likely to be unique.

The auction itself, is pure theatre – or illusion. Peter Wilson in particular – whom all the rest copied – knew the importance of magic and mystery, of captivating his Croesus-rich clients crammed into rows of uncomfortable chairs. Of gravely yet casually mounting the rostrum, dressed in black tie, with a troop of porters as servants. Of giving the slightest of nods from his elevated position to a finger-twitching collector. Of gesturing a benediction above the hushed voices towards the first item reverently held aloft by a porter. Of upping the bidding inexplicably between undetectable competitors, sometimes by hundreds, ultimately by hundreds of thousands of pounds or more a go, while, high above, price levels flashed in half a dozen other currencies simultaneously. Of the extra drama of action by television satellite link. And of the Pinteresque pause that could extract a few more million and create yet another global record.

Regularly Sotheby's and Christie's engaged in battle over record prices. But rarely did anyone question how many were the result of inflation. Or mention that one would-be buyer was perhaps flush with a win at black jack, while his rival was in urgent need of laundering less explainable funds, so the said payment bore little relevance to artist or painting. Or that two collectors left bids *in absentia* without a limit. This was the case when Sotheby's sold a 1928 Steiff bear that was consequently knocked down for £60,000. The teddy, which happened to be dressed as a clown, hardly created a true picture of the market.

But with millions of pounds at stake and Sotheby's and Christie's both eager to get their hands on it, the market seemed less a matter of chance – the supposed test of an item's real worth – than of careful manipulation. Not quite fakery perhaps, but certainly not as straightforward as I first

imagined; for one major collection or single spectacular picture could earn for an auction house in minutes what otherwise might take weeks, even months.

Both major auction houses have a remarkable knowledge of important collections worldwide. Christie's have long been abetted by their royal connections. The staff is always littered with honourables, and Lady Helen Windsor worked on the front counter before becoming an expert in impressionists. Taubman similarly recruited the biggest and wealthiest names he could to put on Sotheby's advisory board, such as Ann Getty, Baron Thyssen, the Infanta Pilar de Borbón, Anne Ford Johnson and Sir Angus Ogilvy. He also managed to lure Lord Gowrie, former Arts Minister, to run his London operation: Christie's then countered by snaffling the obliging former Foreign Secretary, Lord Carrington. Few could better either for personal contacts, though some said Gowrie was too clever for his own good when he boasted of the £75 Hockney he had bought on behalf of Balliol College, Oxford, in 1962 which, had the college had the sense to keep it, would have been worth nearer a million today. I warmed more to Carrington when he glanced around him one glittering evening with a deprecating smile and remarked that *Alice in Wonderland* was 'almost my favourite book'.

The obvious way to win a client or a deceased's estate – obituary lists are circulated at Christie's every morning and staff told to keep a watchful eye on ageing clients – was, it seemed, to suggest their art would fetch more than the rival auction house estimated. But the advantage of obtaining a leading collection for sale amounted to more than money and prestige. It was part of a snowball effect. The better the items an auctioneer sells, the better the items he is asked to sell in future. A vendor's fee may be halved or even dropped entirely, and a minimum result guaranteed in order to get a consignment. Thus Sotheby's acquired the impressionist collection of Campbell's Soup heir, John T. Dorrance, after apparently assuring him of something over $100 million. Luckily for the auctioneers, the pictures made $135 million and if Sotheby's did their usual deal they would have earned up to 60 per cent of the extra cash raised. Christie's, who always said they would never make such promises, were so mortified that they promptly set up a special guaranteed-prices fund for art sellers with up to £100 million available to fight the next round on an equal par with Sotheby's.

Yet this turned out to be only the tip of the iceberg. Rich clients who want to sell their treasures can ask for part of the cash in advance. If they

don't want to sell, Sotheby's will provide a loan using art as collateral, taking possession only if things go wrong. More pawnbroker than auctioneer, it seemed, though the art in question must be worth $250,000 at least. When Sotheby's announced this as a new standard package, Christie's retorted that they had provided financial services since selling Walpole's collection of Rubenses and Rembrandts to Catherine the Great. But they met individual needs and had no need to advertise. Not long afterwards, however, a glossy leaflet with Christie's distinctive reddish-brown cover arrived in the post offering, should I be a Name, to enable me to use my great art collection, should I have one, as collateral for Funds at Lloyds' purposes.

The risk entailed in lending to vendors or clients who did not intend to sell meant that if the auctioneers were to recoup their money on the goods, they would be auctioning items for themselves. It was rumoured they sometimes did this anyway to help a distressed client, but it hardly made for unbiased salesmen. More questionable still was their move into dealing, Sotheby's buying the leading Manhattan gallery of Pierre Matisse and the wealth of twentieth-century art that went with it, and Christie's muscling in on their long-time King Street neighbours, the coin auctioneers and antique dealers Spink, who actually began in business as pawnbrokers in 1666 and more recently numbered Mick Jagger and Sir Alec Guinness among their clients seeking antique treasures. Could auctioneers act wholeheartedly for other dealers if they were dealers themselves?

The right image, it appeared, was hugely important to the 150 or so owners a year who sold pictures, jewels and furniture at over a million dollars a lot, or houses and collections that were worth much more. Christie's devotees naturally included a strong aristocratic contingent (perhaps the real reason why the Duchess of Windsor's jewels went to Sotheby's), among them the Duke of Devonshire, who periodically sold off Chatsworth drawings, the Marquess of Cholmondeley and the Countess of Sutherland. Sotheby's regulars, on the other hand, included the Duke of Westminster and the Duke of Northumberland, as well as Elton John, Claus von Bulow and tin heir Jaime Ortiz-Patino.

Each house will produce a presentation booklet, even a video, of how they plan to market a treasure, and will fly vendors round the world, looking after them in the best hotels and top casinos – like the American, John Whitney Payson, whom I met hovering in a small upstairs room at Sotheby's in Bond Street. I had negotiated a couple of security guards

before stepping into the semi-darkness of the inner sanctum. Spotlit, rather like an altar, at the other end of the room were van Gogh's *Irises*, teeming manically towards me, electrifying, their blueness intensified by the orange blooms beyond. Van Gogh had come across the irises in the garden of the lunatic asylum at Saint-Rémy where he admitted himself in 1888 in considerable distress, and the flowers had become a focus for his emotion. The painting was among many acquired by Payson's mother, along with the Mets baseball team, after she inherited a fortune, and he had grown up very fond of it. After her death in 1975 her collection had been divided among the family and he had built a small museum to house his share at Westbrook College in Maine. Now he had decided to sell the picture, he explained, because he had seen how much van Gogh's *Sunflowers* had made and he wanted to help various charities. He seemed quiet and deferential, yet eager when asked to talk about his painting, a little overwhelmed by all the fuss. No one seeing him amble down the street would have guessed him to be the owner of what was about to become the world's most expensive picture.

Equating art so visibly with cash or considering it as an alternative to stocks and shares, however, brought about a false level of demand – especially among the Japanese who were desperate to acquire Western chic at virtually any price and were targeted by the auctioneers. The fact that Japanese prints had so influenced the impressionists and their followers was a further encouragement and before long pictures were being bought under multiple ownership, businessmen comparing how many square inches of canvas they owned, preferably of a chocolate-box Renoir. Art spending throughout Japan rocketed to billions of pounds a year and the president of the Daishowa paper company, Ryoei Saito, coolly spent $160 million on a Renoir and a van Gogh at one auction in a matter of minutes. He later explained he had once seen the $82.5 million van Gogh – another new record – of Dr Gachet, the artist's physician, hanging on loan to the Metropolitan Museum in New York. Van Gogh had written that the doctor looked more ill than he did, but Saito so fell in love with the portrait that he vowed, if ever it came on the market, to buy it; then he caused outrage by saying that when he died he would have both paintings cremated with him – though he has since relented and, when I last heard, was building them a sort of temple near Mount Fuji.

But these inflated values were bound to topple. It happened when the Japanese economy took a turn for the worse, art as collateral for loans came under scrutiny and a series of art-related tax scandals embroiled a

number of the biggest art-purchasing companies. Demand suddenly fell away, and so did the unreal high prices.

Yet the greatest manipulation of the art market has resulted from Taubman's policy of lending to wealthy buyers as well as sellers. Art can now be bought on the never-never.

Australian entrepreneur Alan Bond badly wanted to become the owner of van Gogh's *Sunflowers*. But he was pipped at the post because Hajime Abe, a director of the Yasuda Fire & Marine Insurance Company, got talking with the brother of Christie's impressionist director who was also in insurance and staying at the same Tokyo hotel. Abe saw the picture, was smitten, and arrived in London in person determined to buy it. Bond commissioned a dealer to bid for him and Abe got the van Gogh for £24.75 million. Afterwards the Australian said that, had he been in the saleroom too, he would not have been beaten.

So when the Payson *Irises* came up for sale in New York in 1987 Bond was an obvious contender. The trouble was at the time he couldn't afford it. Consequently Sotheby's agreed to let him bid the picture up, once more against a Japanese, until he got it for $53.9 million. The deal was that he put down half the money and paid the rest in instalments. The new world record for a painting, more than backing up the result of the *Sunflowers*, produced a monumental surge in art prices. Yet Bond was unable to complete the payments without relinquishing the picture to the Getty Museum a few years later at a reputed £5 million loss. In the meantime he unveiled his van Gogh amid much celebration in Australia; but it must have been a copy, since I heard the original was being kept strictly under lock and key by Sotheby's until they got the rest of their cash. However, real or not, how could such a purchase represent the true market level?

Has anything really changed since the Bathurst fiasco? The auctioneers are not taking chances on important items any more. Even before a sale is announced they check regular computerised lists of possible buyers, according to taste and financial status, send out photographs and special invitations to view and, if necessary, discreetly give away the name of an anonymous vendor. Museum funds worldwide are scrutinised to see what money they have available. Soundings are taken to learn what export licences may or may not be granted. The state of the stock market, local wars and any relevant major exhibitions are taken into consideration. Finally a handful of expected bidders are identified – for Old Masters perhaps as few as three.

Sometimes it may be even less. Just before Christmas a year or two ago, Sotheby's had been eulogising about a painting they were to auction by Francisco José de Goya y Lucientes, son of a peasant and painter to the Spanish king. Goya had been in Paris settling his financial affairs when he painted the bullfighting scene in 1824. He was in exile from Spain following the reinstatement of the absolute monarchy which he had variously flattered and satirically condemned. He was deaf and suffering moods of black despair, but the bullfighting theme was one of his favourites. Reputedly he had been an amateur toreador in his youth. He daubed this picture very freely with a rag and his fingers and gave it to a fellow Spaniard, in whose family it had remained.

The atmosphere in the auction room, hit like the rest by the recession, seemed the more tense and sober for the twinkling of angels and holly berries outside. For once I spotted a slight movement of a hand in the audience. 'It's George Goldner from the Getty. See his sleepy eyes,' whispered a voice in my ear, as one of Sotheby's staff on the telephone raised the bid again with a nod towards the rostrum. 'At £4.5 million . . . at 4.5 . . . at 4.5 million . . .' The gavel came down to Goldner, who smiled momentarily and shifted a fraction in his seat.

Afterwards he said that the Getty Museum had only one other Goya, a portrait of the Marquesa de Santiago. Moreover, this picture, the museum felt, was exceptional. He was very happy. Goyas were not easy to come by, certainly not such good ones – especially given the strict controls on any leaving Spain. It was the last of the artist's later bullfighting scenes still in private hands.

Some time later I spoke to Sotheby's Old Master expert Hugh Brigstocke. I asked him how good an idea he had before an auction about where a major painting would go.

'Take the Goya,' he said. Of those institutions that he knew wanted it, 'the Prado couldn't afford it, Fort Worth had just splashed out on something else, and the result was it went to the Getty. Of course, the real problem for any auctioneer is if all those who could and would buy have just diverted their funds elsewhere.'

Or got cold feet, I thought.

The telephone battle during the sale, I had been informed, was with a bidder through Sotheby's Spanish associate, Edmondo Peel, in Madrid. A wealthy Spaniard, perhaps, who might have left it to the Prado so his own name would also be remembered for posterity? Baron Thyssen seeking to please his Spanish wife? A leading dealer out to remain inconspicuous

by leaving a false foreign trail? Or did the Spanish bidder exist at all? Even though the bidding was within the estimate of £4–6 million, that did not mean it was over the reserve. I had no reason to believe that there was no underbidder. But I had no way of knowing for sure. Only Sotheby's were privy to that. And I couldn't help thinking that, if the Getty Museum only were bidding, was it really an auction at all?

· 7 ·

Van Meegeren's Vermeers

This time there could be no mistake about it: it was neither more nor less than a pig.

The queue was already several people deep all the way round the block when I arrived at Christie's premises in Amsterdam one Sunday in April 1986. Cameras were flashing and a television crew laying cables. The attraction was the preview of the Nanking Cargo which for the last 234 years had been at the bottom of the South China Sea.

The cargo amounted to over 100,000 pieces of blue and white porcelain, as well as some gold bullion. The porcelain was stacked high in a warehouse, like seconds in a Harrods' sale. But Christie's called it treasure since it had come from a wreck, which was much more romantic. As treasure it also sounded far more valuable than it really was. In the doorway a fight broke out as someone tried to jump the queue.

It was as if the original Dutch East India Company auction were actually taking place with virtually the entire china cargo that had been destined for Europe from Canton, except it was to be held by Christie's in the Amsterdam Hilton.

The name of the cargo stemmed from the place where the pottery was transshipped *en route* from the kilns to the waterfront at Canton. The ship was undoubtedly the *Geldermalsen*, which had been recorded sinking after dark on 3 January 1752. Too late the boatswain Urbanus Urbani had spotted waves breaking on a reef ahead of her. As she ran aground, the captain adjusted the sails to carry her off the rocks again but in the confusion set the course the wrong way. A lifeboat and barge were lowered over the side with the second boatswain, Cristoffel van Dijk, in charge and half an hour after midnight the *Geldermalsen* capsized and sank. Only 32 of the 112 people on board survived. After seven days, with only a

barrel of biscuits and a live piglet to keep them going, they reached what is now Jakarta in Indonesia where van Dijk was severely reprimanded for leaving the ship so soon. Details of the sinking are known because officials of the Netherlands' first powerful multinational interrogated him very thoroughly, since he was also under suspicion over the missing gold.

Ironically the 203 chests of porcelain loaded on to the ship – containing 171 dinner services, 63,623 teacups and saucers, 606 vomit pots and much, much more – comprised the secondary cargo. It was mass-produced china intended to meet the conservative tastes of 'foreign devils'. The main commodity, in fact, was 686,997 pounds of tea. This was twelve times more valuable. But the porcelain provided necessary weight and was ideal since it could not taint the tea with nasty odours. It was the tea cocoon, however, which in the end had preserved the porcelain.

Captain Hatcher, who discovered the cargo, greeted me with an amused smile and a flash of gold jewellery. His gamble had paid off. The initial estimate of £3 million for the haul, which he said was approximately the cost of his salvage operation, was rising rapidly. The Dutch government had a major claim on the cargo, but he and his crew could expect 20 per cent of the proceeds. He had been lucky. The wreck was 'not where she was supposed to be' according to the records. He spotted her only by 'two old anchors sticking out of the sand'.

Hatcher had begun looking for wrecks seriously after his accidental discovery of a freetrading Chinese junk a few years earlier. When he and his team had brought that up, it was hailed as a 1640s time-capsule of porcelain which threw new light on an obscure period of Chinese export ware. Scholars were ecstatic. Prices at the ensuing Amsterdam auction were relatively low, since Christie's hadn't seen beyond the dull glaze of Ming porcelain to its greater historic and romantic possibilities. But Hatcher had.

His home is a heavily armed gunboat on the high seas. He is a pirate at heart. 'We are well aware we might be knocked off any time,' Hatcher explained nonchalantly. He lolled back, tapping the desk in his temporary office with a gold pen. He was brought up as a Barnardo's boy, he said, and fell in love with the sea at Newhaven. But he went to work on a farm in Australia and made his first fortune selling barbecue equipment to Aussies. He spent the proceeds sailing the world and made his second fortune salvaging Second World War wrecks in the Far East. Now he had a company and a partner in Singapore, and was looking for much

older wrecks. No one was more successful, he added, with swashbuckling satisfaction.

I met him again at a reception that evening, dodging about among the massed throng of international buyers and the fashionable of Amsterdam. Ladies flitted around him. Several crew members hung near. 'I wouldn't trust him,' one whispered to me under his breath without explanation. The man disappeared shortly afterwards and I never saw him again.

There was a dispute of sorts in progress. I was not sure if it was to do with conservation or the filming of the salvage process – or was it over divers pocketing souvenirs? Hatcher himself had enthused about several magnificent fish dishes. I don't think he cared for much else, though he had been back to the wreck twice after research in the *Geldermalsen*'s records indicated other items that 'had to be there', including two bronze cannon and the ship's bell.

Or was the argument over gold? The ingots were found by chance at the last minute, as divers outside the hull area of the ship were completing a survey of the site. There were 125 solid gold bars, some rectangular about four inches long, others in the form of a 'Nanking shoe', a sort of hemispherical shape that came to be symbolic of wealth itself; for they were acquired in China in exchange for silver bullion and coin and then used to trade in India and elsewhere on the four-month journey home. Judging from where the gold was found, it was probably dropped as it was being transferred from the sinking ship to one of the launches.

The next day Chinamania, the craze which had swept seventeenth-century Europe, took hold once more. The saleroom overflowed. Major dealers strutted prominently, wafting catalogues, while private bidders shuffled anxiously in their seats. A marathon of some 3,000 lots was about to commence.

However, one lot of blue and white china looked to me much the same as another; that is, apart from a few bits of sea-bed encrustation and some incongruous pieces – like the Chinese imitation Meissen of Tyrolean dancers – that would have been stored away separately by senior crew to supplement their salaries. So I sidled out of the auction. I had not discovered the reason for the friction among Hatcher's crew; but a museum curator at the party had revealed that not everyone was as happy as Christie's and the captain, and that a row over salvage rights was brewing.

Amsterdam seemed less capital city than cosy provincial town as I took a taxi across its spider's web of canals towards the Rijksmuseum.

The curator I had met the night before did not want her name mentioned. Her English was more hesitant in cold daylight. However, it transpired that Holland's national museum desperately wanted to bid for the shipwrecked porcelain, which was very important to the country's history. But if it did, that would amount to sanctioning the plunder of a major archaeological site, even if it were on the bottom of the South China Sea.

Yet if Hatcher hadn't rescued the porcelain no one would have had any at all – except the fishes. I didn't understand. And it could hardly be plunder, since the Dutch government was involved. Had anything been stolen, I enquired?

Oh, no, it wasn't that, she replied. The point was that historians believed a mass of otherwise unobtainable evidence about life on board had been destroyed. Little is known about vessels such as this one since very few were lost at that time. Historians thought more research should have been done while retrieving the cargo, or even that the *Geldermalsen* might have been brought to the surface because if so much had survived it was probably relatively intact. Alas, the finds hadn't even been registered systematically. The divers claimed there had not been enough time.

I commiserated. She shrugged. 'What can you do? The government won't fund such work. I am afraid I cannot be of much help to you.' Then she brightened. 'Maybe you have time to see something of our museum while you are here?'

The auction session, I guessed, would be a long one. So I headed for the Rijksmuseum's Rembrandt rooms and the *Night Watch*. Probably Rembrandt van Rijn's most famous picture, it had been restored after being slashed several years earlier. A mass of other visitors, however, had had the same idea. A feverish crowd clustered in front of the canvas, scarcely any having the chance of a proper view. Such is the appreciation for the legendary Old Master as the genial bohemian, friend to beggars and lover of a wild and extravagant lifestyle who rebelled against society by failing to marry two successive mistresses and ended in a pauper's grave in 1669.

Rembrandt is now beyond reproach. Yet some of his paintings had lately been called into question. This was due to an overenthusiasm of attributions which earlier this century totalled 1,000 paintings and 2,000

drawings. Current thinking by a group of Dutch experts calling themselves the Rembrandt Research Project, who were attempting to distinguish the real masterpieces from the dross by pupils and followers, had reduced the figures to less than half. They were far from finished and had already caused considerable outrage.

Rembrandt himself would probably be laughing at the havoc this was causing among just the sort of people who disapproved of him. Millions of pounds were at stake, as pictures were downgraded from Berlin to New York. Values plummeted overnight as they were reattributed to a pupil or imitator. Even the Queen's *Bust of a Young Man in a Turban* was reassigned in 1986 to Rembrandt's apprentice, Isack Jouderville. Their demotion was almost as bad as announcing they were fake.

The tests, of course, were much the same. Wood panelling was scrutinised not just for the date but to pinpoint which paintings were done on oak from the same tree. Canvases underwent thread counts to see if they were from the same bale of linen. X-rays were taken to ascertain how a composition was built up and how many errors and alterations the artist hid with fresh paint; microscopic samples of paint were taken to discover its make-up. But really this proved nothing except that the paintings were of the period, since Rembrandt ran a studio of twenty or so pupils and assistants, all of whom were obliged to copy his methods and style, and all of whom used the same models and materials. Moreover, Rembrandt would add his own signature to any studio work he approved to enhance its selling price, of which he got a cut. On top of this, the project seemed to be ignoring the human aspect of a miller's son turned famous artist, trying out different styles, changing his mind or just having a bad hangover – quite apart from his development from smoothly handled paint as a twenty-three-year-old to a rougher, more expressive approach before he died over forty years later.

The controversy was on a similar scale to that of the disputed Corots. A regular dealers' joke, with slight variation, was that of 700 proven Corots 8,000 are in America. It was sometimes applied to Boucher or Picasso. In each case it was claimed that the master couldn't resist touching up a pupil's work, at which point the latter would say: 'Oh, you've finished it so beautifully, won't you sign it?'

Among the Rijksmuseum's other most precious treasures, according to my guidebook, was its Vermeers. But only a couple of Americans were hovering in front of Johannes Vermeer's *Street in Delft*, apart from a student sketching on an art pad. I had to look closely, as Vermeer's

pictures are small and detailed, and this scene was unusual, since he concentrated mostly on interiors enlivened by figures busy with domestic chores or sometimes playing a musical instrument. Reproductions I had seen were dull and uninspiring, but in the original this picture had a jewel-like quality.

Little is known about Vermeer's life, except that he was born in 1632, married in 1653, had eleven children, was twice elected dean of the Delft Guild and died in 1675 leaving his widow considerably in debt. Only about forty pictures have been definitely attributed to him but although he apparently worked slowly, painting tiny sections at a time, he presumably produced more than that in a career of over twenty years. What has become of the rest is a puzzle.

The mystery of Vermeer's missing pictures is one that appealed to another Dutchman, Han van Meegeren, some of whose fakes had also been acquired by the Rijksmuseum and had become so notorious I expected to find them on show. But I could not spot them.

Van Meegeren, actually christened Henri, was born in 1889 in Deventer where his dictatorial father was a teacher. A sickly child, he secretly entertained himself by drawing. But one day his father discovered the sketches and burnt them. Naturally the youngster began to hate authority. Shortly afterwards he saw a key protruding from the door of the local police station and his anti-establishment career began. He quietly locked the door and threw away the key. Then he watched the spectacle from a distance as embarrassed policemen climbed out of the windows in front of a sniggering crowd.[1]

At school a teacher who was obsessive about Old Masters took van Meegeren under his wing and finally the boy was allowed to study architecture at Delft University. Free of his father, van Meegeren turned to painting and married his first wife, Anna, who was part Sumatran. His life then became a see-saw of highs and lows, one moment a prize-winning artist, then as soon forgotten. As war broke out in 1914 he was declared unfit for military service. By that time he also had a family to support but spent money all too easily. Before long he met Jo van Walraven through her husband, an art critic. Jo was an actress and part Spanish and van Meegeren eventually married her after divorcing Anna.

[1] The police-station tale is related in *Three Thousand Years of Deception in Art and Antiques* by Frank Arnau, though it may be apocryphal.

Yet that only meant he had to earn even more and he supplemented portrait painting by doing posters and printing and other advertising jobs. Portraiture is what he felt he was good at. In 1921 he appears to have begun nursing a particular grievance against critics after one had refused to give him a mention; van Meegeren maintained it was because he had failed to bribe the chap. Others said his only merit was in achieving excellent photographic likenesses.

Then one night a friend who was a dealer and restorer told van Meegeren about a fake Rembrandt that Holland's leading connoisseur of Old Masters, Dr Abraham Bredius, had authenticated. His friend had had the Rembrandt forged to get his own back on Bredius who had condemned a Frans Hals which the friend was sure was authentic. Van Meegeren's idea, so he later explained, was to imitate an important Old Master, get it passed as genuine by one or more acknowledged experts and then admit the hoax. Thus he would prove that he, van Meegeren, was likewise a great painter.

Vermeer was the perfect choice.

After first picking the brains of his restorer friend, van Meegeren may have begun his career as a faker as early as 1923. He was probably also encouraged by the exploits of Otto Wacker, sometime dancer and Berlin gallery owner, who earned a reputation for his van Gogh forgeries in the 1920s. Police spent four years assembling a case against him. Yet it was never fully established if he painted the pictures himself or how many of the so-called van Goghs he sold were genuine, how many false. Some say van Meegeren was responsible for a portrait of a laughing cavalier, supposedly by Frans Hals, which was authenticated by the Dutch art historian, Hofstede de Groot. The dealer who spent 50,000 florins on it began legal proceedings after other experts declared the picture modern. But de Groot promptly rescued the portrait and his own reputation by buying it himself.

According to van Meegeren's own account at his trial, he moved to an isolated house at Roquebrune on the Côte d'Azur to pursue the experiments necessary for him to create a convincing Vermeer. He went equipped with an out-of-print volume on Vermeer's technique, a book on oils to help him cheat scientific tests and an old canvas painted in the seventeenth century, a *Raising of Lazarus* which was the right size for his proposed composition, *Christ at Emmaus*. He also bought a large collection of shaving-brushes since Vermeer painted exclusively with badger hair, and a variety of old goblets, candlesticks and other bits and pieces to

form the décor of his picture. He sent to London for lapis lazuli, which he ground in a mortar to provide the celebrated Vermeer blue, and he tried out the effect on paint and varnish of baking his canvases in a kiln. His house, meanwhile, was strewn with flowers, especially elder and lilac, the former producing a useful oil and the latter helping to disguise the nasty smells that were caused by his tests.

Satisfied with his initial experiments, he carefully rubbed all traces of Lazarus from the old canvas – or almost. A few white marks wouldn't budge, so he disguised them in his own picture under the white surface of a tablecloth. Getting the paint to dry and harden was his biggest problem, but bakelite, an early sort of plastic, gave him the answer. He mixed phenol and formaldehyde dissolved in benzine or turpentine with his paints and then baked the result at 105–110°C for a couple of hours. This, he discovered, gave the paint an appearance of solidity equal to centuries of drying. He made four trial attempts. It could be detected, he knew, but who would risk desecrating a Vermeer to find out?

Van Meegeren also acquired a copy of a book published in 1936 on *North and South Netherlandish Painting in the Seventeenth Century* by the director of the Boymans Museum in Rotterdam, Dr Hannema, and a future director of the Rijksmuseum, Dr van Schendel. It not only emphasised the non-Dutch qualities of early Vermeers such as *Christ in the House of Martha and Mary*, but also suggested the existence of other paintings of a similar nature.

To van Meegeren the book was a gift. He was able to use the knowledge of the very people he planned to con and provide them with what they wanted to see.

The Christ figure, he admitted, was a problem, until a beggar turned up out of the blue on his doorstep and agreed to be painted. The final picture had to be distressed to match its apparent age and then van Meegeren took it to an agent in Paris. The artist claimed that it was the heirloom of an aristocratic Italian family of Dutch extraction. Under no circumstances could their name be revealed. The picture was then handed to Dr Bredius for authentication and he was so convinced it was right that he wrote it up as a major early work even before scientific tests passed it. Bredius, who had discovered *Christ in the House of Martha and Mary* in a Scottish collection, was convinced Vermeer must have painted other biblical compositions. Despite a few voices of dissent, Rijksmuseum experts were among his most enthusiastic supporters and badly wanted

the picture. But the painting was acquired for the Boymans Foundation at Rotterdam as a gift from the Rembrandt Association for 550,000 gulden of which van Meegeren received nearly two-thirds. It was the central attraction in a show of 450 classical Dutch masterpieces held to celebrate Queen Wilhelmina's anniversary, and what van Meegeren recalled most delighted him was that it was actually cleaned prior to the exhibition and the restorers never noticed a thing wrong.

Then, however, instead of revealing himself as planned, he bought a palatial villa in Nice. To pay the bills he had to paint another fake, and chose a Pieter de Hooch, an artist whose style was similar to Vermeer's. By the time war broke out in 1939 and he decided to return to Holland, van Meegeren was planning his next Vermeer. First he did a sketch of a head of Christ, aged it and sold it as a *Study for an Unknown Work*. Then he produced the unknown painting itself. Curiously, this went unquestioned. And in the next couple of years he turned out several more, variously spending extravagantly, investing prudently in property, burying his money to hide it, and inadvertently encouraging rumours that he was taking drugs because of his massive mood swings between melancholy and euphoria.

Among his forgeries *The Washing of Christ's Feet* was purchased, on the recommendation of a whole committee of experts, by the Dutch government to placate the Rijksmuseum for not getting *Christ at Emmaus*. It was considered an outstanding Vermeer. But *The Woman taken in Adultery* which sold for 1,650,000 gulden, proved van Meegeren's undoing since this found its way into the collection of Reichsmarschall Hermann Goering.

The problem was that, after the war ended, Allied art commissions were set up to return to their rightful owners paintings and antiques looted by the Germans. When Dutch commissioners were examining Goering's collections[1] they spotted the Vermeer. It was an unknown Vermeer, and they guessed it had come from the Netherlands. But it turned out to have been bought, not stolen. Since it was illegal to export

[1] Frank Arnau also in *Three Thousand Years of Deception* says investigations relating to Goering's artistic possessions repeatedly pointed to Alois Miedl, a German banker who was somehow associated with Goudstikkers, an Amsterdam firm of art dealers. Examination of their accounts showed the painting, *The Woman taken in Adultery*, had passed through the hands of Goering's friend Walter Hofer, Alois Miedl and art dealer Reinstra van Strijvesande, who admitted buying it from van Meegeren.

a work of such importance, anyone who had handed it over to the enemy was not just a criminal but a collaborator.

The painting was traced back to van Meegeren whose studio was on one of the canals at Keizersgracht 321 in Amsterdam. The director of a German firm to whom van Meegeren sold the picture was known as a buyer for Goering although the transaction was not direct. Van Meegeren, who also traded as a dealer, claimed that he had tried to prevent the picture going to Goering, but that he had been given to understand it was in the national interest since the Germans had handed over a collection of Dutch masters in return which, in total, were much more valuable. However, he could not reveal where he had got the painting, other than repeating his story about the anonymous Italian family. He was interviewed by the military police and his refusal to explain the provenance of such an important artwork aroused their curiosity.

The day after his interview he was arrested on suspicion of collaboration. The choice seemed simple: either a possible life sentence for abetting the enemy or a short imprisonment for forgery. Consequently he signed a confession that he had faked fourteen classical Dutch masterpieces (no one is sure even now of the exact number), of which he had put nine on the market and for which he had, after agent's fees, received 5,460,000 gulden.

The magistrate, however, was sure van Meegeren was lying to save himself. The Rijksmuseum experts in restoration declared that a test of the painting technique proved *The Woman taken in Adultery* could not have been done by a modern painter. But van Meegeren confounded them with the details of his crime, such as the location of the underlying white paint in *Christ at Emmaus*. In the end he gave a demonstration in jail. After two months' work without models and in the presence of at least six witnesses representing the court, the public prosecution, the military government, the police and the art world, he painted *Jesus Preaching in the Temple*. On this occasion, however, he did not sign the work with Vermeer's initials.

Holland's top art historians, museum directors and curators, restorers, technical experts, dealers and collectors were all hugely embarrassed. The world at large, on the other hand, turned van Meegeren into a national hero for fooling the enemy and inundated him with painting requests. Because of ill-health he was sentenced to just one year in prison; he died of a heart attack two months later, on 30 December 1947.

In a sense he had achieved what he set out to do. He had become

famous on the strength of his forgeries. The Rijksmuseum deliberately acquired his experimental 'Old Masters' and his work attained a new value. London dealer David Messum who began his career as a cataloguer at Bonhams snapped up a real van Meegeren for 5 shillings in the early 1960s, and sold it a week later for £50, much to the chagrin of his bosses. 'They didn't like employees buying and making money. It was rather a curious picture of a sandwich-board man and I must say I'm quite sorry I sold it now. Though it seemed a fortune at the time.' What most irked Bonhams, however, was that it took a new boy to recognise the forger – and his potential.

Even Hitler was not clever enough to escape a forger's tricks. The Führer relied on his own aesthetic judgement which he considered infallible, since he had intended to be an artist himself. Yet he could not see beyond the subject-matter and technical ability of an artist. One of his favourite painters was Karl Spitzweg who died in 1895. Spitzweg depicted small-town life, representing the Third Reich ideal of rustic simplicity, cleanliness and a happy, wholesome past that never existed. Hitler gave his Economics Minister Hjalmar Schacht one of these pictures as a sixtieth birthday present. It was well known from reproductions, its subject being a mail coach at a frontier, and was entitled *Only Thoughts are Free of Duty*. The astonished minister initially gasped: it couldn't be genuine because that would be expecting too much. Then he realised it was too pristine. Diplomatically he asked, out of interest as a collector, where Hitler had found it.

Informed that Hitler's personal buyer and photographer Heinrich Hoffmann was responsible, the fastidious minister felt compelled to get to the bottom of the affair. So he had experts confirm his suspicions that it was a fake and then went in search of the original, which he found in a senior officer's flat at Regensburg. The difference became even more obvious, both in size and in the fact that the real one was on canvas whereas Hitler's was on a kind of African mahogany not imported until after the artist's death. The colours were also poor, because, it turned out later, the supposed Spitzweg had been copied from a postcard, as were many others. A dealer had bought them from an artist called Toni, removed his signature, mounted them and resold them at 200 per cent profit. But the dealer came unstuck when a Rhineland collector hung one too near a radiator and the picture warped. Close examination aroused suspicion. Hitler's gift to Schacht had been in that collection.

Somewhat surprisingly, the minister informed Hitler that his present
was a fake and the irate Führer ordered it to be re-examined. A few
months later he proclaimed it genuine and a report was promised to this
effect. The certificate never materialised but Hitler's buyer apparently
asked one of the forgers to prepare it.

Like Hitler, many involved in the van Meegeren case, having been
held up to ridicule, retaliated by still trying to prove the Vermeers were
not forgeries at all. Today, after a greater space of time and with fewer
interested parties, the pastiches van Meegeren created out of various
Vermeers seem more obvious. His hallmarks are heavy-lidded eyes, baggy
garments hiding anatomically dubious figures and a lack of variation in
facial types.

When I finally left the reverential corridors of the Rijksmuseum and
returned to the Hilton, the auction session was ending, though there
were another 2,000 or so lots to go during the rest of the week. A babble
of relief surged through the saleroom as bidders eased themselves from
their seats into clusters and made for the doors, eagerly taking stock of
who had got what. 'If he wasn't bidding we began to wonder what was
wrong with the lot,' joked one dealer to me as I passed, gesturing to
rival oriental porcelain specialist Michael Cohen. Estimates had begun to
look ridiculously low as buyers refused to lose out on what Christie's
called an unparalleled opportunity. Cohen alone must have spent over a
million pounds that week. Porcelain went for up to ten times the
auctioneers' expectations; gold bars up to five times' melt value. Captain
Hatcher's coveted fish dishes might as well have been encrusted with
diamonds. Dealers even began buying on from each other as demand back
home at Harrods or at Portobello Road exceeded supply.

Yet away from the Hilton and the hype and the hysteria, some twelve
months later I spotted a small collection of Nanking treasure gathering
dust in a West End dealer's window. Without the romance of the
wreck – £195 for the privilege of taking tea from a Nanking cup and
saucer – it was neither more nor less than regular blue and white
porcelain.

So wasn't the value of the Nanking really fake? Geza von Habsburg,
one of Christie's royals who got away and formed his own auction empire
from Switzerland, attempted a repeat performance in Geneva the
following year. But without a full-blown publicity blitz it was described
by dealers as a disaster. The china was viewed for what it was. Even
Christie's admit that resale of Nanking pieces is patchy.

But Christie's had cornered a lucrative underwater niche in the market, and continued with auctions of gold and jewellery from Spanish galleons. The Vietnamese government approached them about a newly discovered wreck, on the basis of the Hatcher success, and the auctioneers envisaged another Nanking. A nameless trading junk, probably Dutch, had been discovered in the South China Sea after it snagged fishermen's nets 100 miles south of Vung Tau off the coast of Vietnam. The vessel had sunk 300 years earlier with 28,000 pieces of Chinese export porcelain on board *en route* for Jakarta — only this time, instead of loads of usable crockery, the blue and white Chinese porcelain was mostly vases and other decorative wares. It was intended to satisfy the taste for garnitures, as groups of such ornaments are known. These had become all the rage in England as well as on the Continent thanks to Queen Mary[1] at the end of the seventeenth century. It was a fashion which took off again among Victorians, who placed them on the mantelshelf, on the wall, over doorways, and on every available surface, as Whistler depicted in his paintings.

Christie's answer was to create a new cult for such wares with the help of royal cabinet maker Viscount Linley whose career the auctioneers had helped to boost with a show of his furniture, presided over by Princess Margaret, some years earlier. Lord Linley advocated garnitures against a daffodil-yellow background, pointing out their usefulness as oil and spice jars for bathroom or kitchen, and the publicity mayhem began all over again. Harrods joined in by building a shipwreck, and estimates soon looked as silly as those for the Nanking. Bidders paid up to £40,000 for garnitures that until then were as unfashionable as aspidistras. A few months earlier, without the shipwreck factor, one had sold for little more than a fifth of the amount.

The Vietnamese government, just beginning to pursue *doi moi*, their

[1] The French Huguenot architect, designer and engraver, Daniel Marot (1661–1752) was chiefly responsible for the popularisation of oriental porcelain *en masse* for room decoration. Mary Stuart, daughter of James II of England, had been a passionate collector since her arrival in Holland and marriage to the Stadholder William, and she became Marot's greatest patron. Mary enticed him to spend much of his time advising her in England after she and William ascended the English throne. One bedchamber alone at Kensington Palace was adorned with over 200 pieces of porcelain and Delft; while Daniel Defoe, admiring her newly decorated apartments at Hampton Court, remarked 'the like was not then to be seen in England'.

own version of *perestroika*, stood to get £2.6 million in hard currency and possibly imagined untold wealth at the bottom of the ocean. They had already found another wreck, this time full of Ming Thai ceramics off Phu Quoc island and envisaged a handful more by the end of the century. However, if they uncover too many, their seabed treasures might turn out to be about as worthless as van Meegeren's Vermeers.

· 8 ·

A wealth of expertise

She had quite a long argument with the Lory, who at last
. . . would only say, 'I am older than you, and must know
better.'

Jill Sackler was a collector of the most unlucky sort. She was the young
wife of a wealthy but elderly New York businessman who had been
collecting for years. Perhaps because she felt left out – many collectors
liken their collections to mistresses – she determined to assemble a
collection herself. But it had to be something different. Something on
which her husband was not an expert. Unfortunately, on the subject she
chose, neither was she.

I met her in 1987 shortly before her husband, Dr Arthur Sackler, died.
He was voracious in his appetite for American paintings, Renaissance and
earlier Italian pictures, impressionists and post-impressionists, Middle
Eastern and Islamic art, Italian majolica, European terracottas,
Renaissance bronzes, Graeco-Roman sculpture and pre-Columbian art.
He told all who enquired that the catalytic moment was finding a small
Chinese table at a cabinet maker's: 'I came to realise that here was an
aesthetic not commonly appreciated or understood.' Before long he had
the finest collection of ancient Chinese art in the world.

He had made a fortune as a pioneer of biological psychiatry,
investigating the relationship between bodily functions and mental
illness. He had fingers in advertising, publishing, pharmaceuticals and
Boston's State Street Bank, and he was renowned for his generosity. Dr
Sackler lent or gave from his encyclopaedic collections to institutions
worldwide and built and filled museums and medical research centres,
alone or in conjunction with his brothers. His taste was legendary. Yet
he would explain: 'I collect as a biologist. To really understand a

civilisation, a society, you must have a large enough corpus of data.'

His wife's passion became ancient jewellery. Money was not, of course, a problem as she sought to acquire the best. After seven years she had what was widely regarded as the most comprehensive collection anywhere of ancient Near Eastern jewellery. She chose jewellery of the Near East, she declared, since it was so beautiful and because the area was a crossroads through which East and West had 'met and mingled from the most ancient times'. She said she wanted to advance knowledge in this field and share with others through public exhibitions – just like her husband.

A few months before the inauguration of her husband's latest benefaction, a new gallery at the Smithsonian Institution in Washington, Jill Sackler was invited to show her treasures at the Royal Academy in London in the late spring of 1987. Since she was born in Britain, she regarded this as a great compliment. The president, Roger de Grey, was keen on broadening the Academy's exhibitions. He was also anxious to befriend rich patrons who might pay for new galleries, as the Academy is not government funded.

Jill Sackler had taken on an enormous task in forming her collection. Identifying such jewellery and authenticating it required vast knowledge of how it was made and who might originally have worn it, and why – for protection against evil perhaps, as an indication of status or the gift of a lover. Consequently Mrs Sackler enlisted the help of the London-based dealer Dr David Khalili, an Iranian-born Jew, who was noted among Islamic art lovers for his small office in St James's, which would be eerily empty except for maybe a single object of astonishing beauty.

She housed her treasures, hundreds of them, in New York. There were neck rings and seal rings, bracelets and baubles, wreaths and chains and amulets and earrings. Gold and lapis lazuli featured prominently. The former promised eternity while the latter was a widely used stone in the arid lands of Syria and the Levant because its deep blue symbolised water. Some pieces were said to date back to the third millennium BC, and geographically they ranged from the eastern Mediterranean to northern Afghanistan. The collection was mesmerising. Mrs Sackler was delighted, especially when she felt she was pioneering the study of this ancient jewellery. As her collection progressed, she wrote, she was 'surprised and pleased to find myself almost alone in a field virtually devoid of prior scholarship'.

About the same time as the Royal Academy exhibition, I heard rumours

about a scam involving a shipment of ancient Persian gold and silver vessels and jewellery. They were impressively described as belonging to the Scythian, Sassanian and Achaemenid periods. The shipment had come from London and been stored in a New York warehouse for its Iranian owner, Houshang Mahboubian. The authenticity of the treasure was suspect because of a proliferation of Near Eastern fakes, chiefly from Iran. Mahboubian had it vetted, but the expert, a respected professor of Mesopotamian languages, was not an art historian. Then it was stolen. When, subsequently, the shipment was recovered and re-examined by art historians and metallurgists, it was judged to be mostly fake. But the owner and a relation, who had arranged the robbery in order to collect $23 million in insurance money, were tried for theft rather than for dealing in forgeries or falsely declaring the value of the jewellery. Theft was easier to prove than the allegation that the pair knew the items were fake and intended to sell them.

I had become increasingly sceptical of anything ancient since the auction of fake gold antiquities in Zurich in 1982. No one seemed to be immune, especially those with the best of intentions. For instance, Tokyo's smart Mitsukoshii department store, which was keen to promote its reputation as a patron of the arts as well as actually selling the finest artefacts money could buy, was also preparing a show of ancient Persian treasures. Before the exhibition opened a museum researcher, Katsumi Tanabe, who saw the catalogue, warned the store that a gold goblet with a price tag of £450,000 was 'wrong'. Some of the designs on it were back to front and it was square-shaped when it ought to have been long and thin. The original on which it was based was, in fact, in the Iranian National Archaeology Museum in Tehran. Sixth-century BC glassware encrusted white with age also came under scrutiny and several days into the show it was denounced as entirely fake. Certificates of authenticity turned out to be spurious and a firm of Iranian art dealers in New York was blamed. It was said the same dealers, who had fled to the West after the Shah was deposed, were responsible for much of the fake Persian art around.

Mrs Sackler's treasures were installed at the Royal Academy from 1 May to 28 June 1987 under the banner 'Jewels of the Ancients'. The title was reflected in the catalogue by the research of Dr Trudy S. Kawami into what it was fashionable or protocol to wear a couple of thousand years and more ago. A myriad of small gold discs or spangles, she wrote, illustrated the glittering personal ornaments favoured by the people of

Bactria in Afghanistan. Jewellery was not just the prerogative of women, and the Assyrian king, Assurbanipal, liked to wear long earrings when he went hunting. Scythian mercenaries favoured jewellery with boar's head and, less explicably, fish decoration. Temples had great repositories of gems for the adornment of priests, priestesses and the statues of resident deities. Delicate gold wreaths were essential funerary gifts in Syria and Mesopotamia after their conquest by Alexander the Great, as well as being awarded to the winner of any important competition. Jewellery was also a form of currency and many ancient peoples believed jewels gave protection against evil and death. Dr Kawami related the story of the goddess Innana who, in an epic Sumerian poem of the twentieth century BC, journeyed to the Underworld in a bid to rescue her lover. Innana, later known as Ishtar, goddess of love and fertility in what is now southern Iraq, donned her jewels as protection. But at various stages of her descent she was forced to relinquish them, so the deities of the Underworld were able to claim her as a corpse.

Once in the realms of mythology, of course, anything was possible. Legend has it that the first fake antiquities were created in the time of Numa Pompilius, second king of the Romans, who was presented with a shield which fell from heaven. Numa was advised by the goddess Egeria, with whom he had an assignation in a secret grove near Rome, to found the influential Salii priesthood as custodians of the shield. It was to be a symbol of Roman dominion. But crime was flourishing and the king was afraid it might be stolen. However, Egeria suggested he have eleven replicas made, so there was a shield for each of the twelve priests. Numa employed the artist Veturius Mamurius and swore him to secrecy. When even the king could tell no difference between the shields, he had the forger's name incorporated as a tribute in a Salii hymn. Since there was no material fraudulent gain from the replicas, they might be just classed as copies. But on the other hand, the intention was to deceive. There again, the original was supposedly made of celestial material, so how was it that Mamurius had no difficulty in imitating it? Unless, of course, he had forged the original, too.

Dr Kawami was an expert in ancient Near Eastern rock sculptures and architecture and approached the Sackler jewellery in a similar manner, seeking out comparisons with other documented examples. Like the heavy necklaces that bore resemblances to the jewellery of the royal tombs of Ur excavated in the 1930s, which demonstrated the wealth of the ruling elite in the third millennium BC. Or the pomegranate pendants from

tenth-century BC Iran that were larger versions of earrings discovered at Marlik and Hasanlu. And the laurel wreath that was more unusual, both in how it was made and in the purity of the metal, which pointed to an origin outside the major cities of the Aegean, possibly the northern coast of the Black Sea since it was an area of great wealth and a source of other unprecedented finds.

The exhibition glittered. The allure was magical. Even in the relatively low light upon which conservators insisted, it danced and sparkled. There was a romantic, fairy-like quality to much of it and, ahead of me and behind, visitors oohed and ogled. I gasped, too. It glistened so much. What puzzled me was that jewels so delicate as the wreaths or an exquisite gold flower had survived intact for several thousand years – shimmering as if they had been made yesterday. And how could the existence of such treasure, once discovered, have gone unnoticed until now?

Jack Ogden, whom I had asked about the antiquities auction in Zurich, had enquired casually if I knew about the Sackler show. He was president of the Society of Jewellery Historians. He had warned the Royal Academy, he said, before the exhibition opened, stating his 'wariness over the authenticity of some of the items'. The catalogue actually listed, as suggested reading, his book, *Jewellery of the Ancient World*, on ancient jewellery technology.

'Turn to the chapter on fakes,' Ogden instructed, as I flicked through the pages in his flat a few steps from the Academy, and then I saw an acorn. It was, he explained, from the spectacular gold wreath with oak leaves and acorns, on the back of the catalogue. The wreath was said to date from the late fourth to first century BC, to come from the eastern Mediterranean or western Asia, and to be Hellenistic or Seleucid. But Jack Ogden believed otherwise.

'I examined some of the pieces on view several years ago,' he explained. They had done the rounds of likely dealers. This particular acorn, he remarked, was stamped from sheet gold produced with a steel rolling mill. If you had seen it done before, you could tell. In other words – it was modern. The leaves had been cut out with scissors and the whole piece held together with drawn wire which was not known before the tenth century AD.

'Look, why don't you ask one of the other authors recommended? I wouldn't like anyone to think this is personal.'

If authentic, the wreath would have been worth hundreds of thousands of pounds. Once accepted in an exhibition somewhere as prestigious as

the Royal Academy, any doubts about it would decrease and its value increase, whatever the obscurity of its origins.

So I rang Dr Reynold Higgins, author and retired British Museum expert on Greek and Roman jewellery. He thought I was on the right track. 'It is too good or too bad to be true,' he said. 'I find the flashier items particularly disturbing. It is very rash to put on such an exhibition when so much of it is unparalleled. Some of the pieces are not awfully well made for a start.' His former colleagues at the British Museum had turned the exhibition down, though it was not clear why.

One of the world's major collectors of ancient beads is Lady Gloria Dale. I tracked her down in an apartment in Lincoln's Inn. 'If only they'd asked,' she sighed, and went on to denounce the first item, one of the highlights of the exhibition. It was a gaudy gold and lapis lazuli necklace in which oval stone lozenges in sets of three were interspersed with corkscrew-like squiggles of gold, also in threes. 'I've never seen anything like it before.' She shuddered. 'It's very strange indeed.' The piece was catalogued as 'probably Mesopotamia, third millennium BC'.

'Many of the stone and glass beads are misdated by as much as two thousand years,' Lady Gloria declared. One string was pinpointed as the first millennium BC and said to be mostly from western Iran. She claimed, however, it consisted chiefly of Venetian glass, trade beads of the twentieth century.

She picked up a box from a well-polished table. Most of the furnishing was old and beautiful, like the Tudor building in which her rooms were situated. Inside the box were countless tiny beads. She picked one out and then another and another. At first I wondered why they were so special, but then I peered more closely and they began to develop a warmth and sheen as Lady Gloria enthused. And, if you looked at them and handled them enough, it seemed you could identify them by their shapes and holes and by the quality of the material — glass or stone or metal. Even if they turned up out of the blue, the chances were a real expert could place them. How, she lamented, could it be fair to mislead the thousands of members of the public visiting the exhibition and all those students who would later consult the catalogue as source material? How many would ever realise the truth?

When I asked Roger de Grey, however, at the Royal Academy, he insisted that every object in the exhibition had been examined by leading American museum curators. Moreover, the fact that many of the works were unprecedented in their form and technical achievement, he declared,

made it a privilege to show them. I enquired which curators had studied the jewellery, but he didn't know. He said I would have to speak to Dr Kawami or the Sackler Foundation.

Dr Kawami, who had not worked on jewellery of this area and period before, explained that historical allusion and comparison with items already known was the best she could do under the circumstances. The problem was that everything lacked any provenance except for a couple of masks from another collection.

Provenance is a very sticky question regarding antiquities, since most are not allowed out of their country of origin any more. Therefore they are often only available if they have been smuggled. Naturally this means much information about them cannot be provided. Nor is it usually possible to check up.

This is what had landed the Getty Museum in such deep water a little while earlier over its now-infamous *kouros*, a life-size Greek statue of a nude young man. It had reputedly cost the Malibu museum $7 million in 1985 and was supposedly sixth century BC. The curator responsible for acquiring it, Jiri Frel,[1] said it was from the collection of a Swiss family who claimed that it had come from a Greek smuggler in the early thirties. Frel, however, who left the museum shortly afterwards, had been widely criticised over other purchases, the Swiss connection could not be substantiated, and a number of experts declared the *kouros* a fake. Among them was a colourful Roman art restorer who maintained that the statue had been made by Rodin's former assistants in Paris who produced a number of imitation Greek sculptures and explained them away as coming from illicit excavations in the Gulf of Sounion, where genuine pieces had been found.

[1] Frel, a Czechoslovakian refugee, was curator of antiquities at the Getty Museum for eleven years and built up a spectacular collection there by over-valuing donations which owners could offset against tax. He also spent a reputed $12 million on three Greek marble sculptures, most importantly the *kouros*, which many experts believe are fakes. The Getty president Harold Williams admitted during a *Times* investigation that Frel was relieved of his curatorial duties as a result of 'serious violations' of museum regulations. But Williams added that the museum's inquiry in 1984 found 'no evidence of personal gain' on Frel's part. Attempts by *The Times* to pin down the origin of the *kouros* led to Frel naming Dr Jean Lauffenburger of Geneva, who died in 1985, as its former owner. Dr Lauffenburger's cataloguer, Prof. José Dorig of Geneva, knew nothing of the statue. But Frel, tracked down in Rome in 1987, explained he had been secretly shown the *kouros* in the house of Lauffenburger's mistress.

Getty Museum experts put their faith in the dedolomitisation of the sculpture's surface – that is, an alteration in the marble crust that they said could only be achieved by burial for hundreds of years and was impossible to fake. But the marble, which was of a secondary quality, generally used for buildings, might formerly have been part of something else. Moreover, Italian fakers have apparently taken to cooking marble in various secret substances before burying it to achieve the final effect.

Dr Kawami said the ancient jewels had been presented to her by the Sackler Foundation as a vetted collection. It had been shown to the Metropolitan Museum. Despite that, she left out some items about which she had reservations.

The astonishing thing, of course, is just how much is missed by museum experts. Running down the Getty was all very well, a friend at the British Museum pointed out, but had I ever checked the British Museum basement? For instance, what about the Etruscan sarcophagus, a spectacular stone coffin adorned with two sculpted figures and also meant to be sixth century BC? The sarcophagus had turned up as a pile of terracotta bits at the British Museum in the 1870s and, once assembled satisfactorily, had been purchased from the antiquarian, jeweller and restorer Alessandro Castellani of Rome. Claims were made that the inscriptions had been copied from a brooch in the Louvre, that the male and female figures reclining on the lid were unknown in Etruscan art, and that the reliefs on the chest resembled Athenian black-figure vase paintings. In other words, it was a fake. Nevertheless it was published widely as a major example of Etruscan art until the 1930s. Then someone remarked how odd it was that the woman was posing in nineteenth-century underwear.

The Metropolitan Museum in New York also has its share of antiquity department errors – like the Greek goddess by one of Italy's most famous forgers, Alceo Dossena,[1] who reputedly began his career with a wooden

[1] Dossena was born in Cremona in 1878. His creations were snapped up by museums and collectors worldwide who were so devastated by his revelations that they accused him of lying. The first was Paris antiquarian Jakob Hirsch, who travelled to Rome to confront Dossena over a statue of Athena for which he apparently paid 30 million lire. Dossena produced a piece of stone representing the missing fingers which he had 'amputated' to make the sculpture seem old. In 1928 the forger's dealer Alfredo Fasoli attempted to save himself from Dossena's accusations by countering with claims that Dossena was an antifascist agitator. Dossena enlisted one of Mussolini's friends, Farinacci, secretary of the Fascist Party, to defend him and neither case came to anything. Meanwhile other dealers involved

Madonna he carved in his off-duty hours as a soldier in the First World War. When he tried to sell it in order to buy some Christmas presents, he was discovered by a dealer who found Dossena could sculpt virtually anything, archaic or medieval in any material. The goddess might still be on her pedestal today along with many elsewhere if the dealer had not refused to advance the sculptor some money to cover his mistress's funeral. Dossena was so incensed when he later found his sculptures were being sold for over a hundred times what he was being paid for them that he complained to a magistrate and the scandal came out.

Over the Sackler jewels, however, it seemed the Metropolitan Museum was not at fault. When I contacted the Sackler Foundation to learn who had authenticated them, curator Lois Katz replied: 'It was not possible to show the collection to ancient jewellery specialists because I do not believe there are any. Pieces were examined by scientists where possible, and art historians.'

She added: 'When we first thought of the exhibition in 1982, we laid out what we had for Dr Prudence Harper, curator of Ancient Near Eastern Art at the Metropolitan Museum in New York, to look things over.' This was hardly the same thing as authenticating them – especially considering Jack Ogden's stern warning to me when I expressed a liking for ancient jewellery in general that: 'Over half the Hellenistic and Etruscan jewellery out there is fake.'

But at the Royal Academy, Roger de Grey remained unconvinced. He attacked Ogden's credentials, claiming he was not an expert but a well-known dealer and gemologist studying for his PhD, and that he had not, when he first expressed his opinion, examined any of the pieces. Fellow dealer Dr David Khalili, favoured by Mrs Sackler, dismissed Ogden's criticism similarly. 'It's the most magnificent collection of ancient jewellery ever exhibited,' he assured me.

However, after I recounted the controversy in the newspaper for which I was writing, de Grey announced that the Academy had invited scholars to a symposium to discuss items in the show. It was at the suggestion of Dr Sackler, though his wife insisted: 'I would be very, very surprised if any pieces are wrong.'

Footnote Continued: kept well in the background. In *Unmasking the Forger*, David Sox points out how Augusto Jandolo, the Roman antiquarian, relates Dossena's life story in his own memoirs but conveniently leaves out the fact that Dossena's last studio was next door to the Jandolo family's art-dealing headquarters.

The symposium was held at the end of the exhibition, by which time over 30,000 visitors had admired the spectacle. It was organised by the Sackler Foundation, and scholars and curators spent two days examining the jewellery on the basis of stylistic features and techniques used in making it. Only a small number of pieces could be scrutinised in the time available, but it was long enough to reach a unanimous opinion that some items were fake, and some were pastiches of ancient and modern elements and even different regions. The forgeries included major jewels. Some members of the symposium declared the gold-bead necklace on the front of the catalogue, supposedly Parthian of the second century BC, to be fake, as well as the wreath on the back, though certain gold beads might be genuine. All urged minute scientific investigation of anything with no provenance. Surprisingly, given the very short notice and the purported lack of specialists, twenty-four scholars and experts turned up.

Of course, I would not have known any of this if it had depended upon the Royal Academy, for the press were not allowed to attend the symposium; the Academy chose to ignore the findings and simply issued a statement to say that 'useful discussions' had taken place. The show went on to Edinburgh University with some items removed. But the National Gallery of Washington exhibition for the autumn was postponed indefinitely.

I don't know if Mrs Sackler still collects. But three years later, in 1990, I learnt that her main buyer, Dr Khalili, had funded a chair in Islamic Art and Archaeology at London University. He had reputedly given the university £600,000. He was described as 'Dr Nasser David Khalili' and at first I thought I was mistaken, that it was somebody else.

Another two years passed and I read that one of the world's most valuable private art collections worth an estimated £1 billion was being offered to Britain by a reclusive Iranian-born philanthropist. This was the apparently publicity-shy businessman, Dr Khalili, who was having confidential discussions with Whitehall officials about displaying his 20,000 treasures in a museum in London, his adoptive home. His collection, I gathered, included richly illustrated Korans, medieval arms, jewellery, coins and rare ceramics and pictures. It was temporarily in store in warehouses around the world.

When I enquired further I was told that he was an awesome connoisseur. He had bought all the finest works that had come up on the market in recent years. In the trade he was nicknamed the Getty of Islamic art. Among his prizes was the *Universal History of Rashid al-Din*,

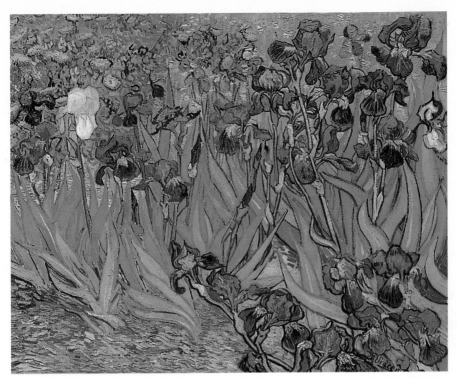

Art on the Never Never. Genuine van Gogh which created an unreal price level in 1987 at $53.9 million. Australian entrepreneur Alan Bond sold on *Irises* before paying off the instalments.

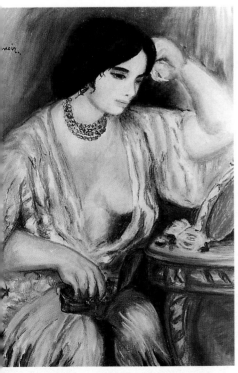

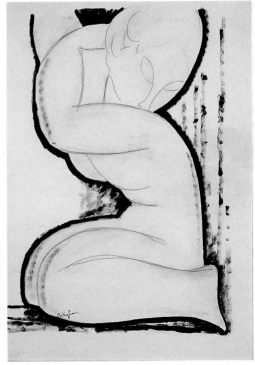

...mous legacy. Elmyr de Hory's *Young Woman with ... and Roses* in the manner of Renoir sold for £8,800 ...1 1990, over 20 years after the faker's exposure.

Imitation unlimited. "I don't think there's anyone in the art world who knows more about Modigliani than I do," wrote de Hory.

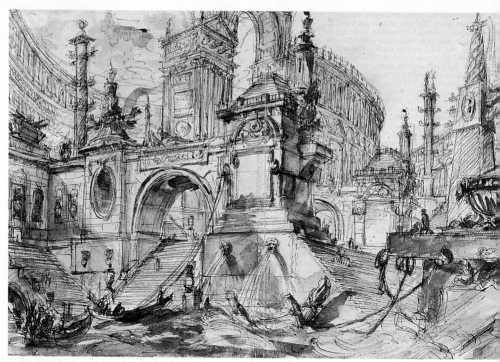

Who knows? A Piranesi authenticated by Anthony Blunt, art expert as well as spy, and bought for $14,000 1969 by the National Museum of Denmark. Blunt's friend, faker Eric Hebborn says it is one of his.

Double bluff. Hebborn provided an unrecorded preparatory sketch (left) for a soldier's helmet in Poussin *Crucifixion* using a Ghisi engraving (detail, right) he believed Poussin copied, but with enough mistakes to r Blunt doubtful. So a dealer Blunt had antagonised snapped it up as unquestionably 'right'.

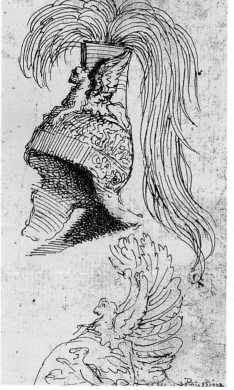

Obvious clue. Tom Keating's pastiche of Turner's *Fighting Temeraire*. Sold for a record £26,400 in 1990 to Eric Smith, an East Anglian builder who had seen a television programme on Keating. In the corner of the canvas Keating depicted himself being bundled away by two peelers up the harbour steps.

Publicity stunt. *Still Life with Pears* by Bruno Hat whose work was mysteriously 'discovered' in the 1930s and exhibited as a hoax to launch the artistic career of the perpetrator Brian Howard, model for Evelyn Waugh's Anthony Blanche of *Brideshead Revisited*.

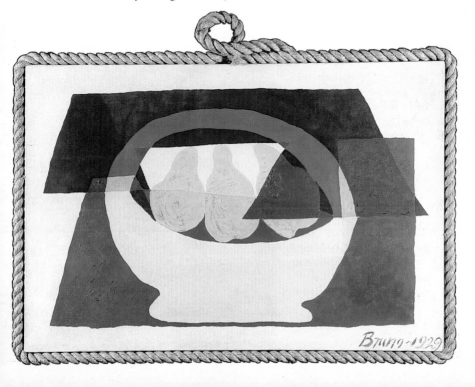

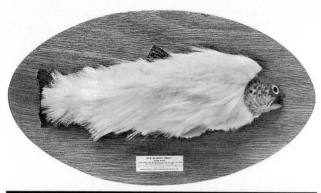

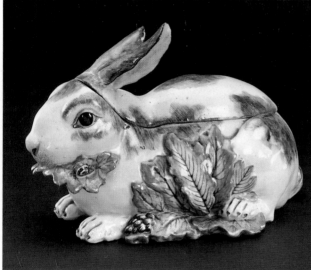

Top: Beyond belief. The Furry Fish which the Royal Scottish Museum had to forge because of popular demand after a curator rejected the original Canadian fake.

Above: Con men all. The 19th century Samson porcelain rabbit tureen, purporting to be 18th century Chelsea, which thieves stole from Sotheby's Black Museum. Did they sell it for £25,000 or its real worth of £700?

Right: Fairytale gold. The impossible Vespasian necklace and two miniature gold vases, one catalogued as third century (*middle*), the other as ninth (*far right*), both apparently by the same maker, part of a collection of fake gold antiquities auctioned in Zurich in 1982.

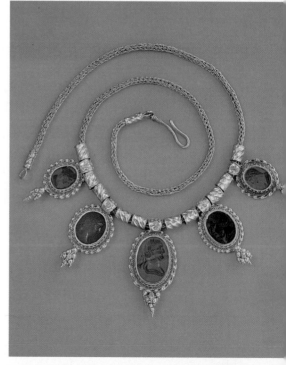

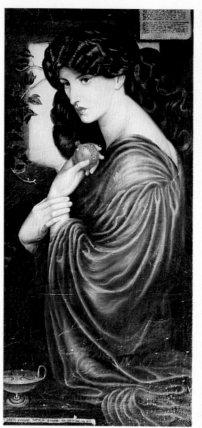

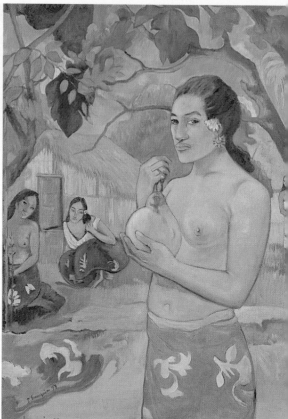

Above left: Pretty walls. Spaniard Miguel Canals, a former wallpaper designer, has discovered more profit in ing attractive paintings like Rossetti's *Proserpine*.

Above right: Safe secret. Copyist Susie Ray has become such a dab hand at Gauguins that her work is destir fill Tahiti's Gauguin museum.

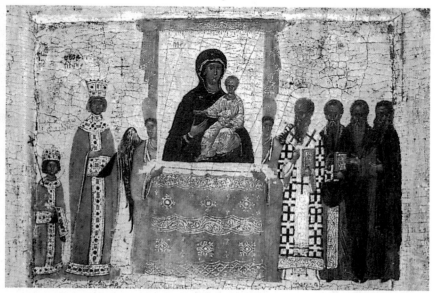

Divine copies. The icon of Hodeghetria or 'She who shows the Way', said to be original-ly portrayed by St Luke and imitated ever since as closely as possible. One version saved Constantinople; another halted Napoleon.

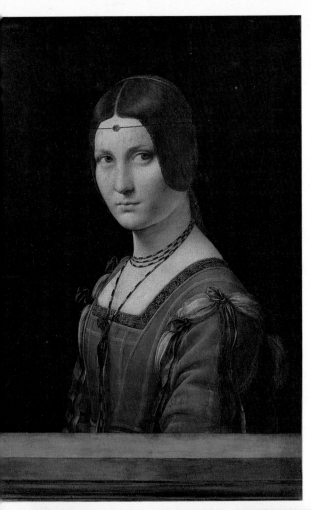

Left: Genuine or not? Leonardo Da Vinci's *La Belle Ferronnière* in the Louvre, the subject of controversy for most of this century after a similar painting came to light in Kansas.

Below: Original fantasy. The Helen of Troy necklace Carlo Giuliano designed for Victorian artist Sir Edward Poynter's model to wear, improving on that discovered by German archaeologist Heinrich Schliemann which was insufficiently heroic.

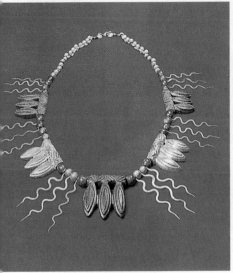

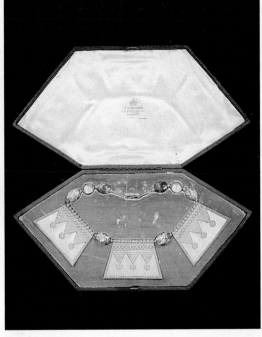

e: Too good. A lapis necklace with undulating rays, catalogued in the Sackler exhibition at the l Academy as probably Mesopotamia third mil-ium BC, but without precedent.

Supplying demand. A sarcophagus sold to the British Museum last century and widely regarded as a major example of Etruscan art until someone in the 1930s asked why the woman reclining on the lid was wearing Victorian undies.

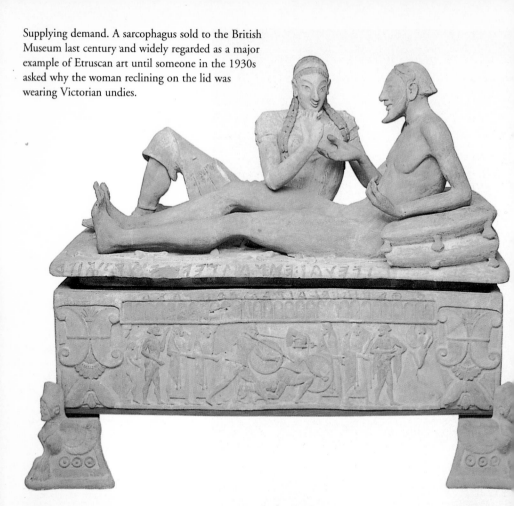

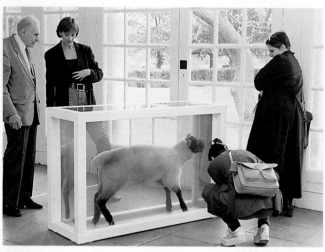

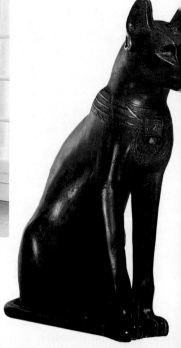

Above: Animal or art? Damien Hirst's pickled sheep, sold to a collector in 1994 for £25,000.

Right: Ad infinitum. A bronze Egyptian cat dating from about 600 BC, the living form of the goddess Bastet and a favourite reproduction at the British Museum to which it was presented in 1939.

one of the most important medieval manuscripts in existence, worth perhaps £12 million. He had missed it at auction but bided his time and at last persuaded the buyer to part with it. The story was that the collection had been started by Dr Khalili's family who were art dealers in Tehran and financed by dealing in art, commodities and property. Dr Khalili, the fourth-generation collector, had left Iran in 1967 to become an American citizen and eventually to settle in London.

His idea, it seemed, was to display his treasures in their own museum in central London at the expense of the British government for a trial period of fifteen years before concluding a deal to exhibit permanently. He was said to have contributed substantially to the Conservative Party and had enlisted the support of Lord Young of Graffham, a former Trade and Industry Secretary. Dr Khalili made him chairman of the Nour Foundation, which he had set up to look after the collection, and launched his proposal with a party intriguingly held at the Foreign Office attended by forty ambassadors and the Foreign Secretary, Douglas Hurd. The billionaire, as it appeared he must be, was slight, immaculately attired, and wore large, owlish spectacles. He had obtained the assistance of Sir Tim Bell's Tory election-winning PR company and, to explain his great munificence, declared: 'I had a vision and with God's help it has been realised.'

Dr Khalili wanted to open the world's eyes to the art of Islam, he said, and to persuade Jews, Christians and Muslims to speak openly to one another and to see clearly the close cultural, social, spiritual and intellectual ties that have existed between them for centuries. His only proviso was that he should retain the freedom to exhibit his collection around the world if he wished and to add to it and sell from it.

His offer was greeted with varying degrees of surprise, jealousy and suspicion among other dealers. Today he describes himself not as a dealer but more as a collector who de-accessions; in other words he sells items when he acquires better ones. Some suggested he was on a big ego trip. Others claimed he was looking for a shop window for his collection, that it was less a case of benefaction than bumping up his investment. And where on earth had quite so much cash come from? It was murmured that he bought on behalf of the Sultan of Brunei and Sheikh Nasser of Kuwait. Since no one seemed able to think of any other explanation, gunrunning and drug dealing were also hazarded in the same breath as computers, but with absolutely no foundation. The mystery deepened. Was this really the same Dr Khalili?

Indeed, was the collection real? Could it be yet more fabulous fakes? I recalled another warning I had been given: if something looks too good to be true, it probably is. I tried to speak to Dr Khalili but I was told he only gave prearranged interviews with specific guidelines. So I turned to various Islamic experts and met an extraordinary silence. The entire collection was being catalogued in twenty-six volumes and for this purpose Dr Khalili had approached the top experts in the field, some forty in all, including most of the leading Islamic specialists in Britain, and asked them to contribute. More than that, to facilitate this he had flown them around the world, with no expense spared. Who could refuse such an offer? Who would risk being left out in the cold? Who would chance a rival expert gaining the lead?

Even the Prince of Wales had been caught in the web. He had been approached to write the foreword to the collection.

The puzzling factor, however, was the money. There was so much of it on tap – almost as if a government rather than a private individual were at work.

Dr Khalili even appeared to have made up any differences with Jack Ogden, who is also now a doctor, and whom I discovered cataloguing Dr Khalili's jewellery. Dr Ogden had politely reworded his view of the Sackler collection to say that only 10-12 per cent of it in numerical terms was fake, which was about on a par with almost any other major collection worldwide. Since the Sackler show he had been invited to go through it piece by piece in New York. Dr Ogden had established the Cambridge Centre for Precious Metal Research, where he can check out purported treasures by testing minimal samples of material almost invisible to the naked eye. He had become the most important person to be reckoned with in the UK if you were trying to pass off forged ancient jewellery – so much so that fakers were liable to turn up for his seminars and some even sent him their forgeries by a circuitous route to learn what mistakes they were making so they could do better next time.

'It's a difficult balance,' he said. 'Do you risk educating forgers or having generations of ignorant museum curators?'

What about the Getty Museum, I asked?

'Well, the *kouros* is a case in point,' replied Dr Ogden. 'They claimed dedolomitisation had occurred because they found calcium on the surface of the figure. But they misinterpreted what they found. In fact when the analysis was rechecked it was discovered the dedolomitisation could be the effect of oxalic acid which would indicate deliberate forgery.'

Detailed comparisons with other *kouroi* and bits of *kouroi*, from tool marks to indications of torsion in the marble, had failed to provide a more definitive answer. Now the Getty was endeavouring to cover its mistake by proving that oxalic acid can occur naturally.

'Of course, a lot of gallery owners will, if they can, give an item the benefit of the doubt. So they may only want to know that the composition of, say, a teapot, is right, not that the decoration on the side includes a bicycle which hadn't been invented at that date.'

Had anything changed since the Sackler exhibition? He laughed. Only that people were more scared of showy pieces and felt happier buying little gold earrings. So, of course, the forgers were now churning out plain gold hoops; and British forgers were having a go at ancient British stuff. The field had expanded. Clever fakers reused old materials, as perhaps for the Getty *kouros*. Ancient-gold necklaces might be forged from melted-down coins. But, Dr Ogden enthused, if you went into something in enough depth you could tell. It was no longer just a matter of spotting a bit of modern solder, but thinking round a problem, minutely. Pure gold is impossible to age-test, but ancient gold was never pure, so you can pick up an alloy pattern for different places and periods. With some antiquities you might examine surface pollution. Or you could identify where the marble of a supposedly Greek statue had come from – and then find the quarry had not been mined before the Renaissance. It was a challenge, he added gleefully.

'Not that you can ever prove anything is genuine, except by elimination,' he warned. 'But you can prove it's not.'

So what about the Khalili jewellery collection? Was he sure of that? Certainly; it was brilliant, he replied. Once it had had a 'bit of weeding' it would be absolutely fine.

In the summer of 1991, some time before Dr Khalili (now also a major Japanese art collector) made his proposition for displaying his Islamic treasures in London, I had been invited to the opening of the Sackler Galleries at the Royal Academy. This was a Sackler donation. It was to the very same institution that had staged Mrs Sackler's 'Jewels of the Ancients' exhibition.

So what about the matter of the fakes? It was almost as if, like Alice, I had been dreaming. Almost.

· 9 ·

Original copies

*'They were learning to draw,' the Dormouse went on,
yawning and rubbing its eyes . . . 'and they
drew all manner of things.'*

Susie Ray had just begun a new Monet when I walked into her studio
behind the Tate Gallery. Gauguins, Modiglianis and a Fantin-Latour
adorned the walls. The new headquarters for MI6 was just visible through
the foliage in the window. 'I'll be with you in a moment,' she said, as
she painstakingly applied a dab of paint, then stepped back and eyed the
canvas critically.

As yet it looked to me like an abstract mess – just a lot of criss-
crossing lines. It bore no resemblance at all to *La Manneporte*, Monet's
spectacular scene of waves breaking through a hole in a promontory of
cliff on the Normandy coast a hundred years or so ago; though it was a
photograph of that work which Susie had beside her.

'I'm not really an artist,' she remarked, adding to my bewilderment.
She said she used to draw flowers for a pittance. 'But as a scientific
illustrator, I spent days at Kew Gardens. I was a hostage to the orchids
or magnolias or some other new hybrid.' If she didn't finish a bloom one
day, it might wilt and the chance would be gone for a whole year. So
she learnt to work fast.

Now she is quickest at Modiglianis. She is Britain's leading copyist
and charges by the hour. She says she'll imitate most artists, copyright
permitting. Mainly she is asked for impressionists. Almost all her copies
take longer than the original. Van Gogh often did four pictures a day in
his last months as a voluntary patient at the asylum at Saint Rémy. Susie's
take five or six weeks to complete. Old Masters much more.

'Yet you still have to get the spontaneity.' Then she grinned. 'You

know van Gogh used to copy Delacroix and Millet for therapeutic relief.'

I examined the Monet photograph and glanced again at the marks on the canvas. 'They're an outline to work from,' she explained. To be accurate she had projected the image from a transparency on to the canvas, rather as if she were looking at holiday snaps. Then she had drawn in the guiding lines from the image. With copying now flourishing from the Canton waterfront to illegal immigrant sweatshops in New York, this is a usual trick among the more serious imitators. The test of a copyist is no longer simply in the correctness of the composition but in the method of painting and attention to detail.

Susie's canvas, she said, was French fine linen. It was stretched to a specified measurement, sealed with rabbit-skin glue and coated with a buff-coloured primer just as Monet would have used. Gauguin's surfaces were much rougher. Occasionally Monet chose mauve but white was taboo. Like black, it was proscribed by impressionists because it was not a pure prismatic colour.

The photograph beside her was a print from an art book. A pile of other reproductions and her own snapshots were on the table. The real Monet is in the Metropolitan Museum, New York, and she had checked out the colours in the reproductions against the original, as well as taking note of the thickness of the paint and how Monet had applied it. Yet her visual research on the artist's technique was already enormous thanks to previous commissions.

Did she ever make a copy without seeing the original?

Only if it was impossible to view it and she felt she knew the artist well enough, she said. 'Then you can get it virtually right. There may be a slight discrepancy in colour, but not noticeably since the two won't be hung side by side.'

Sometimes, however, the most straightforward requests presented unexpected problems. 'There was a chap from Los Angeles who ran a video store and had come over on a house swap. He said to me very aggressively that he knew nothing about art but he had fallen in love with van Gogh's *Starry Night* which is in the Museum of Modern Art in New York.' At first Susie wasn't keen. 'It's one of those paintings that you think you know so well because you've seen them on chocolate boxes and everywhere. But then when you really study them, they're amazing.'

The trouble came when she bought a poster at MOMA and wanted to take it back upstairs into the gallery to compare it with the picture. 'I was told posters weren't allowed,' she said, 'even when I explained why.

So I folded it up to postcard size and put it in my handbag. Two security guards followed me and watched while I opened it up and put it on the ground in front of the painting. The colours in the reproduction were beyond recognition. They didn't do any justice to van Gogh's blues at all. So I took my own photographs and made notes while the guards glowered. They seemed to think I planned to put up the poster and run off with the picture. As if anyone would be fooled.' She sighed.

I watched Susie set to work again on her Monet coastal scene.

'Monet built up layers of paint, sometimes four or five. He gauged it so the paint beneath was still slightly gaggy, to create a textured effect,' Susie continued, concentrating hard. 'So you have to do the same. The colours mustn't look shiny. He never used linseed oil. He soaked his paints on blotting paper overnight to get rid of it. Then he'd write on the back of a picture: "Please do not varnish." He wanted to keep a matt surface. But even the pictures in the Royal Academy exhibition had thin layers of varnish. The excuse was that it was protection. The dealers do it to make the colours sparkle. But they shouldn't.'

I spotted a craggy bit of cliff-side beginning to emerge. Monet's serious pictures, she enthused, were all very thickly daubed because he carried on working on them after he got back to his studio when he had finished painting out of doors. On other occasions he would use his brush almost dry. 'He painted incredibly fast, usually with a cigarette hanging out of his mouth,' added Susie. 'He'd barely even look at the canvas. I can't quite manage that.' But she follows his technique exactly.

She first had a go at imitating Monet and other impressionists in Australia. She had gone on holiday furious at the way in which one design firm had treated her, and she stayed five months. She started doing murals there and then met an Australian woman just back from Paris where she had seen and loved Monet's triptychs. 'She had a big house with huge walls and was bored with Australian contemporary art – though a lot of it is very good. She said, could I do some of Monet's waterlilies on canvas for her? Well, I'd already done *trompe-l'oeil* illusions on walls. So I thought, why not?'

The waterlilies were such a success that the woman's friends began queuing up. So, back home, Susie gambled on renting a studio in Covent Garden and created her own impressionist exhibition. It was the late eighties and she has no idea how many copies she has made since.

She calls the end result a 'Susie Ray Original' and her copies are stamped to this effect on the back. 'I don't want to deceive anybody,' she declared.

Though Susie adds the artist's signature just as on the genuine work 'because it's all part of the picture'. Monet, she said, would sign his work with the last colour he had on his brush, which more often than not was brown.

The last touch is to age the painting to make it look as though it has been hanging in a smoke-filled study for a hundred years or more. So she rubs in dirt and uses 'some ageing stuff' – but that, she said, was a secret.

How, I wondered, did she feel about the pictures after researching them so intimately? One New York painter, Mike Bidlo,[1] who copied Picassos, Kandinskys and many more on a scale larger than the original, was known for declaring: 'They are other people's paintings but they became mine through osmosis . . . In some strange way I have been able to take possession of them.'

Susie laughed. She was painting with a meticulousness I guessed was obsessive. 'I have no illusions about taking on the persona of the artist whose work I'm copying. But when I go round a gallery and see pictures I've copied, it's like meeting old friends. Yet get a nice feeling of familiarity and you think the paintings are yours.'

Generally she only does one copy of a given picture. 'You're liable to lose concentration if you've done something before,' she pointed out. But she was about to make an exception. 'I had a call from a dealer in Bond Street. His client is buying a Corot and wants two copies because he has two houses and will have to keep the original in the bank. I got all excited because I thought a Corot would be nice. Usually when I think that it turns out to be something dreadful. But it's not. It's going to be a great one to do.'

Many other owners faced with high insurance premiums have also turned to Susie, while consigning the real thing to the safety of a vault. Yet even Susie's work is hardly cheap at £5,000 and more a picture. Some buyers, on the other hand, fall in love with a painting but can't afford the original. Others are simply after status, and they commission a little-known work by a famous artist and hang it just out of reach.

[1] Bidlo himself truly represented late eighties New York with these paintings which were promoted by the Leo Castelli gallery. Interviewed for Channel 4 television, Bidlo said: 'My Kandinsky can function as a Kandinsky but it has another level of meaning because it is a Bidlo. In other words, two for the price of one.'

Then there are the art lovers who know they will never get their hands on the original, even if they have the cash, because it is round the corner in the Tate; or, in the case of a retired security guard, in the Rockefeller collection. 'He'd always loved a particular Monet,' said Susie. 'He missed it so much that he came to me. But he was too embarrassed to ask if he could have the original copied. In the end I found another very similar painting of a woman in a garden and copied that instead and he was happy.'

Even major collectors such as former US ambassador Walter Annenberg have admitted they are not averse to having copies of important works to fill the gaps on their walls. So could a copy be just as good? Did it actually matter if a painting was genuine or not? And, if it didn't, why pay a hundred times as much just for the sake of an authentic signature?

Susie smiled. Discretion, it seems, is often the better part of copying and the recession has actually proved a boon. As she remarked: 'One American couple wanted me to copy a painting because the original was going to a buyer in Japan and they planned to make the switch without the rest of the family knowing.' Then there was the car magnate who wanted copies because he had been forced to sell his favourite pictures; and the family heirlooms that didn't quite fit a smaller house, like the eighteen foot-wide, eighteenth-century hunting portrait, depicting the children of the Lycett Green family, which Susie had to scale down to a third of its real size to fit into a descendant's home.

Yet there are some pictures that Susie won't touch. 'Certain Renoirs, for instance. The colours are stunning. But they are so strong that if I ever did a painting like that I would be told it was too bright, that it looked wrong. There are some Gauguins, too, which I would never do. The problem is, Gauguin couldn't paint faces and hands. So I have to avoid works in which they feature prominently or else people would think it was my fault and I hadn't painted them properly.'

She refused to do Monet's magnificent portrait of Madame Gaudibert in green satin when the client asked her to substitute his wife's head. But the most surprising request was for 200 Arab paintings for an Arab who had acquired two massive properties in the UK.

'Couldn't he just buy them?' I asked.

'He was prepared to spend a fortune on gold-leaf, hand-carved frames. But not on actual paintings. Not on art,' she said indignantly. She was doing one for curiosity value. The other 199 he would have to find elsewhere.

Casting an eye round her studio, I had never seen better imitations. The difficulty most copyists and forgers have is that they believe themselves talented artists who haven't been recognised, so some influence of their own creeps into the picture. Susie's biggest headache, she said, had been over a Stubbs which her client wanted to look darker. She darkened it and he wanted it darker still. So she darkened it some more. 'Then it was too dark for him,' she lamented, 'and I had to get in a restorer.'

Before I left I inquired whether, since she cared so much about the paintings, she had any qualms about her profession – about being a party to the market in sham which had grown in an unprecedented manner ever since van Gogh's *Sunflowers* started impressionist prices rocketing?

Susie replied that copying was traditional. It was the way to learn. Students always used to do it, and, she said, still should. The best ones did. Monet's early works, she added, look like Manet because he imitated him, while Pissarro and Monet were so much influenced by each other that in some cases, if you didn't know from the signature, their work was virtually interchangeable.

In the East, copying had always been a particularly strong tradition. It was a form of flattery. In fact in China it had led to one of the UK's more unusual trade projects in the mid-eighties as Peking endeavoured to open up the country to the West. The project was to make and sell copies of the archaic bronzes in the Palace Museum collection with the help of Western technology, and it stirred up something of a hornet's nest.

Britain became involved after the Chinese Ministry of Cultural Relics approached Lord Carrick, then chairman of Bowater's, when he was trying to drum up business in Peking. The idea was to create identical copies of the bronzes, down to every flaw and blemish in patination, and thus provide exactly the same aesthetic experience. However, they would cost collectors only a fraction of the price of the originals, were they ever to be sold. The Morris Singer foundry near Basingstoke, formerly used by Henry Moore, provided the technology and the job was carried out within the walls of the Forbidden City.

The thirty-two bronzes selected for reproduction ranged from the early Shang period, over 3,500 years ago, to the T'ang Dynasty. Morris Singer reduced the copying process from two years by the old Chinese method to ten days and made over fifty sets for sale, including one to go on show at the National Museum of Wales. But they did so in the face of fierce

controversy. This was not for any moral argument about deception. Each piece was stamped with the Palace Museum's cipher and numbered to indicate it was not authentic. Nor was the furore due to the potentially harmful impact of such copies on the value of the genuine antiquities. The anxiety stemmed from the danger envisaged by Chinese scholars of damaging the original bronzes while making rubber moulds for the copies.

The project was also questionable, however, since it seemed to subscribe to the proliferation of fakes flowing out of China. These were in the wake of genuine ceramics and bronzes from newly discovered burial sites that were being disturbed by construction work in the push to modernise the country. Forgeries which simulated age with the help of acid and mud were smuggled out with genuine items through Macao and Hong Kong. Some were also found in government tourist shops.

Few Westerners had ever seen the palace bronzes. However, Julian Thompson, then chairman of Sotheby's in London and an authority on Chinese art, was among the connoisseurs who had. He said the copies were very good, the difference scarcely discernible except to the experienced eye. Yet he remarked that he had seen better fakes that had been made in Shanghai and Japan fifty years or more earlier.

Religious veneration, moreover, has frequently encouraged the custom of copying. In Japan temple figures produced hundreds of years ago are currently being made with traditional tools and techniques in order to ensure the preservation of the image and for display in the rapidly growing number of Japanese museums. Likewise Hindu figures made in India today may appear virtually identical to those created centuries ago. The god Shiva, for instance, is frequently represented as Nataraja or Lord of the Dance in exactly the same position surrounded by fire, since in Hindu tradition the effectiveness of an icon depends on the divine image being just as prescribed in certain religious texts.[1]

In Christian Orthodox religion, too, particular portraits and other

[1] One of the points raised in the British Museum's exhibition Fake? in 1990 – itself a big step in reversing general museum reluctance worldwide to admit to owning any fakes – was that in a number of religions originality is not only inappropriate in creating an image but even blasphemous. Any such image is therefore a copy, but by no means necessarily second-rate; and fake is a term which, even if accurate, might not be applicable. A favourite trick of icon robbers, therefore, is to offer unsuspecting peasants a brand-new image in return for the icon which has faded over the centuries in their village church.

images have become sacrosanct, copied as accurately as possible from generation to generation throughout eastern Europe and Russia. Probably the best example is the image of the Mother of God with the infant Christ. The icon of Hodeghetria or 'She who shows the Way' was reputedly portrayed from life by St Luke. But the Greek physician and companion of St Paul, renowned for painting pictures with words, may never even have seen Jesus as a young man, let alone as a baby. In the fifth century the Hodeghetria was taken to Constantinople, where it became the city's mascot and was given its own church. The people believed it would guard them against their enemies, heal the sick and work all manner of other miracles. In 718 it was said to be responsible for repelling the Saracens.

The icon was enormous and took four men to hold it aloft as it was carried in processions and to battle. It even survived the Crusaders' capture of Constantinople, but it was lost in the fall of the city to the Turks in 1453. However, the image could not really be destroyed since it was by then widely copied. One icon in the British Museum depicts the Hodeghetria mounted on a dais, where it is paid homage by the most important members of church and state. Another Mother of God icon in the cathedral of Smolensk lived up to the original when it apparently caused Napoleon and his army to turn back in 1812.

Copies simply pandering to fashion, of course, come in a multitude of other guises. Two thousand years ago well-to-do Romans, short on souvenir statues from plundering Greece, had imitations made for their houses and their gardens to keep up with the neighbours. These are commonly known as replicas. Similarly travellers on the Grand Tour demanded mementoes to take home. A bust of a Roman conqueror in a niche in your library was a symbol of status. So foundries were set up in Naples and elsewhere, copying popular antiquities and creating new ones.

Museums worldwide sell replicas of their treasures; but the British Museum was a step ahead when it established its own cast service in 1835 and began catering to the whims of interior decorators as well as enthusiastic visitors. In the last thirty years the invention of two new materials, silicon rubber and polyester resin, has extended possibilities hugely. The former is used to make very accurate and flexible moulds so that multiple casts can be taken, using the latter with the addition of powdered marble, limestone, granite, bronze or brass. The British Museum's bronze Egyptian cat with gold earrings is a great favourite. The figure was a votive offering in the form of the animal sacred to the

goddess Bastet, made about 600 BC. However, the museum currently has over 3,000 moulds available, ranging from Aztec figures to the prow of a Viking ship, stacked in its West London repository.

Reproduction, on the other hand, is the word very often associated with furniture. But a hankering for Chippendale is nothing new. The style was widely reproduced last century, which is fine until Victorian Chippendale is mistaken for the real thing. Certainly it is now an antique itself, but it is still a fake if sold as the work of the eighteenth-century Yorkshireman who had extensive workshops in London's St Martin's Lane, didn't stint on his use of timber or make the mistake of carving a chair back exquisitely at a point where it would become worn. These, one country dealer once warned me, were typical errors of a copyist trying to eke out his wood as far as possible and failing properly to understand the design. Though, he added, the real problem was the number of people who believed what they wanted to believe because they thought they had spotted a bargain.

Revivalist was the term I found applied particularly to jewellery when I was invited to have a preview of an exhibition due to be held in March 1989 at Wartski's, among the most discreet dealers in the West End. The shop seemed captured in a genteel time warp matching the elegance of its trinkets and the lifestyle of its royal clientele. The subdued lighting was just sufficient to bring a gleam to the silver, money was never mentioned and the most garish item for sale was a miniature cactus in semiprecious stones.

I had been tempted there by art historian Geoffrey Munn, who is renowned for turning up unexpected treasures, like the imperial Russian egg he identified in the collection of Prince Rainier, who thought it was just another piece of Fabergé instead of one of fifty-seven unique Easter gifts exchanged by the Romanovs, many worth well over a million pounds apiece. Geoffrey explained to me that to be one of the artistic elite in London a hundred years ago you had to be more than just a brilliant painter or sculptor or architect. You had to design jewellery as well and maybe have it made by Carlo Giuliano whose Piccadilly shop was the smart place to go. The fashion, Geoffrey added, was helped by the fact that one of Queen Victoria's daughters, Princess Louise, a sculptor herself, adored contemporary jewellery. These artist jewellers, Burne-Jones among them, naturally preferred hand-crafted work to mass manufacture, and they also favoured reviving past tradition. Carlo Giuliano, who came from Naples, Geoffrey explained, was especially keen on imitating classical

styles, as were the Castellani family of jewellers and antiquity specialists based in Rome.

'Just a moment,' he said, and dived into a safe. It was full of dull-coloured boxes. But when he opened one it revealed a delicate turquoise winged brooch. 'There's an ancient Egyptian symbol of a winged globe that has snakes either side and was regarded as a protection against evil. A Victorian lover would have given this to his girlfriend to ward off other suitors.'

'It's beautiful,' I replied.

One treasure followed another: a ring made for the actress Ellen Terry, shaped as a medieval castle and consequently almost impossible to wear; the marriage jewellery of Pugin's third wife made to match the Neo-Gothic house he designed; an exquisite tiara depicting the myth of Orpheus subduing the lion and lioness with his lyre, but wearing a detachable loincloth for the sake of propriety. And then came the *pièce de résistance*, Giuliano's Helen of Troy necklace. Giuliano, as Geoffrey pointed out, knew all about Helen's gold jewellery. The German archaeologist Heinrich Schliemann, who believed he had discovered it in 1873, had asked Giuliano to test and document the find. But when Sir Edward Poynter wanted some jewellery for a model to wear in his watercolour of the fabled beauty in 1887, he did not think the antique pieces looked sufficiently heroic. So he asked Giuliano to improve on the original and the jeweller created a classical fantasy using silver gilt and green hardstone which had the desired grand and noble effect.

I laughed. I said I thought the argument was usually that a copy could never quite emulate the magic of the real thing.

'Well, it was more a romantic interpretation than a copy,' Geoffrey explained. 'The original resembled par-boiled spaghetti. It was in Berlin before the Second World War. Then it was stolen and now it's been found again in Russia. Only it's never been certain if that is actually genuine,' he added. 'Schliemann was a pathological liar, a real stinker. When he didn't find things he sought to plant them. I mean, why take the necklace to Giuliano's shop to be weighed and assayed? It's like taking the Sutton Hoo ship burial to Cartier.'

In other cases, however, confusion arose. The demand for this sort of revival jewellery stemmed from the Victorian passion for archaeology. Once again, since there was not enough of the real thing to go around, items were faked. But many were honestly copied just as Susie and others like her are today re-creating impressionist works. The problem with

revivalist pieces seems to be the particularly ill-defined borders between jewellery made in homage to the original, outright fakes and pastiches resulting, usually, from over-zealous restoration.

Fortunato Pio Castellani, for instance, was apparently encouraged by an Italian nobleman in the first half of last century to try to revive the techniques used by the ancient Etruscans to produce their wonderful jewellery. This often featured granulation, or tiny globular grains of gold soldered to the surface of the trinkets, and either he or one of his sons, who joined the family business, rediscovered the art. Their work was so admired that the Earl of Dudley paid 1,000 guineas at the 1867 Paris Exhibition, a major international art fair, for a modern Etruscan-style gold coronet, the material value of which was no more than £100.

Another Italian aristocrat, the Cavaliere Campana, a passionate collector, also had dealings with the Castellani family, who sold ancient jewellery and antiquities as well as copying them and running a big restoration business. In fact, the Cavaliere was so obsessed with his collecting that he stole Italian government money to fund it, until he was caught and thrown into jail. His treasures, meanwhile, were confiscated by the government and sold to Napoleon III, who deposited them in the Louvre, where it was later discovered not all were as old or perfect as they seemed. Yet was this a case of a highly respected firm trying to dupe an experienced collector? More likely, the Cavaliere was aware of filling the gaps in his collection with lovingly restored pieces and imitations, just as major collectors do today; except he let everyone else assume they were real.

Copying can, of course, lead to overkill, as in the case of jewellery revivals which are liable to expire if too many ladies are seen wearing Duchess of Windsor panthers. Imitation can also debase the original when, for instance, van Gogh's *Sunflowers* turn up everywhere, even on a pair of cufflinks. Yet the counter to this is that copying means reaching a wider audience. Reproduced paintings in art books and on posters or postcards have brought endless pleasure to people who might never have any chance of seeing the real thing. Painted copies of great pictures can equally bring delight to a wider audience, and a number of museums are now taking this to heart.

Japanese museums appear to have no problem with buying copies when they can't get the original. In fact the Delamare Gallery in Paris was asked in 1989 to provide a museum full of copies. The gallery had been set up two years earlier by Daniel Delamare, employing a group

of anonymous copyists. Khashoggi reputedly went shopping there for 'impressionists' for Imelda Marcos, and it won credibility for selling copies when a descendant of Alfred Sisley opened an exhibition of imitations of the English impressionists' views around Moret-sur-Loing, the medieval town near Paris with which the artist fell in love. The Japanese contract arose after a Japanese collector was so taken with a Delamare Renoir, the original of which he had just seen in the Musée d'Orsay, that he began to order other paintings, including a *Mona Lisa*.

Now Tahiti is hoping to have its own Gauguin museum in the capital Papeete. Gauguin, who was once a successful stockbroker with a Danish wife and five children, gave up his comfortable middle-class life in Europe to search for his personal paradise as a painter. His idyll nearly ended with syphilis, self-doubt and suicide, but he survived and his talent was acclaimed. Tahiti, sadly, has none of his pictures and probably could not afford to buy any, even if they came up for sale. However, Susie Ray's latest task was to create a series of Gauguins for a film on the artist's life and these are destined to form the basis of the museum.

All Susie's copies will, of course, have her stamp on the back. But the problem is, how easy will it be to spot a copy several years on after a relined canvas or change of owner? How long will it be before as much confusion ensues over her work as the Cavaliere's Castellani jewellery in the Louvre?

· 10 ·

Reality limited

'What are tarts made of?'
'Pepper, mostly,' said the cook.
'Treacle,' said a sleepy voice behind her.

On my way out of the Palazzo Strozzi, the setting for a big antiques fair in Florence in 1981, a table of prints caught my eye. Prints are an open invitation to forgers: there are many different kinds and the terminology relating to their production is so confusing.

The fair had just been declared open. The ceremony was in another part of Florence, which was lucky since many participants were still unpacking. I had seen 'Italian impressionists' being hung and endless Madonnas, and I had tried on a pair of amber sunglasses that had once belonged to a Buddhist monk. I had also gasped at the gigantic sideboard being repositioned on the stand of Signor Bellini, my host, who was expecting me at his banquet.

Over the prints, however, I hesitated. They were attractive, scientific illustrations of birds and animals, some I suspected owing more to an eighteenth-century artist's imagination than reality, although carefully labelled in Latin. They were temptingly cheap. Then, from a conversation in a mixture of Italian and French, I thought I discovered why. I was sure they were new prints purporting to be old ones, made from old plates. That made them fakes. But at least export wouldn't be a problem as it would with anything from Italy that was truly antique.

So I bought one. It was a jolly grouping on a palm-tree shoreline of an odd-looking ostrich, two more recognisable flamingoes, an ibis and a wayward sort of heron; and the scene made me smile.

Yet I wondered how many people would be fooled by a stand of new prints that looked old and were being sold at an antiques fair; especially

one as impressive as this in a Renaissance palace built for a rival of the Medici family.

The various types of printing range, of course, from messing about with potatoes to glossy photographic reproduction. Letterpress or relief methods, such as woodcuts and linocuts, are much like potato printing since it is the areas remaining after other parts are cut away that create the impression. Intaglio, which includes line engraving, etching and aquatint (so-called because it resembles watercolour), is the opposite, producing the image from the area removed. Screen printing is an extension of stencilling. Lithography, on the other hand, is like a flat version of letterpress. It was invented by a German playwright in 1799 and is now highly sophisticated. Aloys Senefelder jotted down a laundry list with a greasy crayon on a stone. He was looking for a cheap way of printing the texts of his plays and realised that if he fixed the image with chemicals and wet the rest of the stone, the damp areas would repel any ink with a grease base but the same ink would adhere to the greasy image itself. So it could become a printing block. Consequently lithographs have a somewhat greasy flat image compared with letterpress printing which is sharply defined. Screen printing is also flat, while intaglio printing, particularly copperplate engraving, is characterised by slight ridges from the ink, just detectable to the fingertip.

The first notable print forger was Marcantonio Raimondi, who was born in 1482. He was adept as a copyist and was particularly taken with Dürer's work – so much so that around 1506 he began making engravings of Dürer's paintings and adding the latter's monogram. Albrecht Dürer, who lived in Nuremberg, was well known for his wood and copper engravings, thanks to those illustrating the life of the Holy Family which his wife hawked around local fairs. In fact he found engraving much more profitable than painting and returned to it repeatedly to support his family. So when Dürer realised what Marcantonio was doing, he lodged a complaint with the Signoria of Venice, the city state's supreme authority. Unfortunately, Dürer's monogram was considered a valid token of protection, so Marcantonio was simply forbidden to use it. However, even if he abided by the decree, there was nothing to prevent dealers adding the monogram themselves. In fact, so many other imitators jumped on the bandwagon that there were said to be more forged than genuine Dürer engravings in existence when he died in 1528. Probably the best forgeries were done by a talented German teenager, Jan Wierix, some thirty years after Dürer's death and supposed Dürer prints were still

appearing *en masse* well into the next century when whole bundles were discovered in the effects of the deceased Frankfurt book dealer, Christof le Blon. How many were initially intended purely as copies, it is now hard to tell.

The falsification of print states, however, is a bigger stumbling block than full-scale forgeries. A state is a stage in the development of a print. First state prints are often the most valuable, since they are the proofs initially pulled off the press by the artist. When changes are made these create subsequent states. Rembrandt was notorious for his alterations, sometimes ending up with eight versions of the same etching. Consequently fakers mask or tamper with letters and other identification marks to make prints seem an earlier state than they are.

Then there are the old types of photographic print such as photogravure and heliogravure which are passed off by the unscrupulous as etchings and engravings and the like. Mistakes are easily made because such prints have acquired a veneer of age, but they are comparatively worthless and have a dullness about them, what dealers call 'no surface life'. They are also generally on the wrong paper, since they were mass-produced last century, as were the lithographs now extracted all too often from early twentieth-century art books.

The old printing blocks and plates, of course, present another opportunity for fakers. Sometimes these were destroyed, or they simply wore out. But they were frequently passed on after the artist's death. Then, even if a new owner engraved his own name on the print or block, this might equally be scratched out again. Moreover, even the artist himself might decide to do a reprint at a much later date. Reprints from old blocks are perfectly acceptable among serious collectors, providing they are identified as such. But when the publisher Alvin Beaumont reprinted some of Rembrandt's engravings in Paris in 1906, adding his own stamp, forgers grabbed their chance. They removed the stamp, added artificial watermarks and aged the prints as well – a process likely to include darkening the sheet, adding spots of mould and perforating it here and there to suggest centuries' exposure to weevils, bookworms, mites, death-watch beetles, silver fish and many other insects which feast on paper.

Back in England with my relatively pristine ornithological print, I decided to see if my surmise was right by taking it to Christie's, South Kensington. At the counter where treasures are first examined, a girl with a Hermès scarf held it up delicately, smiled, nodded promisingly

and asked me to take a seat. She needed to show it to the expert, she said.

So I waited. A steady stream of hopeful owners approached the counter. A grey-haired lady in brogues was emptying little parcels wrapped in newspaper from her shopping bag which another assistant carefully undid to reveal an assortment of silver. A young fellow with a stuffed owl in a case under his arm hung around for a few minutes, then turned on his heels and went.

I wondered if the assistant really thought my print was interesting or if it was just a routine check before politely letting me down. I remembered a Bonhams' expert on a valuation day kindly suggesting to an anxious owner that she should hang on to a tea set a little longer for it to realise its value.

Eventually the print came back. The assistant began gently by saying the paper appeared to be of the correct period for an eighteenth-century print, but judging by the quality of the image it was probably a later reprint. Unfortunately it had also been recently coloured. The colours were wrong and as it was intended as a zoological rather than a decorative print, it was doubtful it would have been coloured anyway.

I had previously been warned against Hogarths that were ruined by being coloured at a later date – which they were never meant to be – and about the 'hand-coloured' phrase which appeared on print labels without specifying that this could mean only yesterday. Various 1820s views of London by other artists, much favoured by visitors, are notorious for their wishy-washy colours, intended presumably to be tasteful but completely wrong, since if they had been coloured early last century they would have been bright and garish.

I said the print had cost very little, as the assistant handed it back to me. I wondered if there were warehouses of unused old sheets of paper secreted somewhere in Florence. Dealers there were notorious for the extent of their deception. One had even had a Renaissance tomb faked, buried it in a suitable spot and then had it miraculously discovered.

'You're lucky,' the assistant added.

At least it wasn't supposed to be a Dali. Salvador Dali's later prints had become such a problem that many dealers wouldn't touch them. Rumours had long circulated about the surrealist, then approaching eighty and said to relish the mushrooming of forgeries of his work. The fact that he might even be the most faked artist in history was, after all,

confirmation of his fame. As far as forged prints were concerned, these came in many varieties. There were genuine prints with forged signatures and forged prints with genuine signatures on pre-signed paper. There were lithographs that were photomechanical reproductions from pictures in art books and limited editions that were far less limited than they seemed.

The problem was that Dali's work was being promoted as an investment. But his signature depended upon the whim of the moment, what music he was listening to or who happened to walk into the room. It could vary unrecognisably. On top of this, in the mid-1970s Dali had reputedly signed tens of thousands, if not hundreds of thousands, of blank sheets of paper in order to settle his many debts. He loved spending money, as did his wife Gala. But his business sense was non-existent and he could not always rely on wealthy patrons like Edward James, owner of one of the best collections of Dali's work at West Dean in Sussex before he quit in favour of a surreal residence in the Mexican jungle.

The forgery industry surrounding Dali in the 1970s and 1980s was believed to be worth several hundred million pounds worldwide and has continued to multiply ever since. But attempts to unravel the network of fakers, some connected with each other, others working individually, has proved difficult in the extreme. Many of the fakes are peddled in America, but much of the printing is thought to be done in France. The artist's collaborator and eventual manager, Robert Descharnes, who assisted him in one capacity or another from 1951, is generally regarded as chief authenticator. Indeed he took on this role when Dali's health deteriorated, and he was first cocooned in his Spanish castle retreat and then in a medieval tower adjacent to the Dali Museum established in his birthplace, Figueras. The artist, who died in 1989, was variously said to be suffering from Parkinson's Disease, burns after a fire and malnutrition, and anyway was much more interested in pursuing his art – such as solving the puzzle of how to decorate the outside of his tower with giant rings of bread – than with cracking counterfeit rings. Further confusion has arisen through all the hangers-on who realised money could be made by telling scandalous stories about Dali and fake art.

However, Dali himself said he stopped signing huge quantities of blank paper in 1980, so most prints on paper after that date must be forgeries because by then he was also too ill to do them. Moreover, he made a statement declaring that his confidence had been abused in many ways and his will not respected. But by then the damage was done with buyers

paying on average $2,000 for a fake print, and sometimes over $20,000.

Yet when I happened to mention fake prints to the London dealer Chris Beetles, what really enraged him was the trade in limited editions. Beetles sells watercolours and pioneered the sale of book illustrations and cartoons as fine art. He also collects prints and sometimes teams up with Oxfordshire dealer Elizabeth Harvey-Lee, one of the leading UK authorities on prints, to hold special exhibitions, lately on 'The British Etching Tradition'. Beetles declared that people simply didn't understand the difference between limited-edition, full-colour prints and etchings or lithographs. Yet the latter two involved the direct input of the artist who would personally do the plate and individual inking and run off the whole lot. Limited-edition prints, on the other hand, were marketed as if closely connected with an artist when they were only the result of mass-printing techniques and no better than the newspaper colour supplements in which they were usually advertised, except they were on better paper. 'Though,' added Beetles, 'the artist may join in the jolly bullshit by signing the prints individually.'

How are these limited editions created? Beetles replied that the makers just take a photograph of a picture – albeit with something better than the average family camera – and then sell it as a fine-art print. In Britain such prints generally cost between £150 and £350; in America they are usually more. 'People buy them thinking they are getting a good deal, yet they are often no cheaper than original art and they diminish artistic endeavour,' he seethed.

Somewhat surprisingly in 1992 the Tate Gallery, the British Museum and the Ashmolean Museum, Oxford, joined forces with the publishers Lawrence & Turner to produce sets of Turner watercolours, six views of Venice or six of France in numbered editions of 5,000. At £400 a set, mounted and framed, with such an impeccable provenance, they seemed a blue-chip investment. But dealers used to publishing their own catalogues claimed the price of the prints was outrageous, since they were produced by six-colour photolitho printing which was a standard method that probably cost pence rather than pounds per print and involved no more craftsmanship than running off Esso petrol tokens. The Ashmolean explained their involvement by the need for funds. However, the Tate even provided 'authenticating' documents of the prints, namely a certificate of endorsement from the curator of the British collection and a facsimile letter signed by the director Nicholas Serota stating: 'These remarkable original watercolours have been faithfully reproduced by

Lawrence & Turner under close supervision of the Tate Gallery.' He also said the enterprise would help the gallery to extend its publishing programme, stage exhibitions and acquire new works. Oddly enough, however, a photolitho reproduction of Turner's watercolour of Norham Castle, larger than the limited-edition prints, was available in the gallery shop for £7.05.

How were so many people taken in? The dealer Elizabeth Harvey-Lee recalled a woman explaining why she had bought a print of a watercolour by Sir William Russell Flint, noted for portraying exotic, partially clad dancers, instead of an eighteenth-century etching which took her fancy equally and would have been a better investment. The Flint was signed in pencil by the artist, stamped by the Fine Art Trade Guild and numbered something like '43 of 750'. The etching was unsigned and did not indicate a limited number, though probably fewer than 750 had survived. Yet the woman felt assured. She said that with the Flint she knew exactly what she was getting.

Facsimile, of course, is another nicely technical-sounding term generally used for a mechanically produced copy, as in the photographically reproduced Lambeth *Apocalypse* which was published in 1990. The thirteenth-century original belongs to the Lambeth Palace Library, the oldest public library in England, and is one of its greatest treasures. It contains 100 pages, superbly illustrated and gilded, telling in Latin of the Apocalypse of St John. But it is extremely fragile. For years the library tried to come up with a way in which scholars could consult the *Apocalypse* without destroying it.

The answer was found when the publishers Harvey Miller with two German co-publishers agreed to produce a limited edition of 300, several to be retained by the library and the rest to be marketed separately by the publishers for £2,200 each, purportedly as an investment. When I looked at the original and new versions together in the library's magnificent hall, they were noticeably open at different pages. I was curious to see the portrait of Eleanor de Quincy, Countess of Winchester, who is believed to have commissioned the book in about 1260, but I was not allowed to turn the leaves – though the original had actually had to be taken apart for the copying. The result was certainly magnificent, but it did not have the warmth of colour of the original, its gilding was less burnished and it was not on crinkled and bumpy thirteenth-century parchment. So was it really so valuable in terms of a copy? Single illustrated pages of similar manuscripts were on sale in at least one of

London's antiquarian bookshops. The *Apocalypse* copies, if dismantled, I concluded, would work out dearer.

Even Christie's in King Street succumbed to the copyist salesmanship, to help several racing charities by the auction in 1992 of forty one-off reproductions of privately owned paintings. These belonged to forty patrons of the Racing and Breeding Fine Art Fund who had given permission for important pictures in their collections to be photographed by Colourmaster. Among them was a Stubbs owned by the Queen and a Fantin-Latour belonging to the Queen Mother. The Colourmaster method is to transfer the image on to canvas using a technique that promises to give an exactly colour-matched result; then brushstrokes are added by hand and the canvas varnished like the original.

Since many of the copies going under the hammer for several thousand pounds apiece were of paintings unknown to the public, the process had to be strictly controlled. On receipt of any such print which is clearly marked 'Colourmaster', the purchaser is required to sign a document agreeing not to have copies of the copy made, and this proviso goes with any subsequent sale. The result, complete with old frames, could pass muster in a dark hallway. 'It just looks as though we've splashed out on having the pictures cleaned,' one heir told me triumphantly after his family had sold the originals. 'And we've got cash in hand to boot.'

Artagraph, however, claim to be ahead with the 'most authentic replications of Impressionists and Contemporary paintings'; so much so that 'with the naked eye it's nearly impossible to tell ART's reproductions from the original'. Certain pictures, the firm maintains, actually need an expert to distinguish between the two. This, according to Artagraph salesman Harvey Kalef, is thanks to computerised scanners, laser printers and other sophisticated equipment. The exact colours of a painting, he said, are achieved through laser technology. These are checked and then printed in overlapping layers on to a plastic material called a foil. The surface texture and brush strokes are re-created by an artist who has studied the original and applies acrylic paint on a photo reproduction. Then a mould is taken of the latter using a silica mixture developed by ART which is left to dry for three days. Once it is removed, the texture and brush strokes are detectable embedded in the rubbery mould. The three-dimensional element is ART's big selling point. This mould is next sandwiched together with the colour foil and a laminated canvas backing. The layers are subjected to an intense heat and pressure which causes the

colour foils to liquefy and merge with the mould and canvas. After several weeks' of preparation, this final process takes only a few minutes.

The Philadelphia Museum in America was among the first of over 100 galleries worldwide to allow part of their collection to be reproduced by Artagraph. The firm now has over 160 pictures, mostly impressionists, on its books. Among them are Gauguin's *Vase of Flowers*, Renoir's *Rowing Party* and Turner's *Calais Pier*, all of which are in the National Gallery in London. In return for being paid a royalty, the galleries provide colour negatives and access. The result is an extraordinary collection of imitations of many of the world's greatest paintings. As they hang on the wall of the firm's own gallery in Worcestershire, however, there may be little chance of close comparison with the originals.

Yet even Artagraph with their 'ingenious blend of Art, Science and High Technology' have jumped on to the limited-edition bandwagon. This time it is eight paintings from the Hermitage collection in St Petersburg including works by Pissarro, Monet, van Gogh, Cézanne and Bonnard. The edition is limited to 300, of which 100 sets are allocated for sale in Europe. Funds are desperately needed by the fabulous but crumbling museum. Consequently for an unspecified fee, thirteen officials from the Hermitage apparently oversaw the process and gave their written approval, the chief curator signed a guarantee of authenticity for each edition and allowed the Hermitage seal to be applied to the back of each canvas.

To date the most famous owner of an Artagraph picture is former US President, George Bush, who was presented with a copy of the Benjamin Franklin portrait that hangs in the Green Room at the White House. As a Skull and Bones Club[1] member, Bush was particularly fond of the painting of Hell Fire Club member Franklin, and the copy is now in Bush's new home in Houston, Texas. Harvey Kalef said Artagraph's aim was to make the copies so faithful that people could enjoy them as much as the original. But each had an indelible Artagraph stamp on the back of the canvas just in case anyone got too optimistic.

[1] Princeton initiates to the Skull and Bones Club have to dig up a famous person and then give a dinner at which they present the cleaned skull to the club as a new member. Bush is rumoured to have dined the skull of Orville Wright. Fake skulls have surfaced over the years, but not often. Such is the influence of this powerful Ivy League society that a fake would bring life-long ruin.

I telephoned to enquire further and was told I would have to speak to the chairman. 'But you'll have to do so in writing as he moves around a lot,' added the woman who answered. Where he went she could not say. Yet is it really art, given that it is reproduced by almost entirely mechanical means?

No, it is a form of deception, as the artistic result is not achieved by accepted artistic means, even though the illusion is entirely legal.

Does it matter?

Yes, because, if there is no longer any need to make a distinction, the original may then be no more valuable than the copies. Since such a scenario would devalue the market as a whole by making the world's greatest masterpieces too accessible, new-technology copyists would probably do well not to aspire to perfection any more than makers of ladderless nylon tights.

In less legitimate areas it already matters a great deal. Photography is the best technique for faking drawings. Images can be projected on to any surface treated with photosensitive chemicals. This has been done since the Victorian forger, Frederick Hollyer, got busy snapping drawings by artists such as Burne-Jones. Such fakes are especially troublesome when they are titivated with charcoal to make them more convincing. The only way to tell for certain is with a rubber. If the drawing rubs out, it was the real thing.

· 11 ·

The genuine *Mona Lisa?*

*'One side will make you grow taller, and the other side
will make you grow shorter.'*

One of my favourite possessions is a mask I bought in Bali. I ran back
for it as the sun went down and our driver, Wayan, waited to speed us
back to our hotel. He had decided to become our driver from the moment
he saw us, grinning as we tried out a hire car first and nearly got
imprisoned for going the wrong way down a two-way street – until we
paid the police-patrol bribe and it miraculously became two-way again.

The shop was a dark and dusty one-room shack built against the rocky
hillside on the edge of Ubud where the town gave way to jungle again. The
mask, I was informed by the elderly shop owner, was from a head-hunting
tribe in Kalimantan, part of a much less visited Indonesian island. It has strong
rainbow stripes. It is the real thing, not a tourist souvenir, so he said.

Wayan shrugged. The area was noted for its artists. He had stopped at
every one of his friends' studios and workshops. He had hovered, then haggled
long over one painting before the canvas was finally rolled up for us. But the
carvings lining the roadside were being churned out with slick alacrity.

The problem, of course, is verifying anything from little-known
territories. A bit like antiquities. But tribal art may be even more remote
in understanding, not just a question of time. After all, where do you
start when a civilisation is completely alien in its beliefs and values – as
in the case of the Dayak people of Kalimantan – when history has been
passed down by word of mouth and it is not necessarily judged wise to
tell foreign interlopers the truth?

What's more, any piece is regarded as a forgery if it was not made for
tribal use; that is, anything produced after a tribe has been infiltrated by

Western explorers like Michael C. Rockefeller,[1] who discovered the Azmat art of New Guinea in 1961. Rockefeller's find, before he either drowned or was rescued and eaten, depending on which story you believe, was particularly important since the Azmat were among the last people still to be living in the Stone Age. They carved every surface that could be carved and many of their awesome and unsettling works are now on view in a memorial gallery in the Metropolitan Museum, New York. But once the Azmat discovered wristwatches and radios, their lifestyle was never the same again.

Tribal art created for today's tourists, and therefore fake, is usually relatively easy to spot thanks either to its production-line lack of spontaneity or to the none-too-careful carving. But pieces made for earlier European travellers are much more difficult to detect because of the effect of ageing. Tribal artefacts created to order for dealers are even harder. Moreover, the line between real and fake sometimes becomes very fine indeed.

Shrunken heads are a good example. These have long held a ghoulish fascination. Yet a Cartier exhibition organiser who had to put one up for the night at her Paris flat said she thought her disembodied guest rather a friendly chap. One collector I heard of had so many shrunken heads that he offered them as collateral for a bank loan. However, they are no longer sold at auction, partly on grounds of taste but mainly on account of likely legal problems after Aborigines demanded ancestral heads be returned to their homeland for proper burial. To be classed as authentic, shrunken heads must have been taken in warfare by tribesmen such as the Shuar, Amerindians of the upper Amazon. They, like many other tribes, believed enemies' heads had great spiritual power, which is why

[1] Michael C. Rockefeller had a lot to live up to. His grandfather had given the Metropolitan a whole museum of medieval sculpture, his grandmother was behind the founding of MOMA, and his father Nelson was a major collector of both modern art and tribal artefacts. After coming across Azmat art on an expedition documenting a newly discovered tribe in New Guinea, he returned with a Dutch companion to travel the jungle rivers bartering for all manner of carvings. But little was quite what it seemed to twentieth-century Western eyes. Magnificent hornbills, for instance, carved on canoe prows did not signify bird lovers but head hunters. Simple wooden trays had complex cannibalistic associations since they were used to hand round the worms from the sago tree, a great delicacy because they resembled both sperm and brains, so were both life enhancing and almost as good as tucking into an enemy's grey matter. Michael was last seen when his catamaran overturned in a heavy swell on 18 November 1961. Winter storms were beginning, for which he, as a foreigner, would have been blamed. His collection, however, was saved, stored at the local Catholic mission station.

they chopped them off and shrank them. But, once they had been spotted by Western collectors, demand exceeded supply. So extra heads were apparently acquired by unscrupulous dealers earlier this century from unclaimed bodies in city morgues and then passed to the Shuar experts for shrinking. Thus, strictly speaking, they were fake. Since even these heads are hard to come by today, villagers in Ecuador have solved the problem by using moistened goat skin over a clay form to produce imitation shrunken heads. These are regarded as souvenirs for the tourist trade. But some are so convincing that the only immediate way to tell is by examining the eyebrows where the hair, growing only in one direction, has had to be trimmed and combed and coaxed into place.

When I mentioned my mask to Hermione Waterfield, Christie's expert in tribal art whose great speciality is the Pacific, she said she had a Kalimantan mask herself from early this century. She knew exactly what it was because of the collection it had come from. It was made of black, yellow and beige wood, had round eyes, a big nose and bat-like ears from which ornaments were suspended. My heart sank.

'Of course, in the twenties or thirties the tribesmen got hold of a few oil paints and began to use brighter colours,' she added. 'And the ears might be missing.'

I couldn't quite imagine the mask with ears. But if it was a Kalimantan mask, she declared, it was unlikely to be a forgery. 'The Dayaks have faked amulets for ninety years, but not masks. It's surprising how many people took yachts round that part of the world at the turn of the century picking up curios. You had to avoid certain spots because the tribesmen had a reputation for eating any visitors, but at some of the mission stations you could have a very good time.'

Some artefacts, she explained, were mission stimulated. So they could be called forgery. But didn't it seem better to have 1905 or even 1945 mission 'fakes' than pieces made in 1975? In tribal art, fake was sometimes a question of degree.

Recently some 'bad' ship-cloths had been emerging from Sumatra. These were pieces of material of varying size and colour that were handed down for display at important family ceremonies from birth to death. They were so named because they were decorated with what was originally thought to be a ship of death and they could be worth £2,000 apiece. The oldest to have survived their use and the climate were nineteenth century. But interior decorators had latched on to them and new ones were now being produced which could easily be mistaken for the originals.

To a collector the new cloths were fake because they hadn't been wrapped around the handles of a funeral bier or sat upon by a law-giving elder; although doubtless the Sumatran makers would argue that the new ones were better, and the old cloths merely second hand.

Other forgeries, however, are not only blatant but highly profitable if successful. Benin bronzes plundered from the West African state in 1897 on a so-called punitive expedition by the British Navy after a peace force was inadvertently massacred, are among the most costly items of tribal art around. They are much sought after, especially in America, but in the last five years a series of major fakes have appeared, including a number of big leopards – inspired by a genuine couple which were the star attraction in an exhibition at the Royal Academy – and a flute player. A genuine example of the latter had been sold by Sotheby's in 1973 for £185,000 which at the time was a record for any piece of tribal art.

'The flute player was very convincing,' remarked Hermione. 'It was shown to me for possible sale. But it had no provenance and I couldn't believe such an important piece could just turn up out of nowhere. Often there are give-away signs in the costumes or faces of forged figures. But the trouble now is some catalogues play into the forgers' hands by illustrating the best items from all angles. With so much help, fakers make far fewer mistakes.'

She advised me to look carefully at as many genuine items as I could, to get a feel for them. So I thought I would try the Museum of Mankind. Perhaps there I would spot a mask resembling mine.

The museum was an outstation of the British Museum and has in the past received so many donations from adventurous travellers, including a number of shrunken heads, that the vast proportion of it is kept in store. The imposing building in Burlington Gardens is chiefly given over to long-term exhibitions on one particular culture or another. When I arrived most items relating to Indonesia were packed away in the museum's East London warehouse. I could make a request to see a particular piece. But if there was a Kalimantan mask I found no record of it, and I didn't know what else to ask for.

However, it seemed I was not alone in attempting to turn detective. The museum itself had a variety of items that had baffled curators for years. Among them was an extraordinary rock-crystal skull which had come from Tiffany's in New York about a hundred years ago and is startling to behold. Tales of its origin are numerous but at the time it was said to have been brought from Mexico by a Spanish officer before the French occupied the country and that it had been carved before the

Spanish got there, too. Stylistically this is considered possible, though the skull little resembles Aztec carving of the time. Scientifically nothing has been proved except that the incised lines shaping the teeth appear more likely to have been done with a jeweller's wheel than any technique known to the Aztecs. The rock crystal could be from Brazil but, while the Aztecs would have had access to similar stone, this source was not mined until much later. I plumped for the suggestion that the skull was an example of colonial Mexican art that had been used in a Spanish American cathedral, produced by a native Amerindian but influenced by European taste. In other words, it was not what it was originally thought to be, but in tribal terms it was a 'working object', so arguably not a fake.

It was a hunch, that was all, and I heard echoes of Dr Jack Ogden's warning to me that given enough time and money, virtually anything can be conclusively tested, even marble or rock crystal. Yet tests can only prove something to be a fake – like the Turin Shroud, debunked by carbon dating; or a fifteenth-century portrait of Edward IV discredited by dendrochonology (counting tree rings). None can prove an item indisputably genuine. Even thermoluminescence, widely used on suspect ceramics, is no longer infallible. Firing a pot sets its age at zero, and the test reveals the period since that time, during which an item has stored up cosmic rays. However, forgers are apparently now learning how to 'adjust' this process, notably on areas such as the base of a piece that are most often tested.

Hunches, nevertheless, can be dangerous, not least when relied upon in professional judgement; but then the word is generally 'connoisseurship'. Art critic Bernard Berenson and Joseph Duveen, later Lord Duveen of Millbank, donator of three rooms of ancient Greek sculptures to the British Museum, were renowned for their connoisseurship. Berenson was a Lithuanian Jew who was born in 1865 and by the turn of the century had become the acknowledged world authority on Italian Renaissance painting. As in the case of Anthony Blunt, many of the curators of the world's major museums and galleries were either Berenson's former pupils or his disciples. Lord Clark of *Civilisation* fame was among them. In Berenson's later years scholars and princes and socialites all made a bee-line for I Tatti, his spectacular hilltop villa outside Florence. Duveen was one of a Jewish family of art and antique dealers with royal clients and a worldwide reputation for acquiring great pictures.

Berenson was Duveen's adviser for thirty years, and for this he was given a hefty annual retainer. But Berenson also received 10 per cent of the price fetched by every picture sold as the result of his unbiased expert

opinion. This came to light in a court case in New York in 1929 brought by Mrs Amédée Hahn, a Frenchwoman living in Junction City, Kansas. She had begun legal action against Duveen after the sale of a portrait she owned, widely thought to be by Leonardo da Vinci, fell through because Duveen declared the picture to be 'a fake, a copy like hundreds of others'. The original, he added, was hanging in the Louvre. The picture, like its counterpart in the Louvre, was known as *La Belle Ferronnière* or *The Blacksmith's Beautiful Wife*. However, this was probably a misnomer, since it was a head-and-shoulders portrait of a personable young woman in elegant dress, more like that of a lady at court. It had been a wedding gift when Mrs Hahn married Harry J. in 1916.

Mrs Hahn was about to get $250,000 for the portrait from Kansas City Art Gallery when a New York World reporter asked Duveen, as the world's leading art dealer, for his opinion. Duveen's reply was unhesitating even though he had never seen the picture. When Mrs Hahn sued, the case took some eight years to come to court because of the many witnesses from Europe lined up by Duveen, including Berenson and the London art historian, Maurice Brockwell. The case was heard by Judge William Harman Black in the New York Supreme Court.

Duveen's counsel quoted a report by Berenson describing the portrait in the Louvre as the undisputed original and Mrs Hahn's as the copy. Berenson himself specified that the Hahn picture was a nineteenth-century imitation and Brockwell condemned it equally. Other experts declared it Flemish or even detected the hand of Joshua Reynolds. But Mrs Hahn too quoted Berenson, who had written in a book on North Italian painters that he had studied the Louvre painting over forty years, that he had changed his mind from time to time over fifteen years, and his final conclusion was that the Louvre picture showed no trace whatsoever of Leonardo's hand. Likewise Brockwell conceded that he had based his opinion solely on a monochrome photograph. He explained that in the great majority of cases experts gave their reports on old paintings on the strength of such snapshots.

Mr Justice Black, addressing himself to the experts, remarked that few were painters, and their conclusions were based not on knowledge, experience or study, but on some mysterious 'infallible eye'. Art experts, he said, 'too often expound theories largely by vocal expression and gesture . . . others state they possess a sixth sense, some a gut or inner feeling or perhaps a golden eye.' He was not impressed.

The result was that Duveen decided to come to terms. Mrs Hahn withdrew her charges in return for an indemnity of $60,000, or possibly

more, and all costs and legal expenses were paid by Duveen. However, without any evidence whatsoever, he had tainted the painting.

The Hahns were consequently piqued into researching the origins of the picture which had been handed down in Mrs Hahn's family. She was descended from a French revolutionary general who had acquired it from the Palace of Versailles in the 1790s with the break-up of Louis XVI's collection. It had hung in the King's Gallery at least since 1683 when it was listed in the first inventory of Louis XIV's paintings. It also appeared that it must previously have hung at the Palace of Fontainebleau, as a copy was recorded there in 1693 which had been made upon the removal of the original to Versailles. Moreover, it was one of the pictures in the royal collection selected in 1777 by Louis XVI for the innovatory, if damaging, process of transfer from oak panel to canvas by his chief restorer, Sieur J. L. Hacquin. This alone indicated the painting's importance. Because of the expense only four other Leonardos are known to have been so transferred – two Madonnas in the Hermitage, and another Madonna and a Bacchus in the Louvre.

In 1964 Mrs Hahn went further and commissioned two chemical analyses from the National Gallery in London where experts concluded that no pigments had been used in the Hahn picture which would not have been available in Leonardo's lifetime. Indeed there was an extensive use of ultramarine which was then Italy's most expensive pigment. This was ground from the semiprecious stone, lapis lazuli and was an extravagance unlikely on either a studio picture or an outright copy. On the other hand, the pigment was absent in the Louvre painting. One of the same experts also claimed the painting was done with the left hand and displayed many characteristics of Leonardo's style. The Louvre version, he declared, was inferior in both quality and technique. Of course, the National Gallery and the Louvre have long been at loggerheads over another Leonardo, the *Virgin of the Rocks*, one version of which hangs in London, the other in Paris, with both institutions claiming to possess the genuine article.

The controversy surrounding *The Blacksmith's Beautiful Wife* bubbled over again in 1988, three years after Mrs Hahn's death, when the picture, by then owned by her nephew, Leon Loucks of Wichita, Kansas, came on the market again with a price tag of around £28 million. Its new title was simply *Portrait of a Woman*.

The appearance of supposed Leonardos happens fairly regularly. Probably only fourteen are known definitely to be by the master who was born at Vinci in 1452, the illegitimate son of a Florentine notary, and became one

of the greatest Universal Men of the Renaissance. The problem was that he diversified his genius at court so much that, although he made thousands of notes and drawings, he brought hardly any major enterprise to a conclusion, from projected aircraft to paintings – even with the help of assistants, since he employed boys that he fancied rather than those who could be of real use to him. From this it might also be assumed that he would have been unlikely to paint two versions of the same picture.

The UK authority on Leonardo, Professor Martin Kemp, who was lured to see the picture this time, was full of praise for its appearance, its subtle balance of flesh tones and the extraordinary response of the head to changes in lighting. But its polished perfection worked against it being by Leonardo. The painting of the loops of material at the top of the sleeves, for instance, he felt owed more to practised formula than to direct observation. Comparable details in the Louvre painting had a delicate and elusive touch more in tune with the desire to capture the effect of light on something that has been closely scrutinised. Overall, he explained, the characterisation of form appeared one step further removed from the visual experience than in the Louvre painting. His 'hunch' was that the Hahn portrait was by a 'seventeenth-century French classicising artist' – meaning presumably someone in the Nicolas Poussin mould, good at doing romantic scenes amid idealistic classical landscapes.

He said: 'It has been done by somebody of great skill and ability. It is a nice picture, a good picture. But a copy in this context becomes a rotten picture.' And thanks to Professor Kemp's instinct *à la* Duveen, albeit having seen the picture, £26 million was promptly wiped off the portrait's value.

The owner, however, is still working on further scientific tests. Meanwhile, former chief curator at the Louvre from 1945 to 1984, Madame Sylvie Beguin, a specialist in fifteenth- and sixteenth-century art, has had second thoughts. Throughout her period in charge she acquiesced with the labelling of the Louvre picture. But in 1993 she declared that she was no longer happy with the attribution of that version to Leonardo. Of course, Leonardo's work is among the most controversial of all when it comes to fakes because of the money and prestige involved, as in the case of the *Mona Lisa*. Some regarded the painting as questionable in the first place since it was neither signed nor dated and no record of the commission or of any payment made to Leonardo was ever found. Consequently any number of theories have been put forward, even that it is a self-portrait. Generally, however, it is said to represent the young

wife of a Florence merchant, Francesco del Giacondo, and is sometimes referred to as *La Gioconda*. It is painted on white poplar wood and is believed to have been done over a period of four years from 1502, when Leonardo was seriously concerned with the study of the flight of birds, his father died, other members of his family tried to disinherit him and he faced major competition from the then upstart Michelangelo, whom he detested. The *Mona Lisa* was apparently bought by the French king Francis I, who gave Leonardo the château where he died in 1519. The king called the painting incomparable, but patronised artists such as Andrea del Sarto as well, who was on occasion a less-than-honest copyist.

The picture has been in the Louvre since 1804. It was unimaginable that it could ever be stolen. But it was coolly removed, still in its ornate frame enclosed in a thick glass-fronted box, on Monday 21 August 1911. Four iron hooks remained glaringly on the wall. Yet as there was a massive security force in operation, and the gallery was closed to the public on Mondays anyway, the cleaners and maintenance workers who noticed its absence assumed the painting had gone for routine photographing or cleaning.

So the alarm was not raised until eleven o'clock the following morning, when exits were belatedly barred and dozens of police officers descended on the Louvre. But all that could be found was the protective box concealed under a staircase. France was scandalised. Many Louvre employees were dismissed and its director, who was also the French Fine Arts Minister, was forced to resign. The police claimed they had a lead thanks to a fingerprint, but failed to find a match. Airports, docks and stations were checked and supposed sightings investigated but to no avail. After fifteen months the blank space was filled with a Raphael.

Astonishingly the only lead the police had was to Picasso, then a comparatively little-known artist experimenting with Cubism, and to his friend, the French poet and art critic, Guillaume Apollinaire. The police thought the pair were involved after discovering that they had a number of carvings illicitly taken from the Louvre. Mostly they were tribal pieces and Picasso argued that no one else appreciated them and he had borrowed them to study for his paintings. The police began asking questions after Apollinaire panicked and tried to return an Iberian bust which another friend had left with him for safe keeping. Picasso and Apollinaire were hailed as the tip of a major international art ring responsible for stealing all the treasures missing from Paris museums. However, after Apollinaire and Picasso handed back the carvings, the police found no further evidence against them and proceedings were dropped. So it was back to square one.

Finally in November 1913 the Florence art dealer, Alfredo Geri, received a letter bearing a Paris box number. The writer claimed he had the real *Mona Lisa* and wanted to sell it back to Italy. His price was 500,000 lire. Geri promptly sought the help of Giovanni Poggi, the director of the Uffizi Gallery. They wrote back, and to their astonishment an Italian carpenter in his thirties, Vincenzo Peruggia, turned up in Florence, glibly explaining that he had been able to steal the picture because he had worked on fitting the protective box and knew the gallery's Monday routine. Taking it down and strolling out with the canvas under his overalls, he told them, was easy. Since then he had kept the *Mona Lisa* in a trunk at his lodgings a few hundred yards from the Louvre. He invited the pair to his hotel room, dived under the bed and produced the painting with a flourish.

The Italians thought it genuine and the Uffizi director tipped off the police who arrested Peruggia. Other experts confirmed it was the stolen *Mona Lisa* and the Italian government returned it to the Louvre. Reinstated, it received more visitors than ever.

But why had Peruggia taken so long to come forward? And was it beyond doubt that the painting was the original Leonardo?

One possibility was that an international crook called the Marques de Valfierno was behind the theft, a fact which only came to light after his death in 1931. The Marques purportedly had a thriving business selling copies of various Old Masters as the real thing to top collectors around the world, and his partner was a talented copyist, Yves Chauldron. The scam was clever. According to the story, he first had Chauldron spend months in the Louvre making six copies of the *Mona Lisa*, painting with pigments which Leonardo would have used and creating hairline cracks as they would appear in an old painting. Then the Marques enlisted the help of Peruggia and planned his theft of the real *Mona Lisa* with the help of a couple of accomplices pretending to be maintenance men. Peruggia was to hide the painting and do nothing until contacted. After the theft and its worldwide publicity, the Marques went to New York and approached six wealthy collectors, five in North America and one in Brazil. To each he offered the *Mona Lisa* at a bargain price, made over $2 million and retired to North Africa, leaving Peruggia waiting for the call that never came. Meanwhile, even if the collectors realised their error, they would never own up for they would be implicating themselves in the crime.

If this scenario was correct — and a number of 'original' *Mona Lisas* have since turned up in America — the follow-on was that Peruggia, eventually realising he too had been duped, decided on the idea of returning the

Mona Lisa to Italy as a way to achieve credibility and make some money.

After retracting an initial statement implicating a couple of Italian brothers, he never admitted that anyone else was involved. Important collectors' names were found in a diary at his Paris lodgings but before further investigations were undertaken, Peruggia was pronounced mentally unstable. In the end he only got seven and a half months of jail.

Other leads, however, have suggested that the painting Peruggia took to Florence was actually a fake. At one point the Paris art dealer, Edouard Jonas, maintained he had the original, but changed his mind under threat of being charged and said it was a copy. However, his claim fitted with British conman, Jack Dean's version of events: he insisted he had helped Peruggia steal the *Mona Lisa* but said he had substituted a copy for the genuine picture and sold the latter to a Paris dealer.

X-rays, carbon-dating and micro-chemical analyses have all supported the belief that the picture hanging in the Louvre today is the real thing – just as tests to date have failed to prove the Hahn *Blacksmith's Wife* a fake. Thus it's back to hunches and connoisseurship, though it is so hard now to get near the *Mona Lisa* with its bullet-proof glass and maze of highly sophisticated security devices that probably no one would notice if it were 'wrong'.

I still don't know about my mask. I can't find anything like it, and without any point of reference I feel baffled. But I am told the mask has a presence.

'Live with something for a while. You'll get to know," said Dr Thomas Pilscheur, whose opinion I one day sought at his house in Connaught Square which doubles as a gallery. He poured the coffee amid a room full of Indonesian grave quardians. On the next floor was his 'dream beam' of ancestral Toraja figures, hundreds of years old. Much like their Easter Island relatives, they were otherwise encountered dotted around Sumatra Sitting buried to the waist in the ground.

I admired a stylised pottery figure of a cat that was sitting alone on a small table. He said it was supposed to be a Jomon piece from Indonesia, one of the oldest in existence. Thermoluminescence testing had proved impossible because the clay contained minerals which decomposed on heating to give a spurious signal. The Oxford laboratory, which was consulted worldwide, reported that its scientists had come across no other Jomon clay like it before. Yet Dr Pilscheur knew his source was good.

After three months' living with it he was not absolutely sure, yet he felt it was 'wrong'. Three months later he had sent it back.

· 12 ·
Fake art

*Alice thought the whole thing very absurd, but they all
looked so grave that she did not dare to laugh.*

'If you stare at it long enough you'll see something,' one of Sotheby's art
experts with very large glasses assured me as I viewed a plain black canvas
before an auction in New York.

I have never been entirely convinced of the colour-field approach to
painting which had proliferated in America in the sixties – the idea that
an image reduced to its ultimate, a canvas all one colour, can justifiably
be called a picture. Maybe it is all right to make such a statement once
or twice, as Yves Klein, the French judo expert, did in the mid-fifties
(though he had a preference for blue). After all, it is important to
experiment. But the only thing worse than an artist finding a formula
and going no further is for other artists to copy that formula *ad infinitum*.

I stared at the black canvas, which wasn't a Klein but a Rothko, for
a full five minutes. Was it some form of magic trick? But I saw nothing.

Sotheby's sales in York Avenue are especially theatrical, and the
auctioneers were quick to jump on the bandwagon of the importance of
the new in exactly the same way they promoted the value of the very
old. One of the stars of the auction, as at most other contemporary sales
in the mid-eighties, was an abstract expressionist work by Willem de
Kooning, whose brush stroke was said to travel at ninety-five miles per
hour and who was best known for his paintings of women. Unlike Picasso,
however, he didn't take the shape of a woman and then abstract it; he
drew lines and then created figures out of them. The painting was expected
to fetch hundreds of thousands of dollars. (Another has now made $20.5
million, making him the highest-priced contemporary painter.) I was
told the estimate was reasonable since pages of the *New York Times* on

which he had wiped his brushes years earlier often changed hands for tens of thousands of dollars. Acquaintances simply asked him to sign the sheets and he obliged.

His estranged wife Elaine, who had returned in 1978 to manage his affairs and wean him off alcohol and tranquillisers had, I heard, even been asked to authenticate a three-hole outhouse loo seat de Kooning had painted to look like marble for a party in 1954. The salvaged object had been framed and was now hanging on a collector's wall. De Kooning, however, was getting old and reclusive rather like Dali. His best friends found themselves suddenly, unaccountably banned.

Later it transpired, after Elaine died in 1989, that de Kooning's health and mental capacity were seriously in question. He was diagnosed to be suffering from Alzheimer's disease, though some suggested he was just sick of small talk. He still painted at his home and studio in East Hampton, surrounded by a barrage of nurses, accountants and studio assistants, and the price of his work continued to rise. But did he even know what he was doing? Had his painting become a form of therapy? Was he simply operating on automatic, a memory-less person going through the motions? Was his art therefore fake?

De Kooning, who was born in Rotterdam in 1904, and began his career as a house painter after stowing away to the United States, had become one of the leaders of the New York avant garde by the 1940s. He always declared that if you did know what you were doing, you were going in the wrong direction because then it was just craft. So his painting without rational thought could be called the purest form of abstract expressionism, which makes it at least as valid – or not – as it ever was. The fraud, then, is the value placed on it by dealers, auctioneers and hangers-on.

Dealers have a lot to answer for. In contemporary art, auctioneers, like artists' groupies, only ever follow the lead of major galleries, Larry 'Go-Go' Gagosian in New York, for instance, or Anthony d'Offay in London, who kicked off in 1980 with a show by the German sculptor, installation and performance artist, Josef Beuys, renowned for once accepting full personal responsibility for any snowfall in Düsseldorf in February.

Andy Warhol said: 'To be successful as an artist, you have to have your work shown in a good gallery for the same reason that, say, Dior never sold his originals from a counter at Woolworths. You need a good gallery so the 'ruling class' will notice you and spread enough confidence in your future so collectors will buy you, whether for $500 or $50,000.

No matter how good you are, if you're not promoted right, then you won't be one of the remembered names.' Above all, anyone shown by Leslie Waddington in London has it made.

However, even the New York auctioneers who are noted for being the most adventurous in contemporary circles were still hesitating to put their money on Jeff Koons when I made a return visit in autumn 1991. So I took a taxi to SoHo. Previously I had only seen Koons's fish tank full of tennis balls, which I had been advised had a Zen-like quality and 'required looking', rather in the manner of the black canvas. This time I gathered the gallery was burgeoning with butterflies and flowers and cherubs, painted or sculpted, surrounding portrayals of Mr and Mrs Koons.

'Gee, they're in the missionary position,' squealed a New Yorker in regulation black, as I squeezed to get a sighting through a non-existent gap in the Sonnabend Gallery opening-night crowd.

Koons, enthused an admirer, was way ahead of Warhol. And hadn't Warhol done well with all those images of Marilyn and cans of beans?

Warhol's excuse for his repetitive style was that he was commenting on the mass media and its icons. His idea stemmed from Marcel Duchamp's use of production-line items which the Dadaist argued his powers as an artist transformed into art works when he presented them together. Thus with a multitude of urinals, Duchamp expanded the concept of originality and perhaps began the culture of the copy as real art.

But was Koons's art real art, pornography or fraud?

Koons's obsession is kitsch. And he is a frantic publicity seeker. He said: 'I believe that taste is really unimportant. My work tries to present itself as the underdog. It takes a position that people must embrace everything.' This includes painted china poodles, cutie-pie angels and fairground-style sculptures of himself and his then wife, the Italian porn star and politician, La Cicciolina, having sex. Images are usually produced in triplicate so he can stage shows in three cities round the world at the same time.

According to his biographical details, Koons studied at the Art Institute in Chicago. Further inquiry elicited the fact that he was influenced by seedy bars and strip joints and a midget club where the tables and even the beers were tiny. In 1976 he moved to join a mass of struggling young artists in New York. So where did he really learn his art?

One Californian photographer, Art Rogers, had cried plagiarism. Loudly. In fact he was so certain a Koons sculpture *String of Puppies* resembled a greetings card photograph he had taken that he accused the artist of removing the copyright mark and sending the snap to a team of European craftsmen who sculpted the image into Koons art works at $125,000 apiece. Koons's answer was that he gave the photograph spirituality and animation, that he took it to another vocabulary. But in court the judge agreed with Rogers.

The problem, however, is that any scandal or censorship only adds fuel to the fire, increasing publicity of and interest in Koons's work. Koons maintains artists must exploit themselves and he does so readily. He told only too eagerly how he encountered his wife. He was thumbing through a porn magazine researching an exhibition on banality when he first saw her picture. They met after one of her performances singing nude at which she allowed her future husband and anyone else in the audience to touch her. Via an interpreter they declared undying love and Koons claimed to have immortalised this in his new show unveiled simultaneously in Los Angeles and Cologne. Koons had also been confiding to everyone that he wanted to out-sensationalise any artistic *cause célèbre*, like the furore over the explicit images of the late photographer, Robert Mapplethorpe. But there, any similarity between them ended. Mapplethorpe erred in favour of beauty, Koons only towards the crass.

Of course, Koons had once been a Wall Street salesman. He knew the value of shock tactics and had a passion for making money. He had an 'apple-pie' sales ability and could equally sell pork-belly futures or himself and his beloved as a work of art. They aren't. It isn't. But if anyone could convince you, Koons could.

In London, when I was invited to the Tate annual November prize giving, it occurred to me that Joseph Mallord William Turner would be shocked indeed by the award bestowed in his name. It is presented to a British artist under fifty for an outstanding exhibition during some twelve preceding months and is meant to promote new developments in contemporary British art. Turner himself was vilified for his innovative landscapes as 'pictures of nothing, and very like' because of his magical emphasis on coloured light. But there appears to be no link between Turner and the prize apart from the Tate's large holding of his work. For the award seems to have become devoted to conceptual art and is dispensed according to the novelty of an idea rather than on anything recognisable

as art in terms of actual execution. No painter has won it since Howard
Hodgkin in 1985.

At the 1993 ceremony I watched with fearful fascination. There was
Hannah Collins who enlarged photographs of fish or rubber dinghies – I
couldn't think of any reason why; and Sean Scully, aged forty-eight, who
for years had been painting stripes. My bet was on Laos exile, Vong
Phaophanit, for his tubes of neon lights buried in a field of rice. But the
award went to Rachel Whiteread for her cast of an entire terraced house
in London's East End. The building itself had subsequently been
demolished along with the rest of the terrace and I was told the sculpture
stood there as a monument to human life and endeavour. Until, that is,
the council razed it to the ground.

Rachel, who was born in London and studied at the Slade, said she
wanted to 'challenge the way one looks at domestic objects' and make
solid the 'negative space' that these objects displace. The Turner jury,
chaired by Tate director Nicholas Serota, commended the way her work
engaged the audience with 'issues of immediate relevance to their lives'.
They complimented her originality, albeit echoing ancient art such as
Egyptian tombs, and said they felt her work made 'a very positive
contribution to the debate about the place of art in society'.

But was it really art? Was it anything more than an interesting
idea?

Of course, once accepted by the Tate, anything can be miraculously
transformed into art, whether a mangled bit of piping on the floor or
mud splats on a wall. Just like the forgeries put through the salerooms
to gain credibility by inclusion in a glossy catalogue.

Conceptual artist, Damien Hirst, was widely publicised as a contender
for the Turner prize the year before, and the Tate now displays one of
his works. His sculpture of a white Suffolk lamb pickled in formaldehyde,
became the most expensive sheep in London when it was sold before its
exhibition at the Serpentine Gallery to a collector for £25,000, only to
have ink thrown on it there by an incensed visitor, raising Hirst's profile
higher and making the lamb more valuable than ever. This was the latest
in a line of creatures pickled by the young artist – quite apart from the
maggoty cows' heads as living sculptures and the pupae of butterflies
attached to canvases with bowls of sugar-water waiting for when they
hatched out. Or Damien's most famous shark piece preserved in a fish
tank – I have noticed a curious propensity among artists towards fish
tanks of late – and entitled *The Physical Impossibility of Death in the Mind*

of Someone Living, which the collector Charles Saatchi financed to the sum of £45,000 and then paid another £10,000 to purchase.

Saatchi, who is Britain's biggest collector of contemporary art, has been buying Hirst's work since 1990 when he drew up in his Bentley convertible at the artist's studio in a disused biscuit factory in Bermondsey and bought something resembling a medicine cabinet. Hirst was the slickest product of the Class of '88 at Goldsmith's College. Some dubbed him as ephemeral but his rise has been meteoric. Why has he been so successful, still in his twenties? Well, once Saatchi has given the thumbs-up, other collectors worldwide follow suit like lemmings. A new patron is Dave Stewart, formerly of the Eurythmics band, who has struck up such a rapport with Hirst that he has dedicated a song track, 'Damien, Save Me', to the artist. Other investors include Saatchi's ex-wife Doris, Jay Chiat, the American advertising mogul, and Gordon Watson, Chelsea's most exotic jeweller.

Saatchi is notorious for his stealthy approach, examining artists' work on the quiet, then buying up their studios in bulk; providing them with the money to go on creating art, yet rarely having any contact in person. He has changed artists' entire lives overnight, simultaneously buying and boosting their reputations. Occasionally he off-loads mercilessly as well. Such is the low profile he keeps that I learnt only recently that Saatchi had shown Koons's work before anyone had heard of him in Britain. And, added my dealer informant, he bought Whiteread's *Ghost*, a catafalque-like plaster cast of a room, which led directly on to her spectral *House*. But has Saatchi really got a 'golden eye' that can tell what should or should not be called true art? What is genuinely worth £10,000 or £100,000?

Or is the mystery behind his purchases all part of a sham? Does he simply enjoy wielding power with cryptic messages and big cheques from behind the scenes? Testing his puppets to see how far they will go in faking art? I wonder.

'Art is all a question of belief,' my dealer friend explained. 'And so is its value.'

Epilogue

'That's the most important piece of evidence we've heard yet,' said the King.

I was in St Petersburg when my interest in icons was sparked again. It was May 1992 and the snow had almost melted. I saw new ones for sale in every tourist shop, garish and badly painted. Nothing like the Hann icons, whose authenticity I had never quite managed to ascertain. But then most of the contemporary art in Russia was the same poor quality. Even Sotheby's had failed after their first attempt to hype it, though they blamed the authorities' red tape.

The problem really was that Russian artists had a lot of catching up to do after their long isolation from outside influences – just as the West was so ignorant of the former Soviet Union that forgers could have a field day. Almost all art that left the USSR had had to be smuggled out, so it was impossible to check if it was genuine.

I had been invited to a party at the Hermitage, where Cartier were holding an exhibition. Bread queues were still the norm in the city but the jewels were unashamedly sumptuous and the museum served champagne. St Petersburg wanted to be part of Europe again, to recall the days of Peter and Catherine the Great, and this was a start.

I was pondering over a tiara when I spotted the then Hermitage director, Vitaly Souslov, through the glass case. All the speeches had been in Russian and I had sneaked off around the museum in search of the odd Leonardo or El Greco. There were three million or so exhibits, many sadly in need of conservation. However, with the help of an interpreter I learnt that Souslov had great plans for the Hermitage. It was top of the bill for renovation as a key tourist attraction in a city that would once again rival Venice.

What about funds, I asked Souslov through the interpreter? Would he be selling off treasures to raise the cash?

He was optimistic. No treasures would be sold, he said, and then he had to rush off.

The official acting as interpreter remained hovering and, trying to think of something to say, I happened to mention icons. Had he, I wondered, ever heard about the Hann collection?

To my surprise he suddenly became very voluble. He knew all about them, he replied. It was a terrible smear on the reputation of Russia. On the Tretyakov Gallery in Moscow. On all Russian museums. On her curators. On her heritage. Of course they were authentic. How could anyone possibly ever believe otherwise?

When I returned to London, Roy Miles, who pioneered the sale of modern Russian realist art in the West, was also giving a party at his Mayfair gallery. His parties are famous as the best in London with red carpets, balloons, caviar and champagne. He also had his latest selection of Russian art on view, and one of his few contemporary Russian painters, Sergei Chepik, was there with his French wife, Marie. Chepik, who now lives in Paris, is large and generally cheerful. He found France much more conducive to painting, partly since it was easier to get hold of canvases and brushes. However, today he was in thoughtful mood. His wife was glaring.

Chepik was probably the best-known current Russian artist around. The result was that someone had been faking his work. One example was called Les Acrobats and was the left half of his picture, The Entertainers. He was not sure whether to be flattered or angry.

I remarked upon my trip to Russia and the fact that I had finally learnt from an official there that some icons I feared were fake were actually genuine. Many had come from the Tretyakov.

Roy Miles, who was nearby, overheard. 'You know there have been far too many twenties and thirties Russian paintings turning up on the market. They're copying them in the Tretyakov and assuming gullible Westerners won't notice.'

'Who is?' I said.

'Well, it's the government officials selling the stuff,' he replied.

So the Russian official's evidence about the icons was about as meaningless as the verses the White Rabbit read to the King.

I wondered if the faker, assuming there was one, knew of the embarrassment his work had caused, the fortunes wasted, the reputations lost, the heads that rolled.

Yet real fraud is less the fault of the individual forger, a flawed and ephemeral individual trying to make a living, than the salerooms and the market-makers, since they stand to profit from fakers just as they do from 'legitimate' artists.

Fakers vanish like the Cheshire Cat. The market is eternal. It is the most complete fake of all.

Author's Note

I was first asked in 1980 by the *Daily Telegraph* and later *The Sunday Times* to follow the rise and rise of the art business and report on the untold wealth that was changing hands. I travelled from New York to St Petersburg seeing fortunes gambled in auction rooms and lost treasures found.

But behind the glamorous facade I discovered a parallel, seamier world, highly secretive, sometimes violent and frequently immoral. It is disguised by the private language of the dealers and the strange codes of the salerooms, and the more I delved, the more I felt like Lewis Carroll's Alice. Old Masters turned out to be new, ancient gold artefacts recently fashioned. Restoration had a host of different meanings. Reputed experts were discretely filling gaps for major collectors; and fakers, far from being villains, were often more innocent than auctioneers and dealers.

I found myself in a Wonderland where nothing was ever quite as it seemed. The allusions made to Carrol's fable appeared especially appropriate when a friend who calls me Alice, seeing my own paintings, suggested I do some 'nice Monet waterlilies' for him to sell. I declined and wrote this book instead.

Bibliography

Arnau, Frank: *Three Thousand Years of Deception in Art and Antiques* (Jonathan Cape 1961).

Baesjou, Jan: *The Vermeer Forgeries: The Story of Han van Meegeren* (Geoffrey Bles, 1956).

Bly, John: *Is it Genuine?* (Mitchell Beazley 1986).

Brown, Christopher, Kelch, Jan & van Thiel, Pieter: *Rembrandt: the Master & his Workshop* (Yale University Press, New Haven and London, in Association with National Gallery Publications, London, 1992).

Cross-Section: *British Art in the Twentieth Century* (Peter Nahum, 1988).

Daix, Pierre: *Picasso* (Thames and Hudson 1965).

Fleming, John and Honour, Hugh: *The Penguin Dictionary of Decorative Arts* (Penguin Books 1979).

Foundation Cartier pour l'art contemporain: *Vraiment faux* (1988).

Ford, Peter & Fisher, John: *The Picture Buyer's Handbook* (Harrap 1988).

Gere, Charlotte: *European & American Jewellery 1830–1914* (Heinemann, London 1975).

Gregorietti, Guido: *Jewellery through the Ages* (Paul Hamlyn 1970).

Haywood, Ian: *Faking It: Art and the Politics of Forgery* (The Harvester Press 1987).

Hebborn, Eric: *Drawn to Trouble: The Forging of an Artist* (Mainstream Publishing 1991).

Herbert, John: *Inside Christie's* (Hodder & Stoughton 1990).

Herrmann, Frank: *Sotheby's: Portrait of an Auction House* (Chatto & Windus 1980).

Hochfield, Sylvia: 'Cast in Bronze' (ARTnews magazine, February 1989).

Jones, Mark (editor): *Fake? The Art of Deception* (British Museum Press 1990).

Jones, Mark (editor): *Why Fakes Matter: Essays on Problems of Authenticity* (British Museum Press 1992).

Jorg, CJA: *The Geldermalsen, History and Porcelain* (Kemper Publishers, Groningen, 1986).

Keating, Tom and Norman, Geraldene and Frank: *The Fake's Progress: Tom Keating's Story* (Hutchinson 1977).

Kurz, Otto: *Fakes: A Handbook for Collectors and Students* (Faber and Faber 1948).

Lucie-Smith, Edward: *Lives of the Great Twentieth Century Artists* (Weidenfeld & Nicolson)

Mendax, Fritz: *Art Fakes and Forgeries* (Werner Laurie 1953).

Munn, Geoffrey C, *Castellani and Giuliano: Revivalist Jewellers of the Nineteenth Century* (Trefil, 1984).

Murray, Peter and Linda: *The Penguin Dictionary of Art & Artists* (Penguin Books 1982).

Orpen, Sir William: *The Outline of Art* (George Newnes, London).

Rijn, Michel van: *Hot Art Cold Cash* (Little, Brown and Company 1993).

Schuller, Sepp: *Forgers, Dealers, Experts: 'Adventures in the Twilight of Art Forgery* (Arthur Barker).

Simpson, Colin: *The Artful Partners: The Secret Association of Bernard Berenson and Joseph Duveen* (Unwin Paperbacks 1988).

Sox, David: *Unmasking the Forger: The Dossena Deception* (Unwin Hyman 1987).

Sylvester, David, Shiff, Richard & Prather, Marla: *Willem de Kooning Paintings* (National Gallery of Art, Washington & Yale University Press, New Haven and London 1994).

Talbot, Ken: *Enigma! The New Story of Elmyr de Hory the Greatest Art Forger of Our Time* (ONT 1991).

Temple, Richard: *Icons: A Sacred Art* (The Temple Gallery, London 1989).

Wright, Christopher: *The Art of the Forger* (Gordon Fraser 1984).

Index